NINE OLD MEN

THE WALT DISNEY FAMILY FOUNDATION PRESS

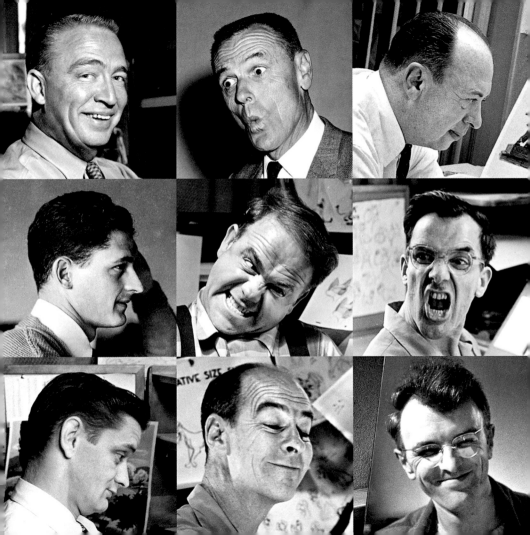

WALT DISNEY'S

NINE OLD MEN

MASTERS OF ANIMATION

CURATED BY DON HAHN | TEXT BY CHARLES SOLOMON
MAY 17, 2018—JANUARY 7, 2019
THE WALT DISNEY FAMILY MUSEUM | SAN FRANCISCO, CALIFORNIA

CONTENTS

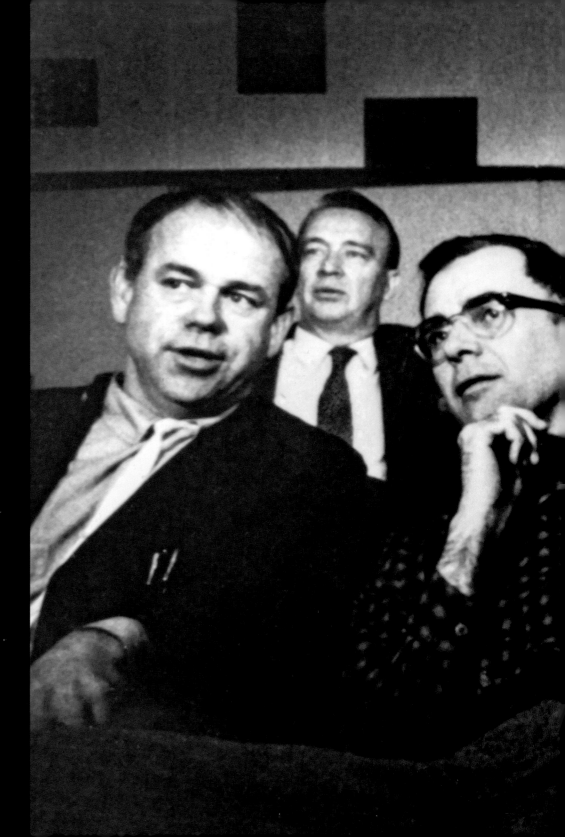

Nine Old Men, Left to Right: Ward Kimball, Eric Larson, Frank Thomas, Marc Davis, Ollie Johnston, Les Clark, Milt Kahl, John Lounsbery, Woolie Reitherman.

FOREWORD: RON MILLER

The first animated Disney film I remember seeing was *Snow White and the Seven Dwarfs* (1937), and it left an unforgettable impression on me as a young child. Eventually, in my work at The Walt Disney Company, I would come to know some of the men who worked on that film, along with other animated classics such as *Pinocchio* (1940), *Peter Pan* (1953), and *Sleeping Beauty* (1959). This group of talented artists, referred to as Walt Disney's Nine Old Men, were Walt's key animators and helped bring his masterful storytelling to life. Walt worked alongside the Nine Old Men, pushing their artistic boundaries to create Disney's timeless and beloved style of animation.

During my time at The Walt Disney Studios, I produced live-action films. When I became involved with Walt Disney Animation after Walt's passing, I knew little about producing an animated film, but many of the Nine Old Men were gracious enough to guide me in the process. The first animated feature I worked on was *The Fox and the Hound* (1981), which was also the last film the remaining members of the Nine Old Men were involved in. They helped mold the story and led the new group of talented animators during early stages of production. Many of the young animators who were fortunate to have been mentored by these key artists went on to be leaders in the animation and film industries. For me, *The Fox and the Hound* would come to represent the past, present, and future of Walt Disney Animation. I am grateful that I was able to know—and learn from—the artists featured in this exhibition.

Walt Disney's Nine Old Men: Masters of Animation allows visitors to understand the impact that these artists had on the Studios' culture, animation techniques, and the next generation

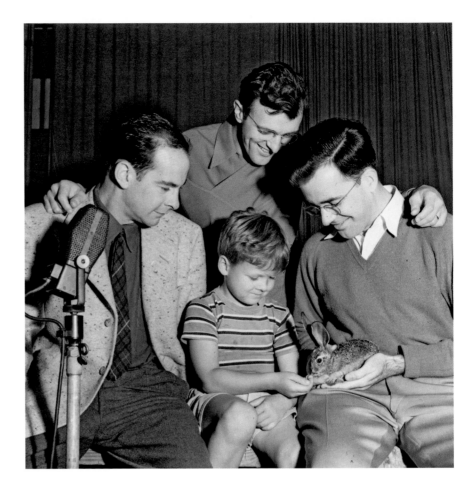

of animators. My wife, Diane Disney Miller, established The Walt Disney Family Museum in 2009 not only to tell Walt Disney's true story but also to celebrate the lives and works of artists who worked with or were influenced by her father. I am honored to carry on Diane's tradition and continue her legacy of preserving the history of animation.

RON MILLER
PRESIDENT OF THE BOARD
THE WALT DISNEY FAMILY MUSEUM

▲ Left to Right: Ollie Johnston, Milt Kahl, Peter Behn (voice of Thumper), and Frank Thomas | *Bambi*, 1942

FOREWORD: KIRSTEN KOMOROSKE

It brings me great pleasure to share with you *Walt Disney's Nine Old Men: Masters of Animation*, the catalog for the retrospective exhibition at The Walt Disney Family Museum. The exhibition showcases the artists who became a cornerstone of Walt Disney Animation and continue to influence the animation industry today. *Masters of Animation* is curated by museum advisory committee member, dear friend, and Academy Award®-nominated producer, Don Hahn.

Don began his career at The Walt Disney Studios in the mid-1970s as a summer intern—he would bring coffee to many of the talented animators featured in this exhibition and ask questions about their work. These men inspired Don to enter the world of animation. Joining the Studios as an assistant director years later, working for Woolie Reitherman on *The Fox and the Hound* (1981), Don would later be mentored by the remaining members of the Nine Old Men. Ultimately producing some of Disney's most well-known films, Don's time with these famed animators left a lasting impact and influence on his filmmaking.

Don is an accomplished producer, filmmaker, author, artist, and musician who has graciously given his time to the museum and our mission of promoting innovation, education, and inspiration. Beginning in 2010, and through a series of public programs, Don has shared his deep knowledge of filmmaking and animation history with our visitors. In 2009, he produced the heartfelt film *Christmas with Walt Disney*, which plays exclusively in our theater every holiday season. Don has also served on our advisory committee since its inception in 2015. In that same year, Don guest-curated the museum's retrospective of animator Mel Shaw's work, and produced a fundraising gala in honor of songwriter and composer Richard Sherman.

With *Masters of Animation*, Don has applied his energy and talent to curating a rich and comprehensive exhibition about a

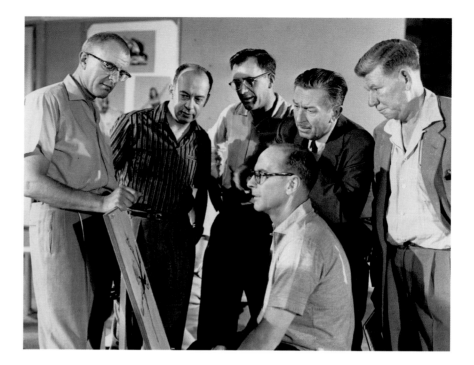

group of diverse artists who helped define the standard of Disney animation. The exhibition imparts a unique understanding of these nine individual artists, and, thanks to the efforts of Don, we are able to tell these stories with original character sketches, family mementos, and never-before-seen artwork from each of these talented animators. A true friend of the museum, we deeply appreciate Don's involvement at every level.

We hope you find inspiration in the work of these legendary artists. Please accept my sincere gratitude for your support of The Walt Disney Family Museum.

KIRSTEN KOMOROSKE
EXECUTIVE DIRECTOR
THE WALT DISNEY FAMILY MUSEUM

▲ Left to Right: Milt Kahl, Marc Davis, Frank Thomas, Walt Disney, and Wilfred Jackson watch Ollie Johnston at work, 1957

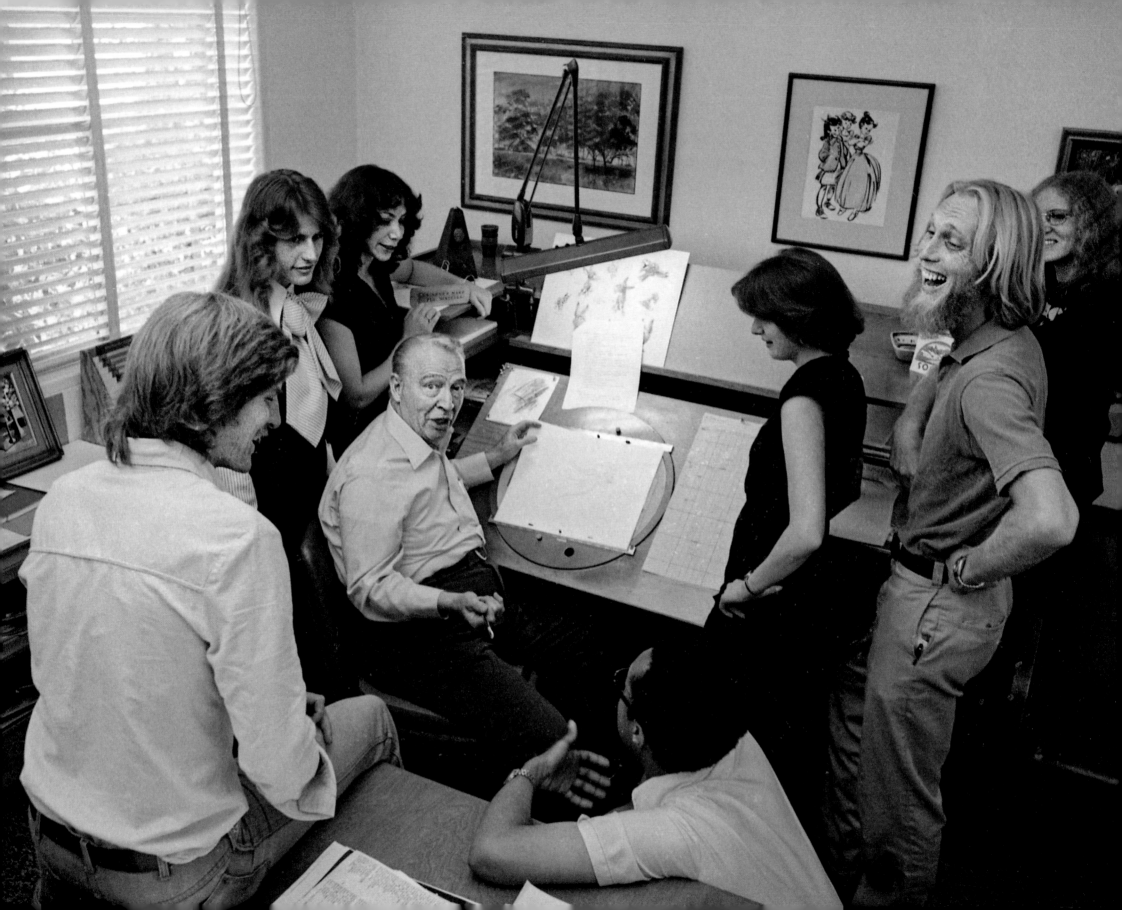

CURATOR'S NOTE: DON HAHN

Animation is an artistic movement. Animators, especially Walt Disney's animators, were part of a movement that can stand alongside the impressionists, cubists, surrealists, and other artistic innovators of the twentieth century. And the Nine Old Men are its master artists, the ones who took the art form to new and unexpected heights. Yet there has been no exhibition of their personal and professional work to validate their genius—until now.

Curating a show for nine prolific twentieth-century artists has been incredibly joyful and seriously challenging. I knew most of these artists personally and worked closely with a few, so when it came time to curate the first exhibition of their work, I turned to their families to gather their personal art, much of which has never been seen by the public.

Additionally, the Walt Disney Animation Research Library, Walt Disney Imagineering, and the Walt Disney Archives Photo Library loaned generously from their collections to showcase the professional accomplishments of these brilliant artists, who, with their colleagues at The Walt Disney Studios, took the crude craft of cartooning and turned it into an art form that continues to revolutionize filmmaking today.

The Nine Old Men gave generously to future animators—a fact that supplies an important epilogue to their story. Today, the animation industry is on fire because these artists passed on their fundamental skills to a new generation. Today's modern animated features owe a debt of gratitude to these pioneering artists, who led with their genius for storytelling and their astounding craft of acting with a pencil on paper.

I owe special thanks to Ron Miller, president of the board, and Kirsten Komoroske, executive director, for asking me to curate this show for The Walt Disney Family Museum; it has been a privilege. Thank you to my friends Andreas Deja and Charles Solomon, who contributed their wisdom and knowledge to the exhibition, and to the entire staff at The Walt Disney Family Museum, who endured my late-night emails to achieve the incredible task of mounting nine exhibits simultaneously. You have my respect and thanks always.

DON HAHN
EXHIBITION CURATOR
FILMMAKER, PRODUCER, AUTHOR

‹ Eric Larson surrounded by animation trainees Lorna Pomeroy Cook, Heidi Guedel, Bill Kroyer, Dan Haskett, Emily Jiuliano, Henry Selick, and Becky Canfield, 1978

INTRODUCTION: THE NINE OLD MEN

Walt Disney called them "the Nine Old Men," playing off of Franklin Roosevelt's disgruntled description of the U.S. Supreme Court. Walt's nine—Les Clark, Marc Davis, Ollie Johnston, Milt Kahl, Ward Kimball, Eric Larson, John Lounsbery, Woolie Reitherman, and Frank Thomas—were anything but old or disgruntled, however. They had become the core of his animation studio and the foundation of his entire enterprise.

They were not the first cadre of Disney animators. An earlier group of artists had been the leaders of Walt's initial triumphs, from *Steamboat Willie* (1928) to *Snow White and the Seven Dwarfs* (1937): Art Babbitt, Norm Ferguson, Ub Iwerks, Ham Luske, Fred Moore, and Bill Tytla. These veteran artists trained the Nine Old Men, who later replaced them.

Unlike their predecessors, many of whom were self-taught cartoonists, the Nine Old Men were graduates of some of the nation's leading art schools. Woolie and Ward wanted to be watercolorists; Marc was interested in animal anatomy. Unable to find work during the Depression, they answered the ads reading "Walt Disney is looking for artists."

These weren't the only artists on whom Walt relied. There were dozens of other key artists—men and women—who worked at The Walt Disney Studios alongside the Nine Old Men. People like head of the Character Model Department Joe Grant, story artist Bill Peet, art director Ken Anderson, and concept artist/color stylist Mary Blair were arguably just as crucial to the art of animation at the Studios, but it was Walt's joking term of endearment—the Nine Old Men—that stuck almost as a brand name for these nine lead animators. Historians, journalists, and other animators began using it, and the term became part of Disney lore.

It's not clear if the Nine Old Men really saw themselves as a group. They were united by their efforts to realize Walt's vision—even when that vision seemed impossible. Nevertheless, friendships and rivalries flourished among the artists. *The Incredibles* (2004) director Brad Bird commented, "Every time you get Frank on the subject of Milt and Milt on the subject of Frank, it's like two thoroughbreds kind of bumping each other on down the line." As Marc said, "Sometimes I think Walt's greatest achievement was getting us all to work together without killing each other."

The use of the term "Nine Old Men" has overshadowed the fact that they were not a collective entity but nine individual artists with unique strengths, interests, styles, and approaches. Marc was never without a sketchbook, Milt never carried one. Frank and Ollie were the closest of friends, as were Marc and Milt. Ollie and Ward shared a fascination with railroads. Ward and Frank played Dixieland jazz in the Firehouse Five Plus Two. Woolie and Frank went into the military during World War II, making films that were vital to the war effort, while the others stayed at the Studios.

They didn't always function as a unit, either. Some of them worked on one film but not another, depending on who Walt felt had the talents a particular project demanded. Marc was so involved in developing *Bambi* (1942) that he didn't work on *Fantasia* (1940), *Pinocchio* (1940), or *Dumbo* (1941). Walt would later shift Woolie from animating to producing and directing, move Les to television work, and assign Marc to Imagineering.

They were united by their belief in Walt's genius, and together they created some of the greatest animated films ever made. Their work remains the standard by which all animation is judged, decades after their deaths.

▸Publicity photo of Walt Disney's Nine Old Men. Top row (left to right): Milt Kahl, Marc Davis, Frank Thomas, Eric Larson, and Ollie Johnston. Bottom Row (left to right): Woolie Reitherman, Les Clark, Ward Kimball, and John Lounsbery, 1972

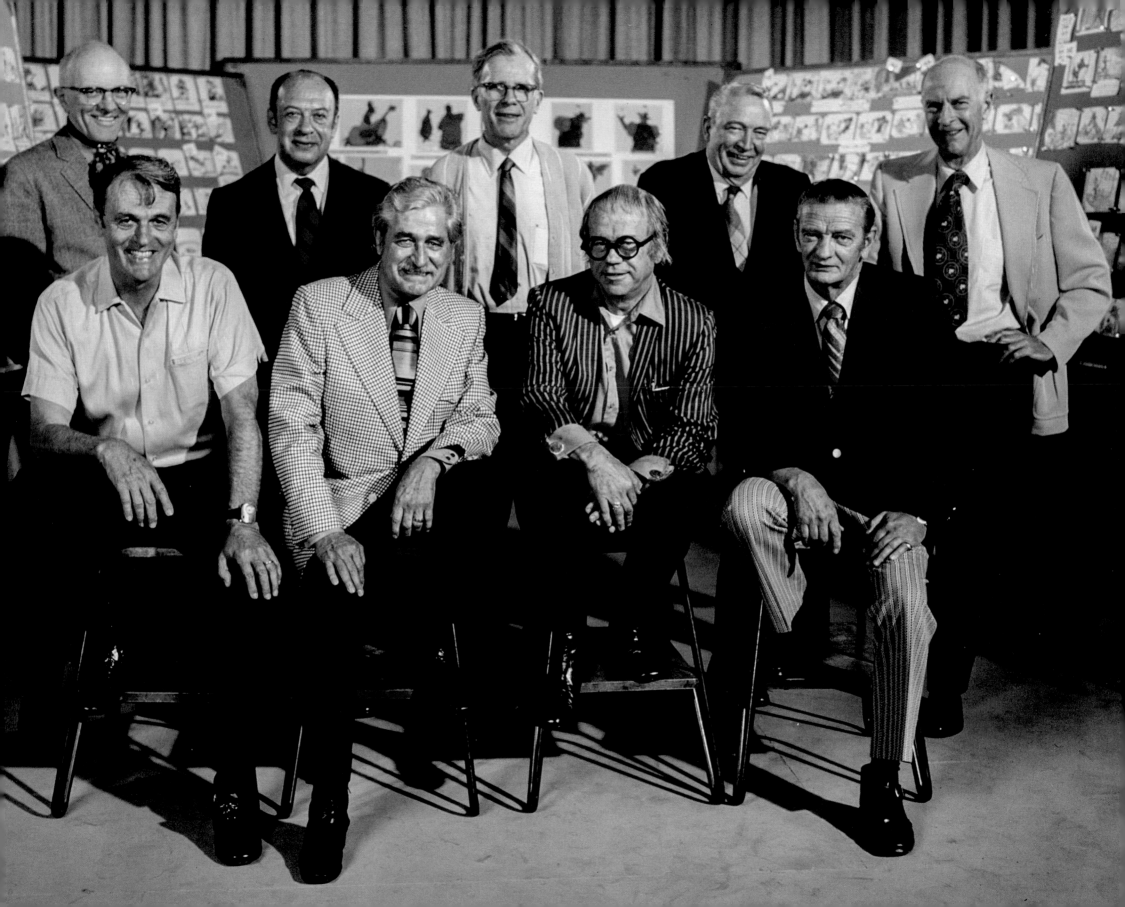

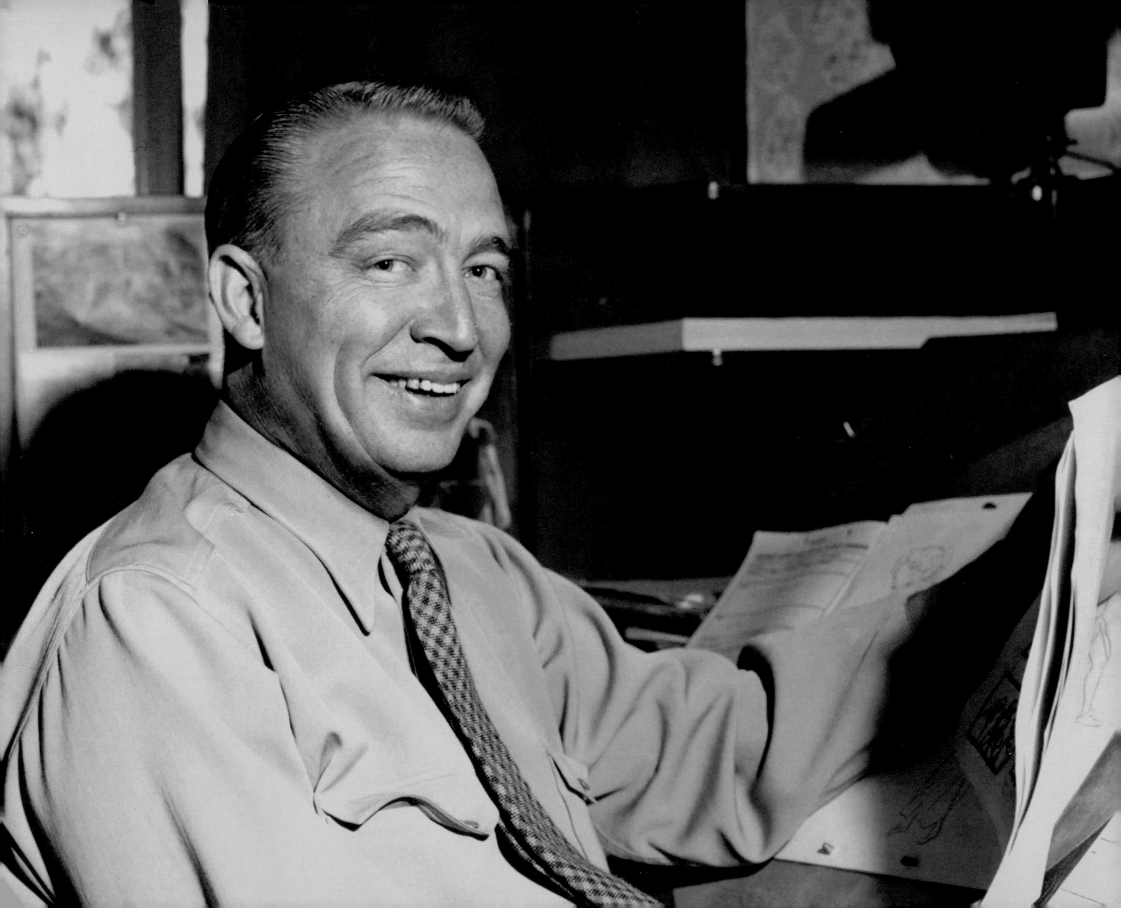

ERIC
LARSON

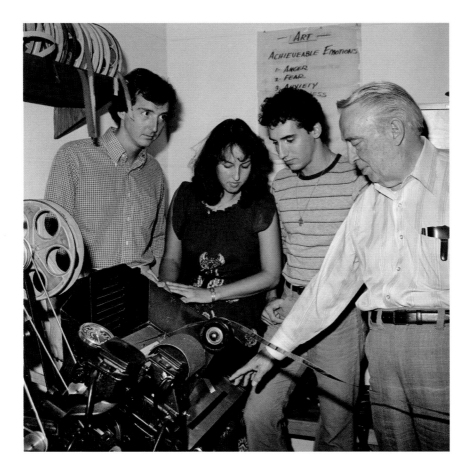

Left to Right: Trainees Bill Frake, Kathy Zielinski, and Matt O'Callaghan, with Eric Larson

ERIC LARSON

Gentle and soft-spoken, Eric was the man the other artists went to when they had troubles, knowing they would find a sympathetic ear and good advice. His kind demeanor made him the logical choice to head the training program for young animators. His students—who adored him—included Brad Bird, Tim Burton, Ron Clements, Mark Henn, John Musker, John Pomeroy, and Henry Selick, all of whom became celebrated animators and directors themselves. They later joked that Eric came to resemble the paternal owl he animated in *Bambi* (1942). Animator and historian Andreas Deja described him as "someone you'd want to have as your grandfather." Decades later, animator Glen Keane recalled one of Eric's key tenets: "Observation is the key to what you are going to animate."

Before coming to the Studios, Eric worked in commercial art, but he also made woodblock prints, winning honorable mentions at an international exhibit in Los Angeles. In his spare time, he experimented with writing for radio. His friend Richard Creedon, a former radio writer who had moved to the Disney Story Department, encouraged him to come to the Studios.

As an animator and a director, Eric cherished the collaborative spirit he found at The Walt Disney Studios. In a 1986 interview, he reflected, "One thing about this business: Nobody is an island unto himself. We used to have a saying that everybody worked over everybody else's shoulder and in everybody else's lap. That's what impressed me about that darn place: Everybody was willing to share the knowledge they had; you didn't have to use what someone else said, but it was given without any petty feelings of superiority."

◂ Publicity photo of Eric Larson at the animator's desk | *Peter Pan*, 1953

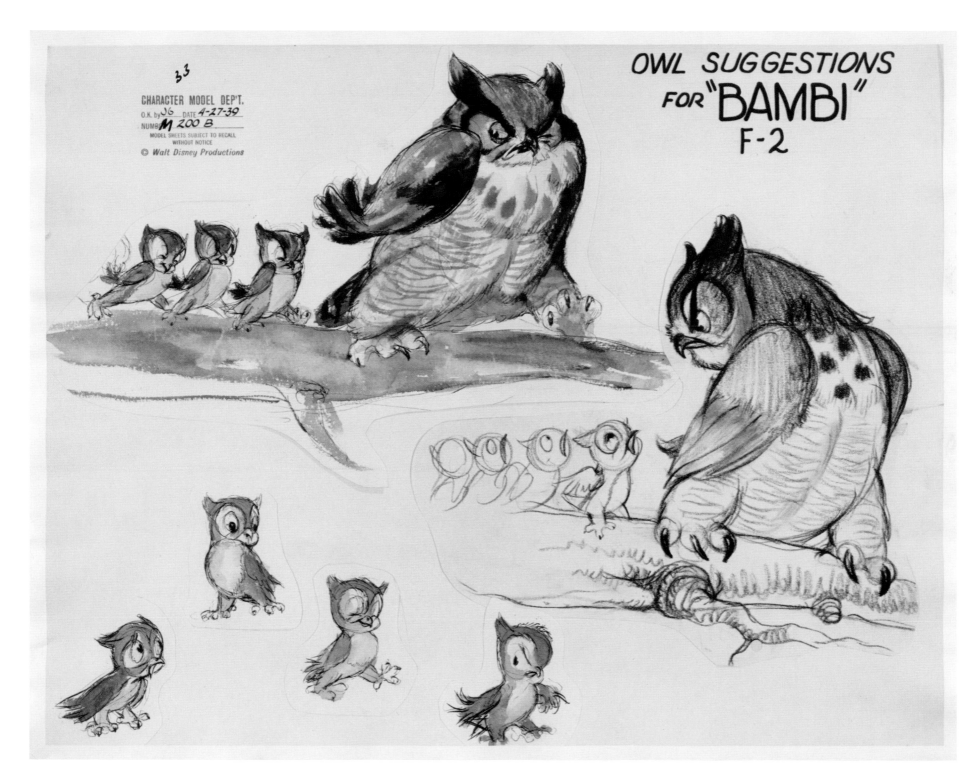

OWL SUGGESTIONS FOR "BAMBI" F-2

Model sheet, 1939 | *Bambi*, 1942 | Photostat on paper

Clean-up animation drawing | *Pinocchio*, 1940 | Graphite and colored pencil on paper

Eric Larson with Walt Disney, 1957 | *Sleeping Beauty*, 1959

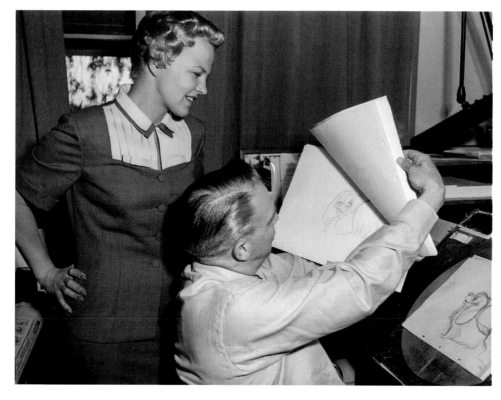

Eric Larson flips an animation scene for Peggy Lee, voice of Peg, 1953 | *Lady and the Tramp*, 1955

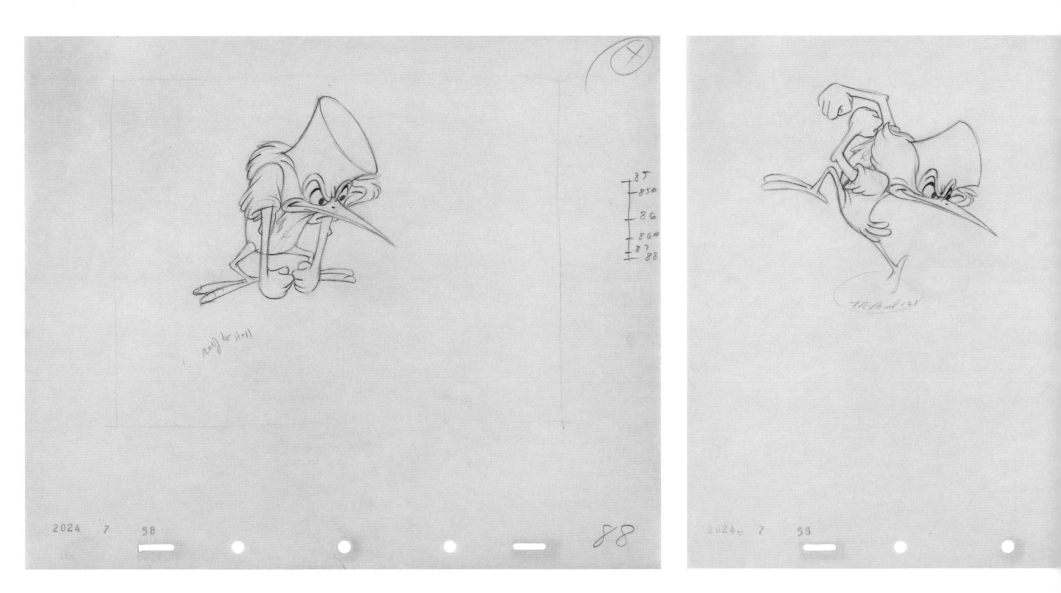

Clean-up animation drawings from the "Peter and the Wolf" segment
Make Mine Music, 1946
Graphite and colored pencil on paper

2024 7 58

112

131

Rough animation drawings from "The Flying Gauchito" segment
The Three Caballeros, 1945
Graphite and colored pencil on paper

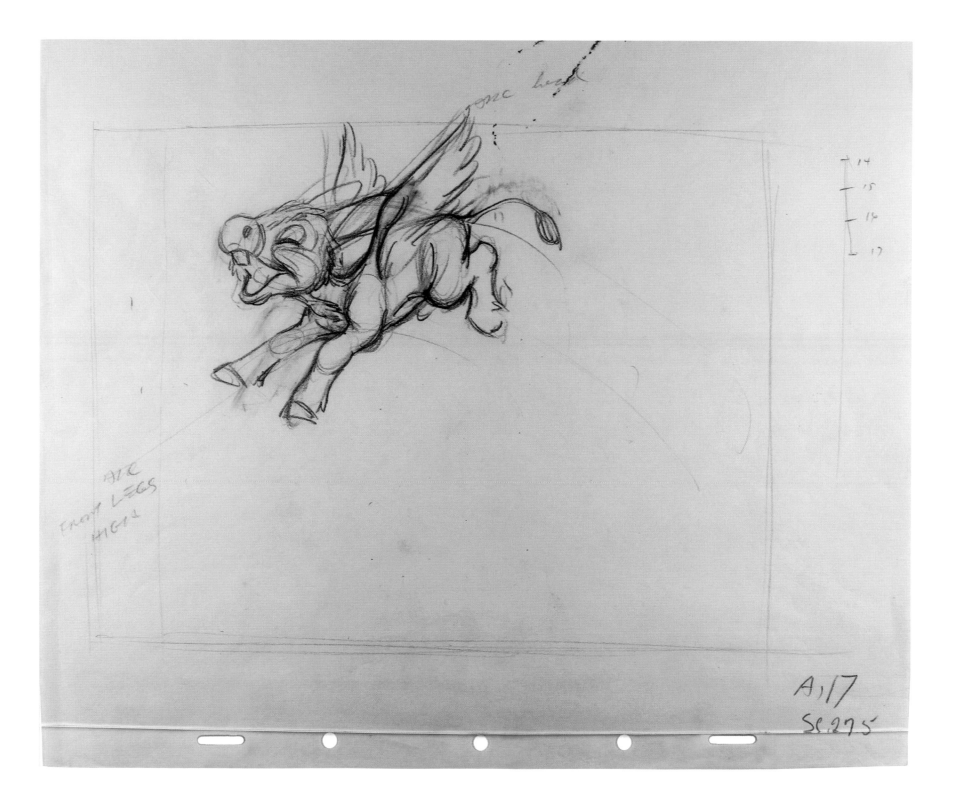

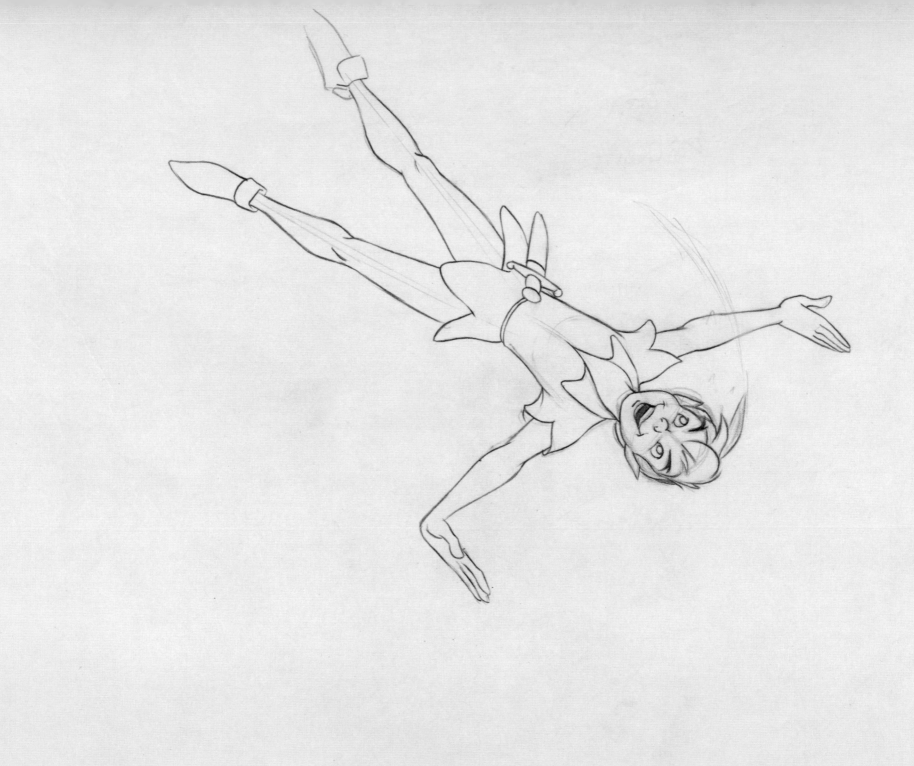

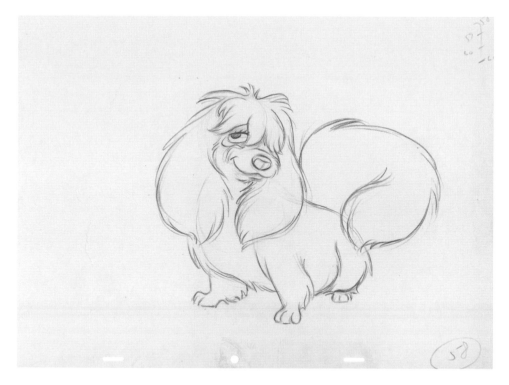

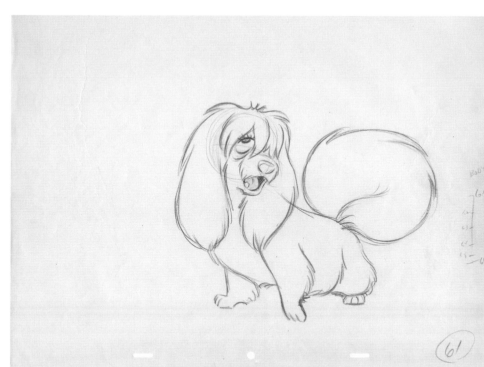

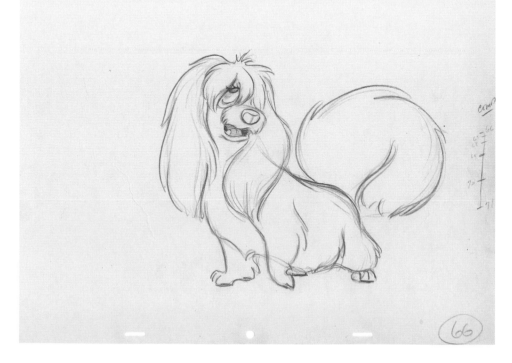

Clean-up animation drawings
Lady and the Tramp, 1955
Graphite on paper

‹ Clean-up animation drawing | *Peter Pan*, 1953 | Graphite and colored pencil on paper

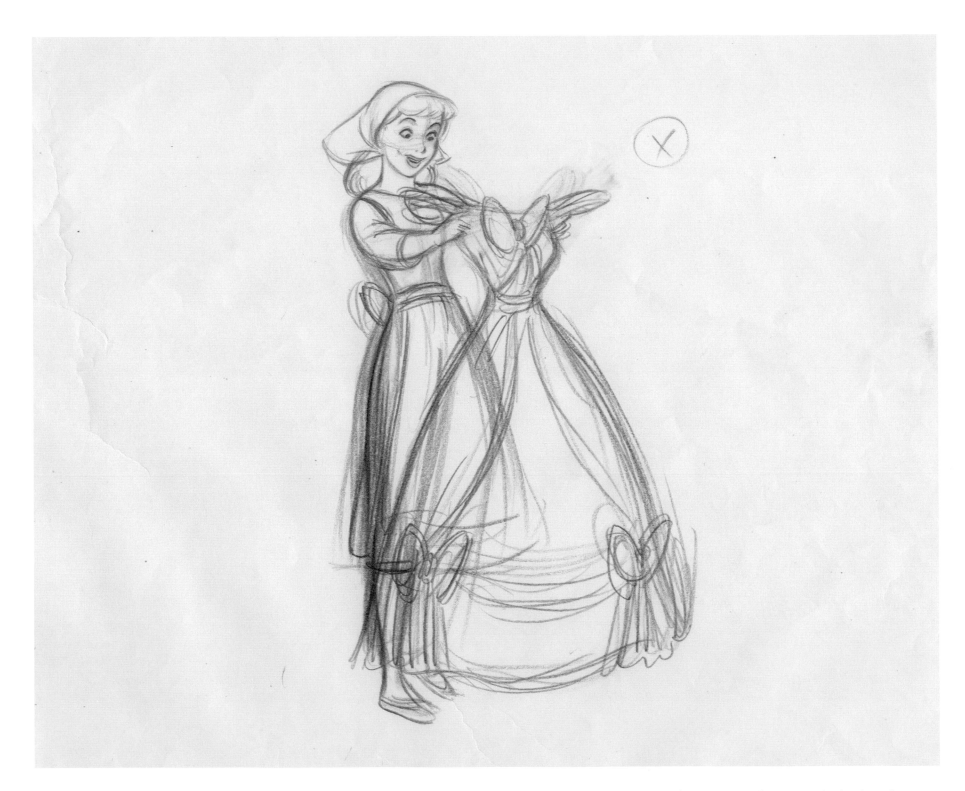

Rough animation drawing | *Cinderella*, 1950 | Graphite and colored pencil on paper

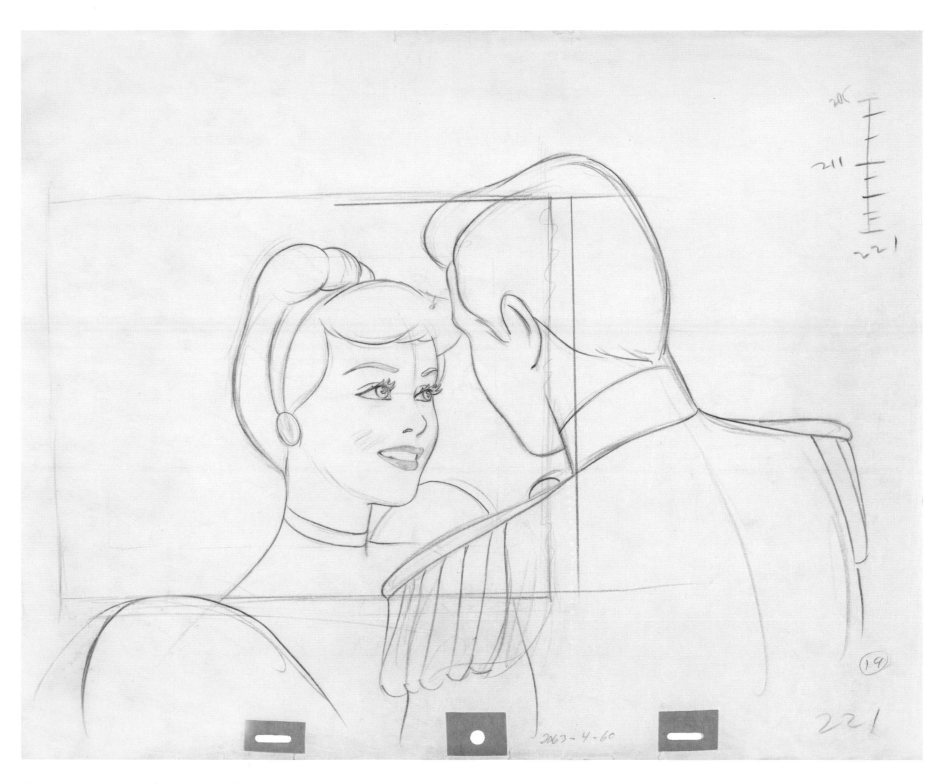

Clean-up animation drawing | *Cinderella*, 1950 | Graphite and colored pencil on paper

FRANK THOMAS

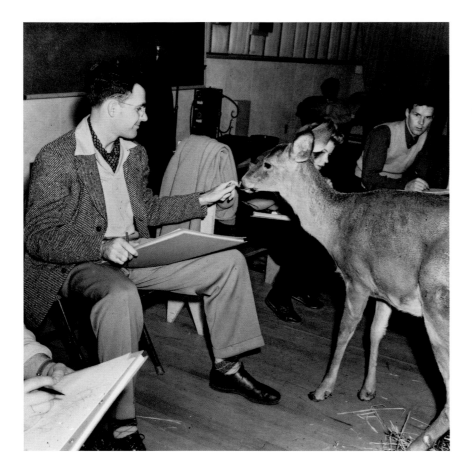

Frank Thomas studying deer in art class, 1940 | *Bambi*, 1942

FRANK THOMAS

An animator's drawings are as individual and recognizable as his signature. Frank's rough, often scribbly sketches reveal his constant striving to find the best way to depict a pose, a movement, an emotion. He stressed character and acting over fine drawing, and is best known for his skill at conveying his characters' deeply felt emotions—the dwarfs weeping at Snow White's bier or Merlin expressing awe at the power of love. Animation historian John Canemaker praised Frank's work for its sincerity: "His characters' emotions and thoughts are always believable. Captain Hook, Baloo, and Pongo have nothing in common—except the sincerity Frank gave them."

Frank was demanding of himself as he was of others. *Who Framed Roger Rabbit* (1988) animation director Richard Williams called him "as cuddly and innocent as a roll of barbed wire," a comment that Canemaker says Frank always enjoyed.

After touring South America in 1941 with Walt as part of the Disney research team dubbed "El Grupo," Frank enlisted in the Army Air Corps. He served in the First Motion Picture Unit, making training films with artists from Disney and other studios. In the military, he had fuller control of his work than he had under Walt, and he learned the importance of making a point quickly and clearly, then moving on.

Frank enjoyed playing the piano in Ward Kimball's Firehouse Five Plus Two, which provided welcome relief from the stresses of work and allowed him greater freedom of expression. His wife, Jeanette, commented on his performances: "He's a ham, that's why he's a good animator."

‹ Frank Thomas at his animator's desk | *LIFE* magazine, 1953

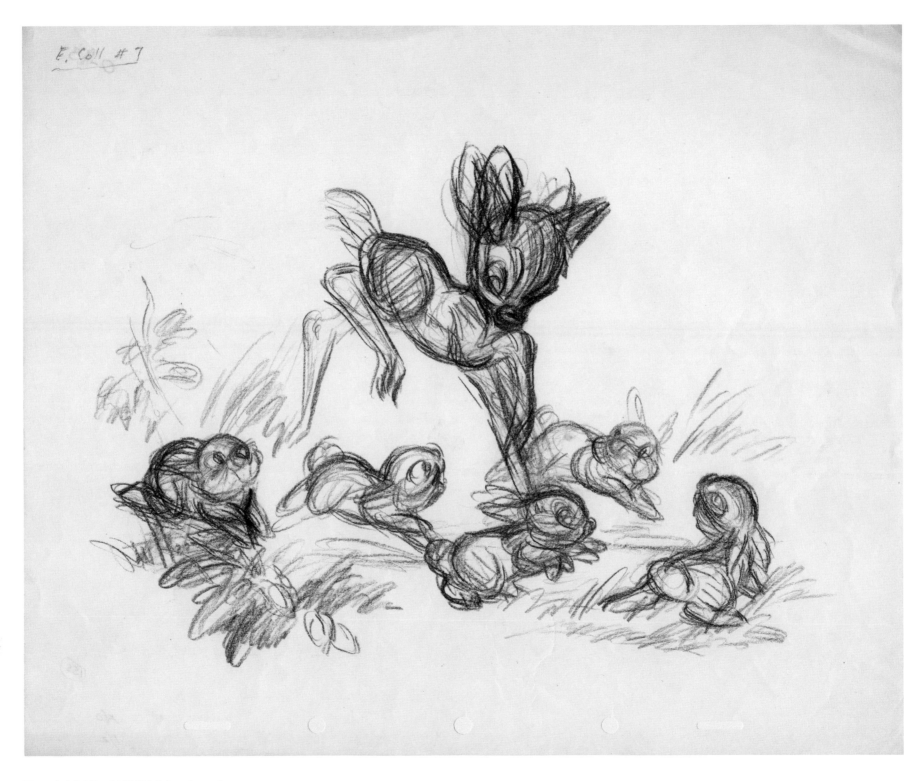

Story sketch | *Bambi*, 1942 | Colored pencil on paper

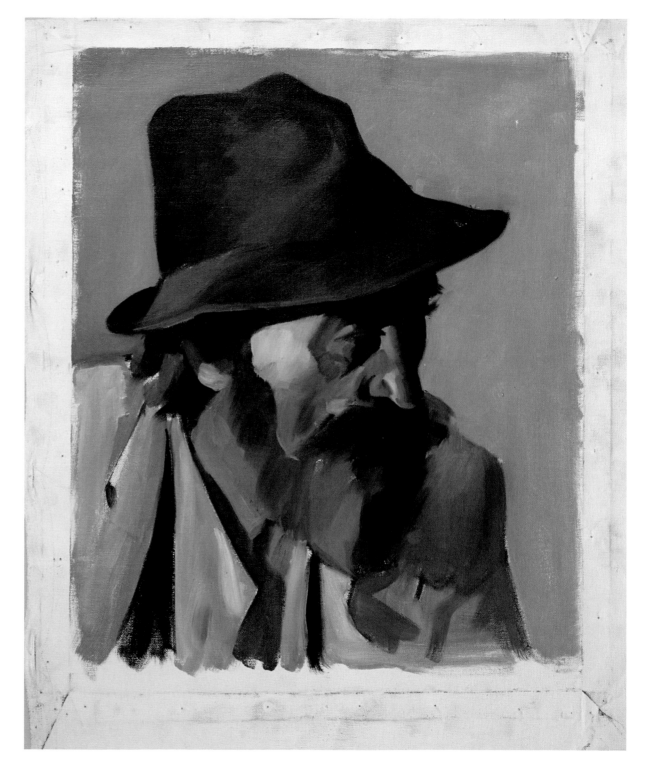

Portrait of a Bearded Man, c. 1933 | Oil paint on canvas

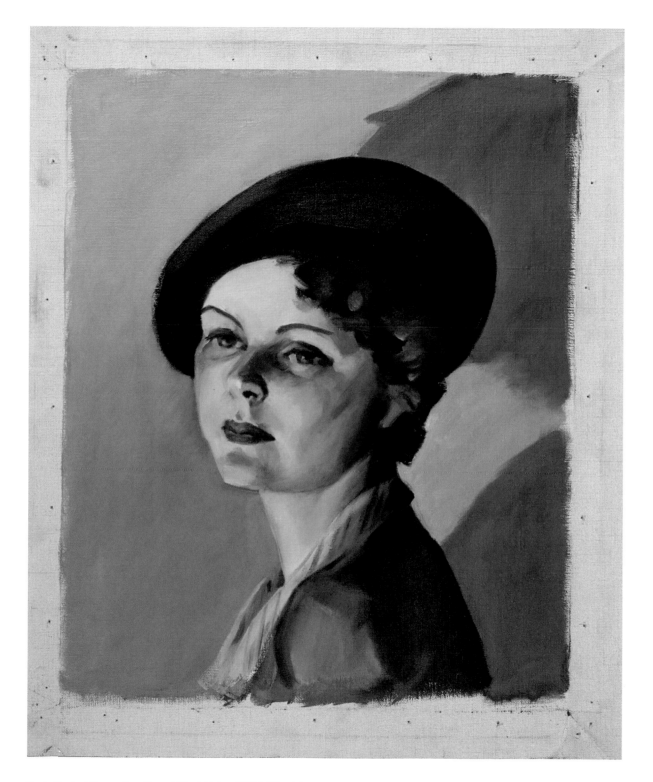

Portrait of a Woman in a Round Black Hat, c. 1933 | Oil paint on canvas

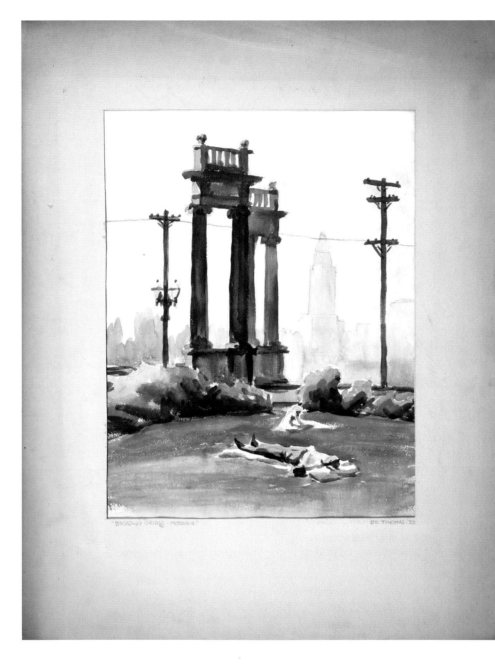

Broadway Bridge – Morning, c. 1933 | Watercolor on paper

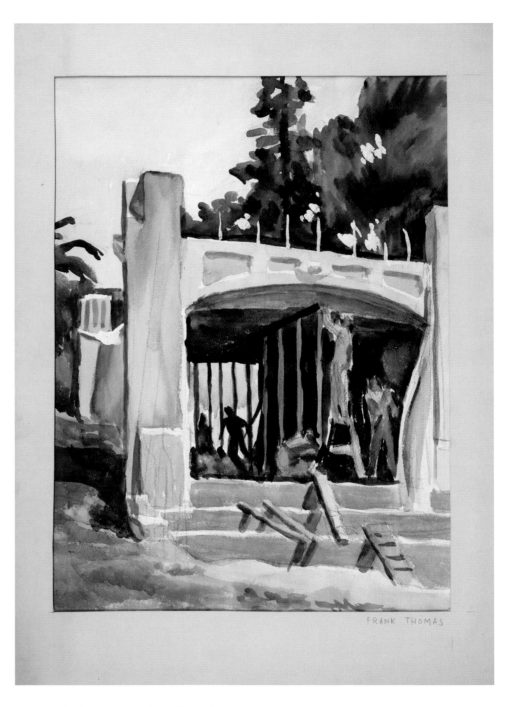

Builders Working on a Tunnel, c. 1933 | Watercolor on paper

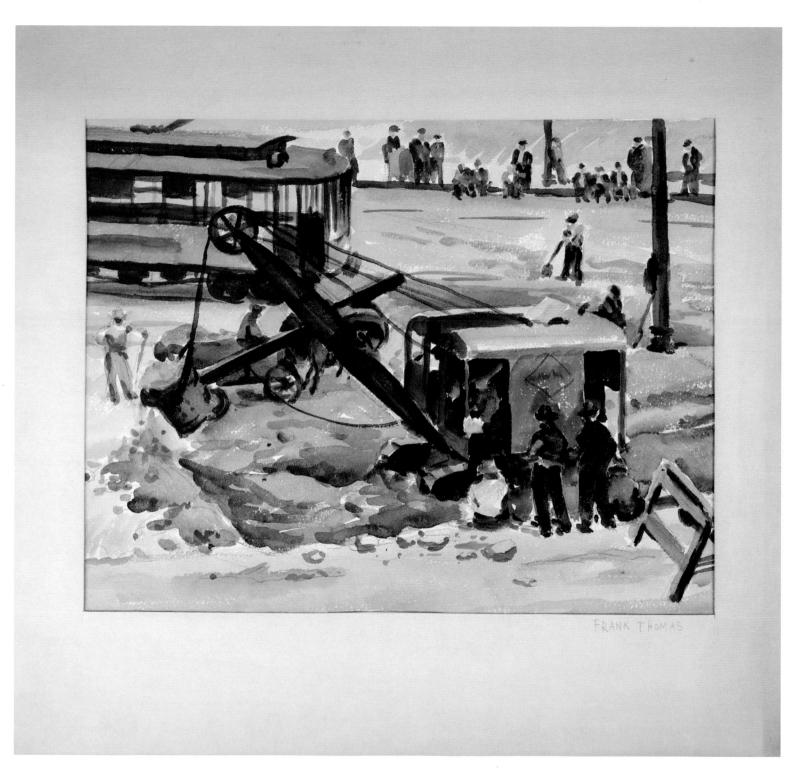

Steam Shovel, c. 1933 | Watercolor on paper

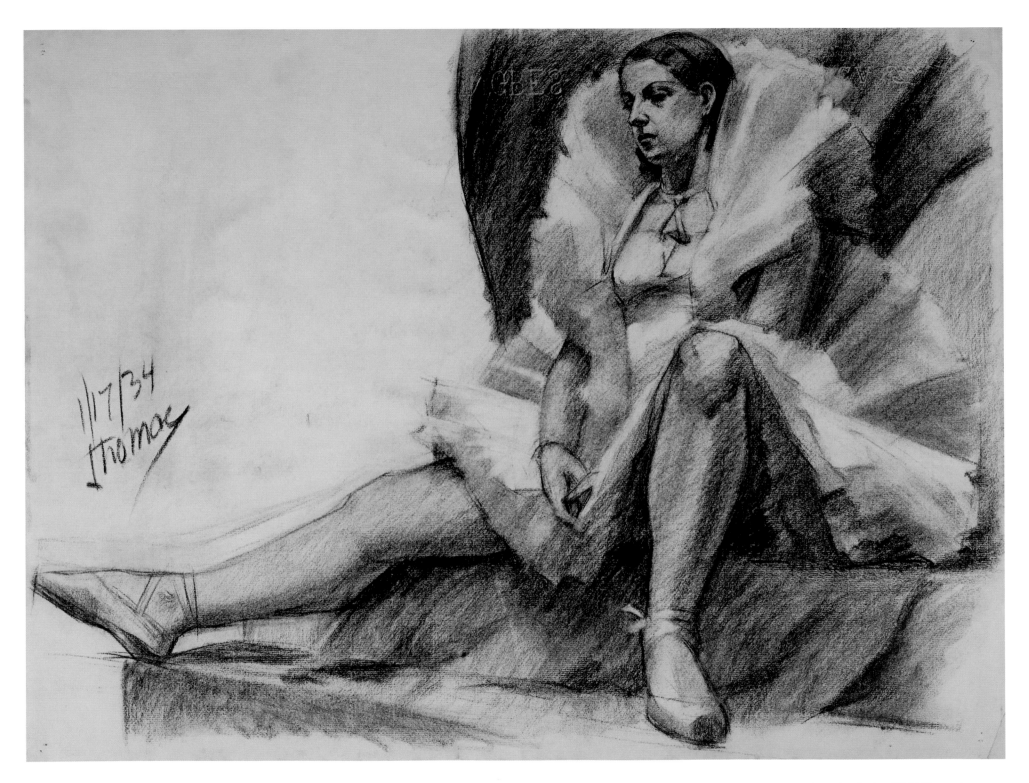

Seated Ballerina, 1934 | Charcoal on paper

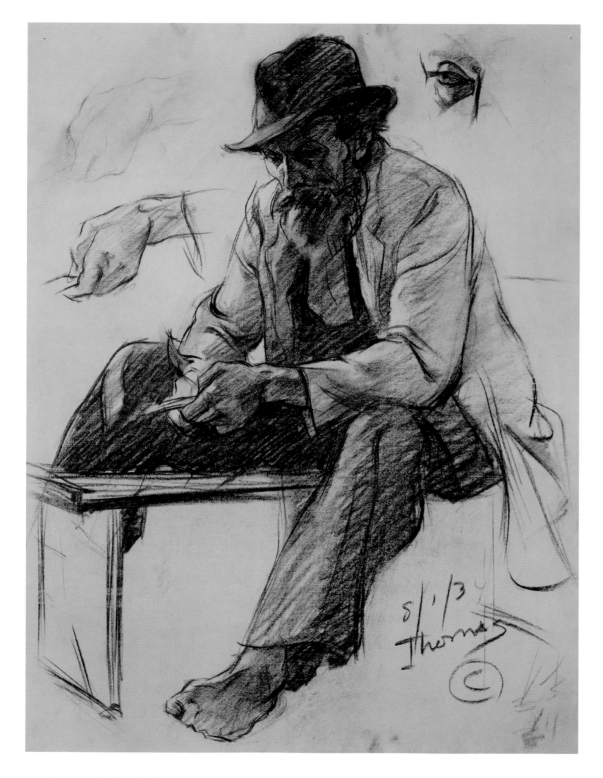

Bearded Man with Hat, 1934 | Charcoal on paper

Clean-up animation scene
Pinocchio, 1940
Graphite and colored pencil on paper

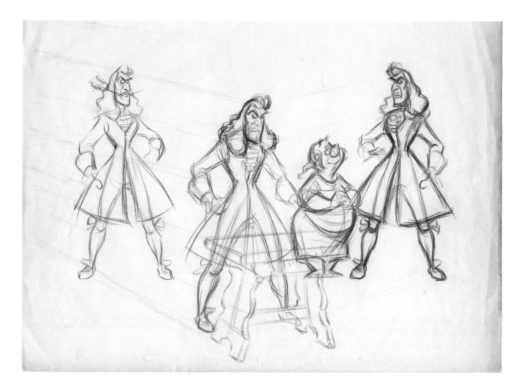

Concept art
Peter Pan, 1953
Colored pencil on paper

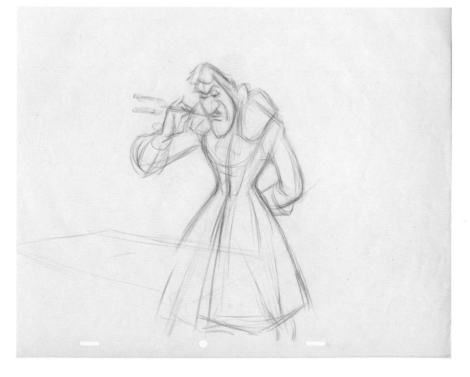

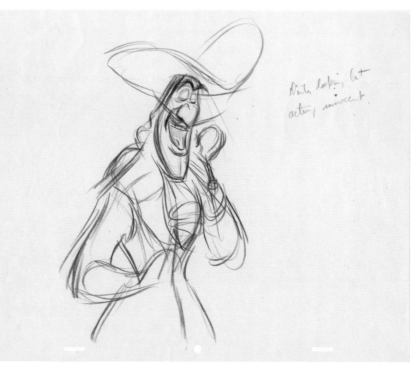

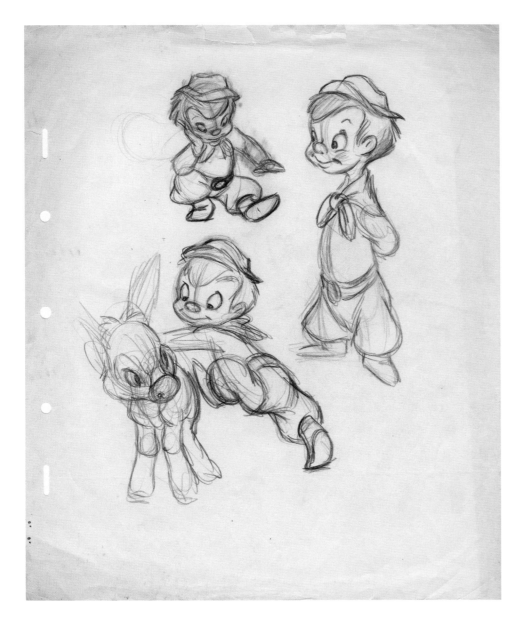

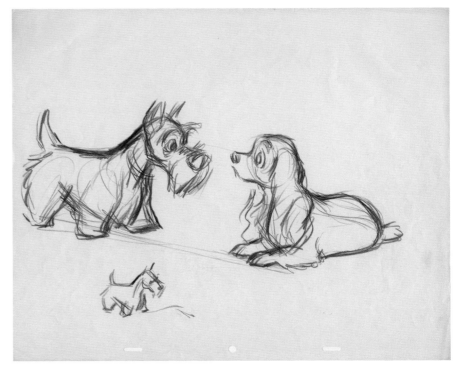

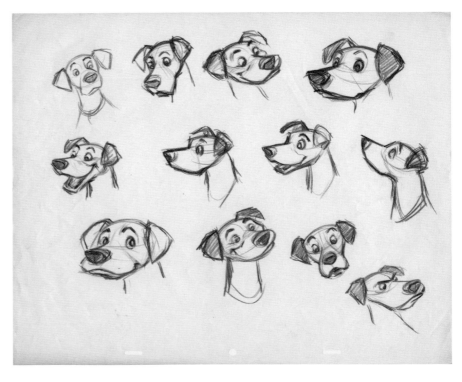

Concept art from "The Flying Gauchito" segment
The Three Caballeros, 1945
Colored pencil on paper

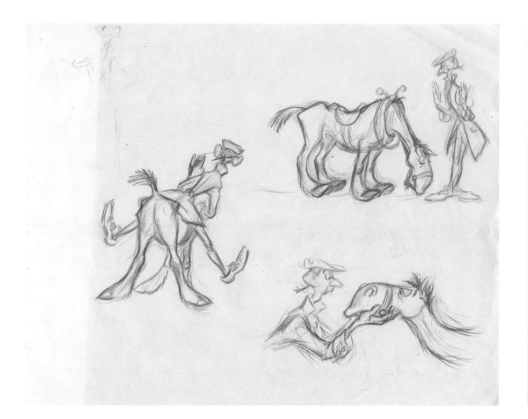

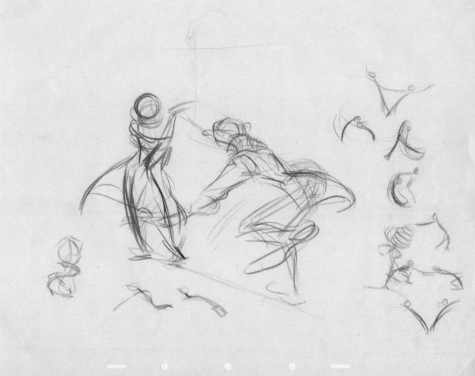

Concept art from "The Legend of Sleepy Hollow" segment
The Adventures of Ichabod and Mr. Toad, 1949 | Graphite and colored pencil on paper

Concept art from "The Legend of Sleepy Hollow" segment
The Adventures of Ichabod and Mr. Toad, 1949 | Colored pencil on paper

◄▊ Concept art | *Lady and the Tramp*, 1955
 Colored pencil on paper

◄▊ Concept art | *One Hundred and One Dalmatians*, 1961
 Colored pencil on paper

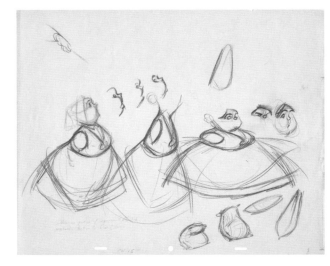

Concept art | *Sleeping Beauty*, 1959
Graphite and colored pencil on paper

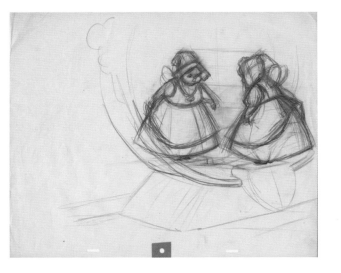

Rough animation drawing | *Sleeping Beauty*, 1959
Graphite and colored pencil on paper

Concept art | *Sleeping Beauty*, 1959
Colored pencil on paper

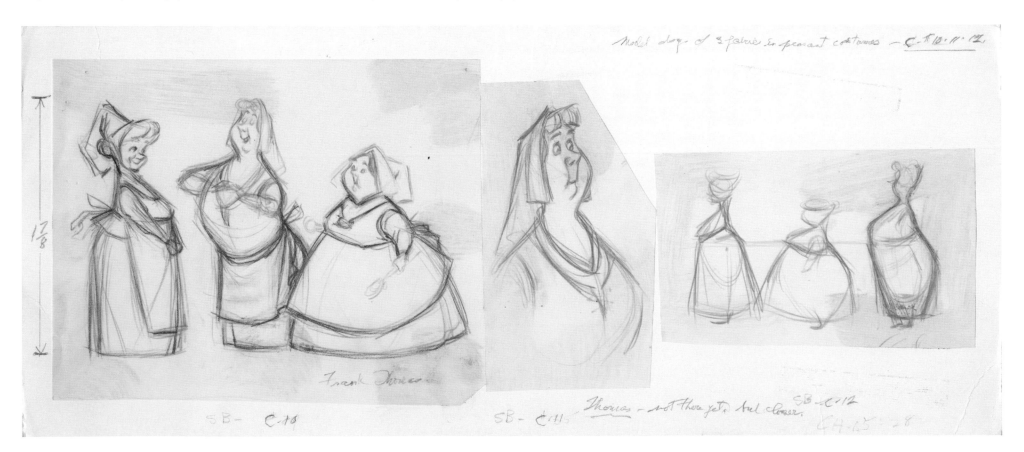

Model sheet | *Sleeping Beauty*, 1959 | Graphite and colored pencil on paper, collaged onto paperboard

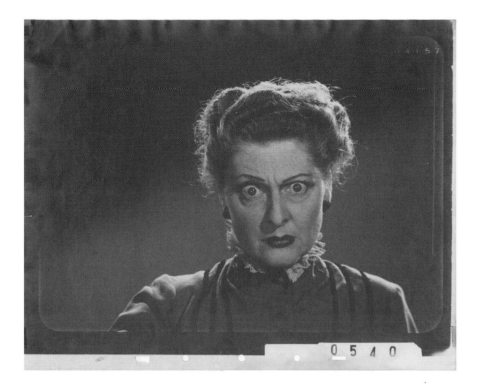

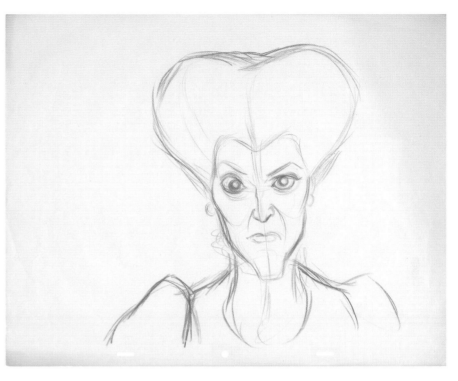

Live-action reference of Eleanor Audley as Lady Tremaine | *Cinderella*, 1950
Photograph on paper

Rough animation drawing | *Cinderella*, 1950 | Colored pencil on paper

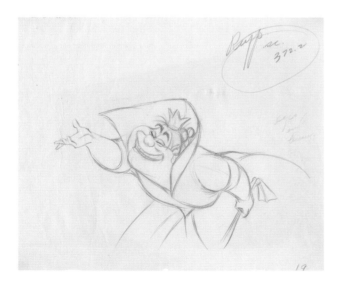

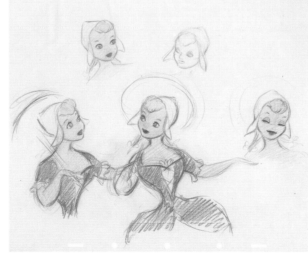

Rough animation drawing
Alice in Wonderland, 1951
Graphite and colored pencil on paper

Concept art from "The Legend of Sleepy Hollow" segment
The Adventures of Ichabod and Mr. Toad, 1949
Graphite and colored pencil on paper

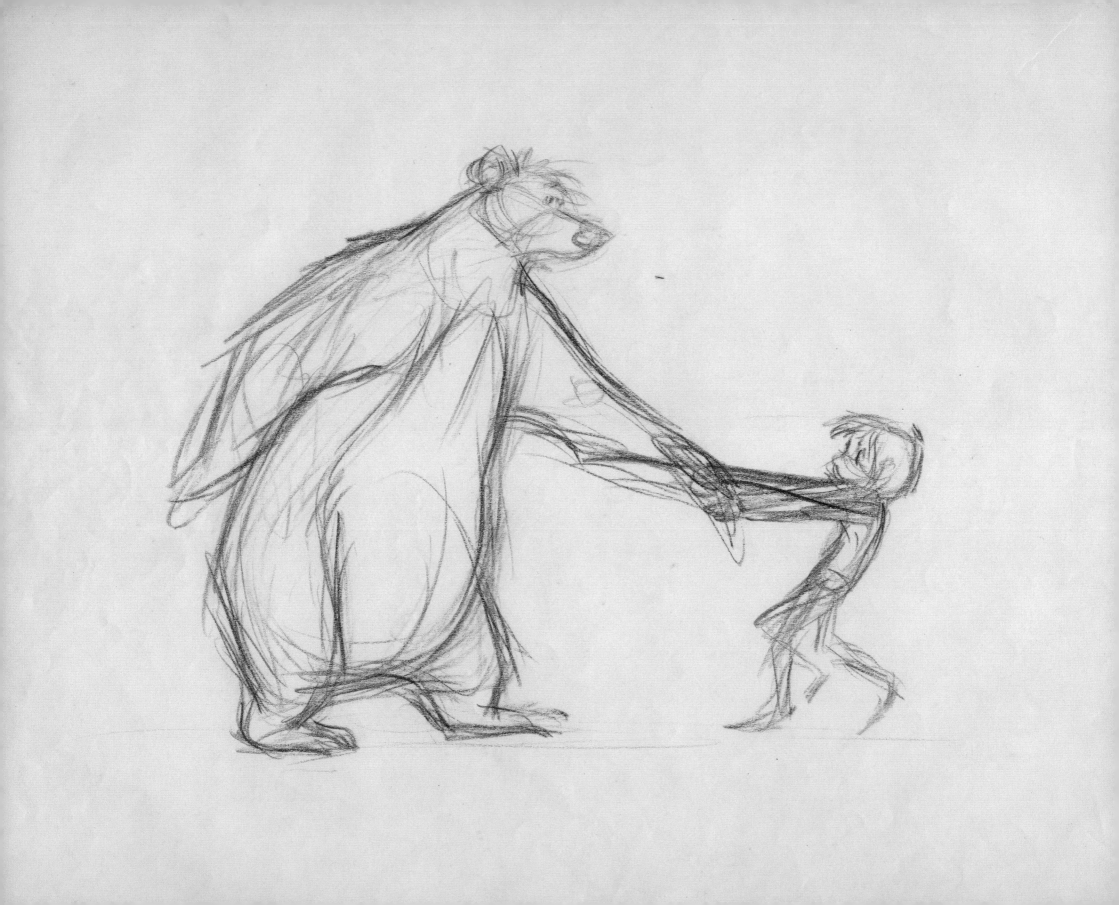

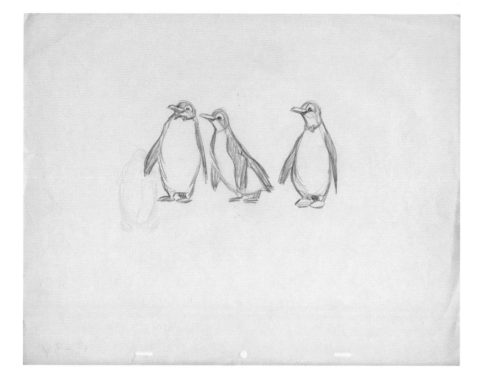

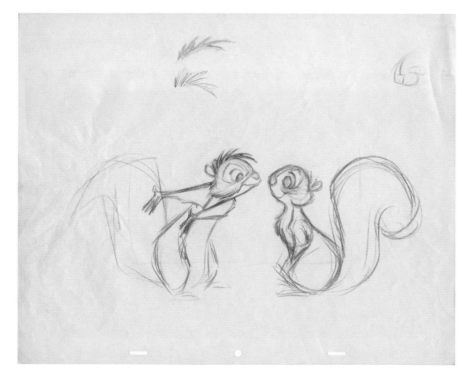

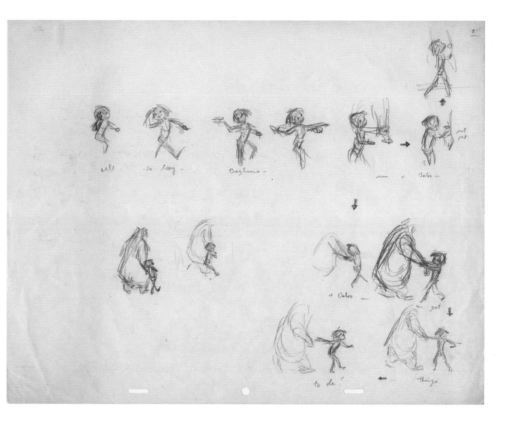

Animation thumbnail drawings
The Jungle Book, 1967
Graphite on paper

▯ Concept art | *Mary Poppins*, 1964
 Graphite and colored pencil on paper

▯ Concept art | *The Sword in the Stone*, 1963
 Graphite and colored pencil on paper

◂ Concept art | *The Jungle Book*, 1967 | Colored pencil on paper

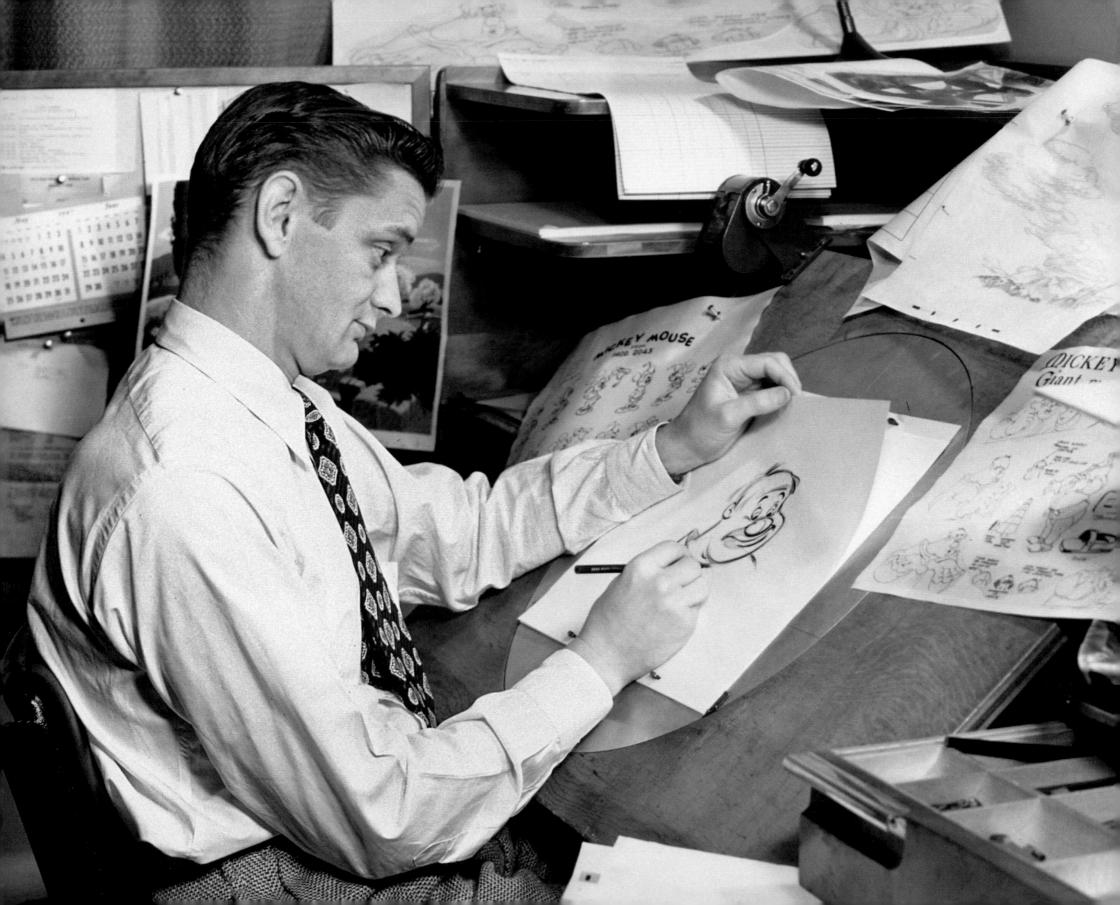

JOHN
LOUNSBERY

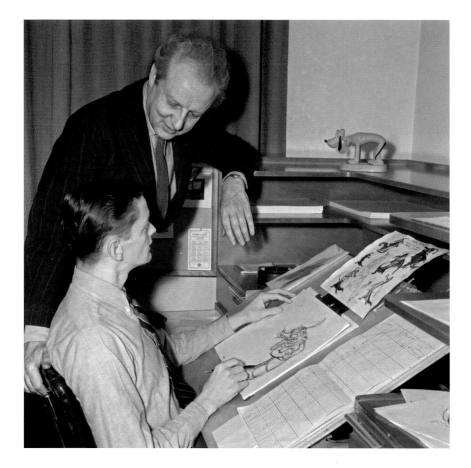

John Lounsbery with conductor Leopold Stokowski at the animator's desk | *Fantasia*, 1940

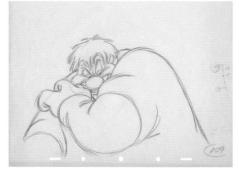

Clean-up animation drawing from the "Mickey and the Beanstalk" segment | *Fun and Fancy Free*, 1947 | Graphite and colored pencil on paper

‹ John Lounsbery drawing Willie the Giant from the "Mickey and the Beanstalk" segment | *Fun and Fancy Free*, 1947

JOHN LOUNSBERY

A quiet, self-effacing man, John was both respected and loved by his fellow artists, who praised his kindness and gentle demeanor. Some thought that his humility caused him to underplay his talent, but he let his exquisite animation speak for itself.

After graduating from East High in Denver, John worked as a lineman and pole setter for Western Union; a crack shot, he picked off rattlesnakes that threatened the other workmen. He studied briefly at the Art Institute of Denver before he switched to the Art Center School (now ArtCenter College of Design) in Los Angeles. At the suggestion of one of his professors, he responded to Walt's search for artists in 1935. John was mentored by Norm Ferguson, and they worked together on the Witch in *Snow White and the Seven Dwarfs* (1937), but his superior draftsmanship and education led him to eclipse his mentor. An unusually versatile artist, John animated characters who ranged from the amorous Ben Ali Gator in *Fantasia*'s "Dance of the Hours" segment (1940) to Tony and Joe in *Lady and the Tramp* (1955), and from the dim-witted Gideon in *Pinocchio* (1940) to the pompous Colonel Hathi in *The Jungle Book* (1967).

John loved animating. When he was promoted to director, he told director Richard Williams, "They pushed me into this thing." Animator Dale Baer, who spoke to John as he was preparing to move to the director's chair, recalled, "He said all he wanted was just to be a good animator someday."

John loved the West. He and his family lived on a six-acre ranch, where they raised chickens, horses, and cows. His ranch burned to the ground in the 1970 Chatsworth-Malibu fires, but he and his wife, Florence, rebuilt it from the ashes. His daughter, Andrea, said he "could have been a pioneer settler." His shyness, and the fact that he died before many historians began interviewing the older artists, have caused John to receive less attention than his work warrants.

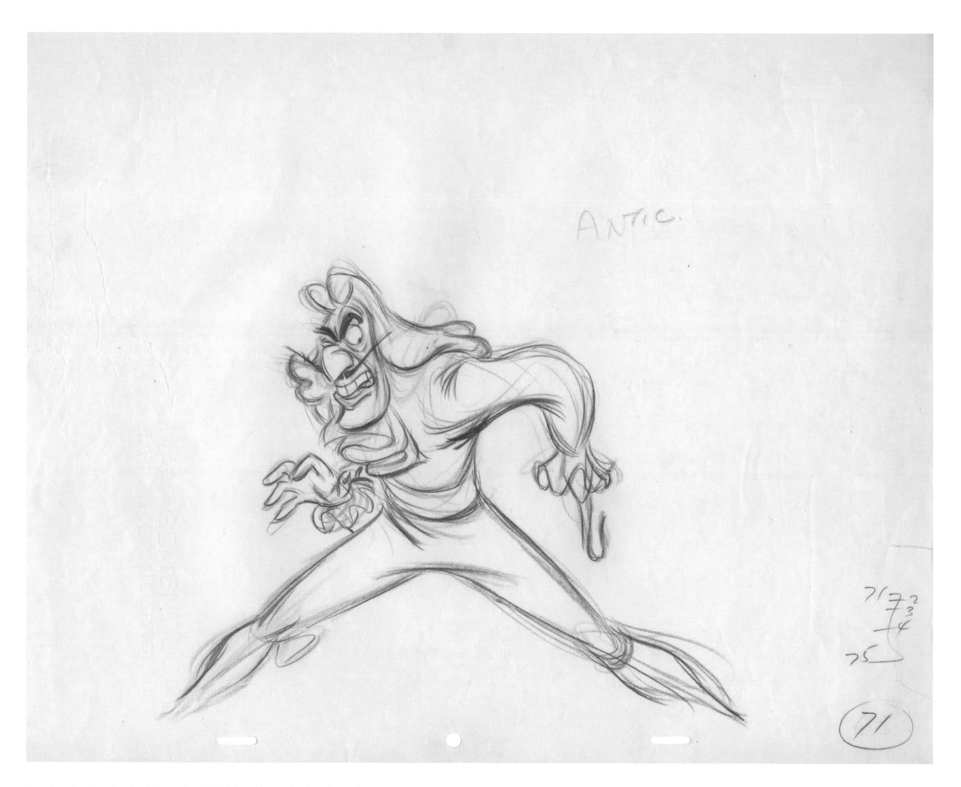

Rough animation drawing | *Peter Pan*, 1953 | Graphite and colored pencil on paper

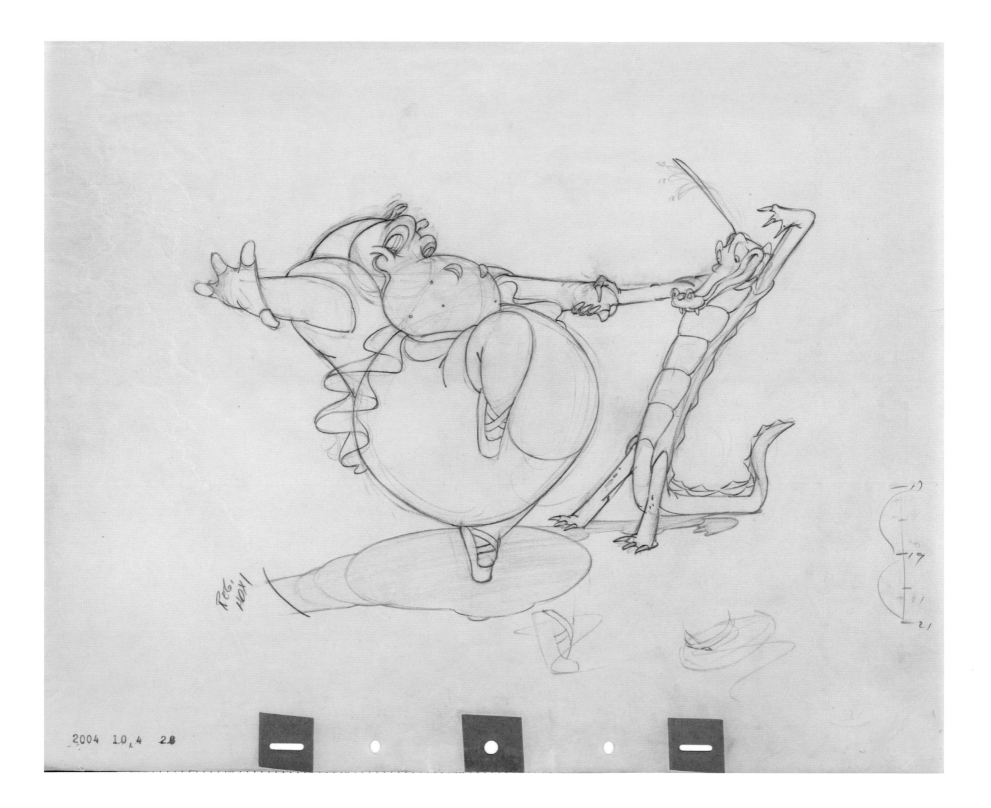

2004 10.4 28

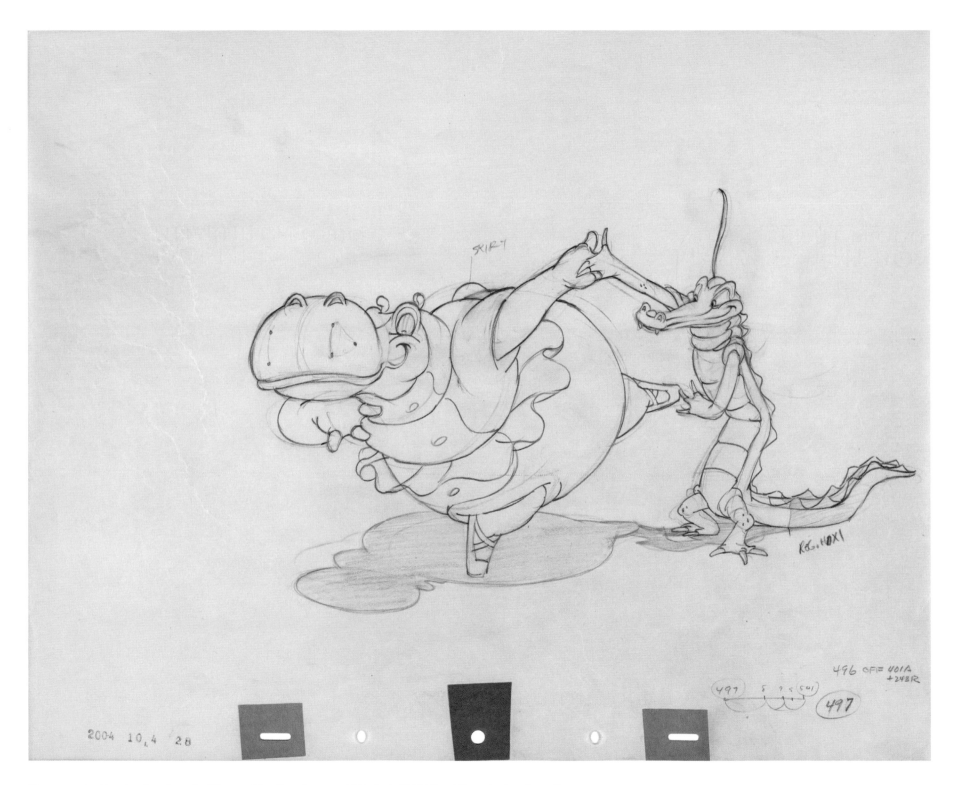

Clean-up animation drawings from the "Dance of the Hours" segment | *Fantasia*, 1940 | Graphite and colored pencil on paper

Clean-up animation drawings
Pinocchio, 1940
Graphite and colored pencil on paper

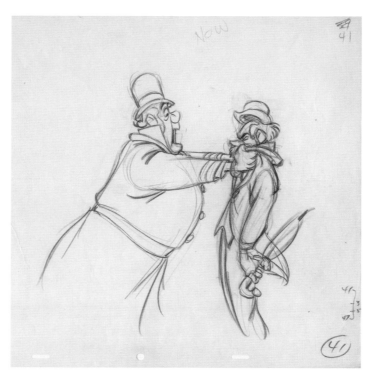

Rough animation drawings
Lady and the Tramp, 1955
Graphite and colored pencil on paper

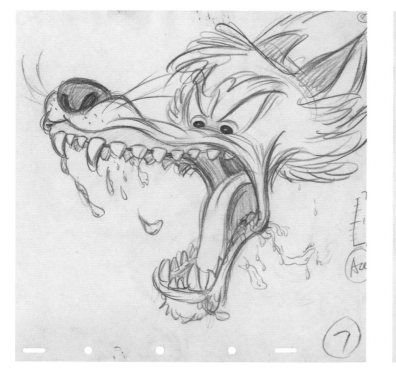

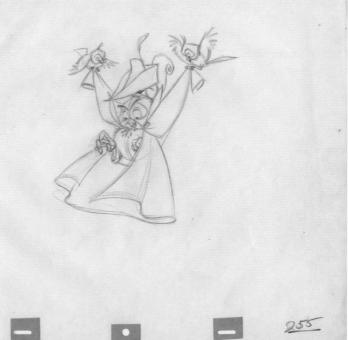

■□ Rough animation drawing from the
"Peter and the Wolf" segment
Make Mine Music, 1946
Graphite and colored pencil on paper

□■ Clean-up animation drawing
Sleeping Beauty, 1959
Graphite and colored pencil on paper

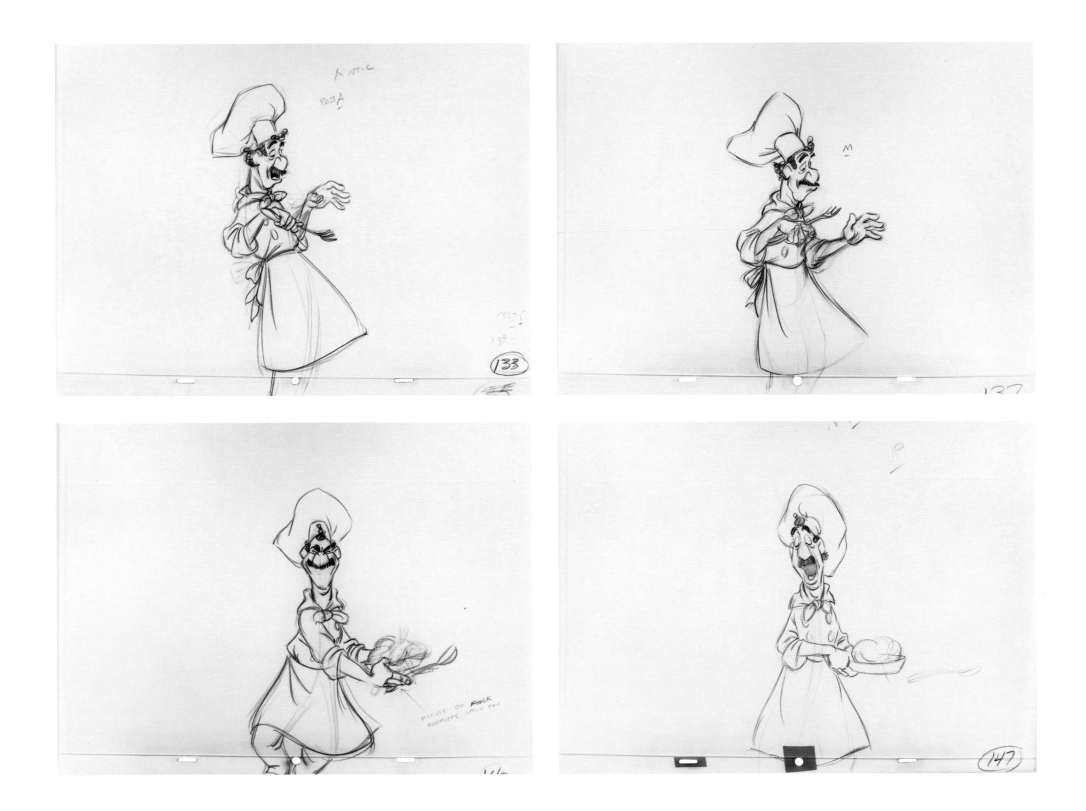

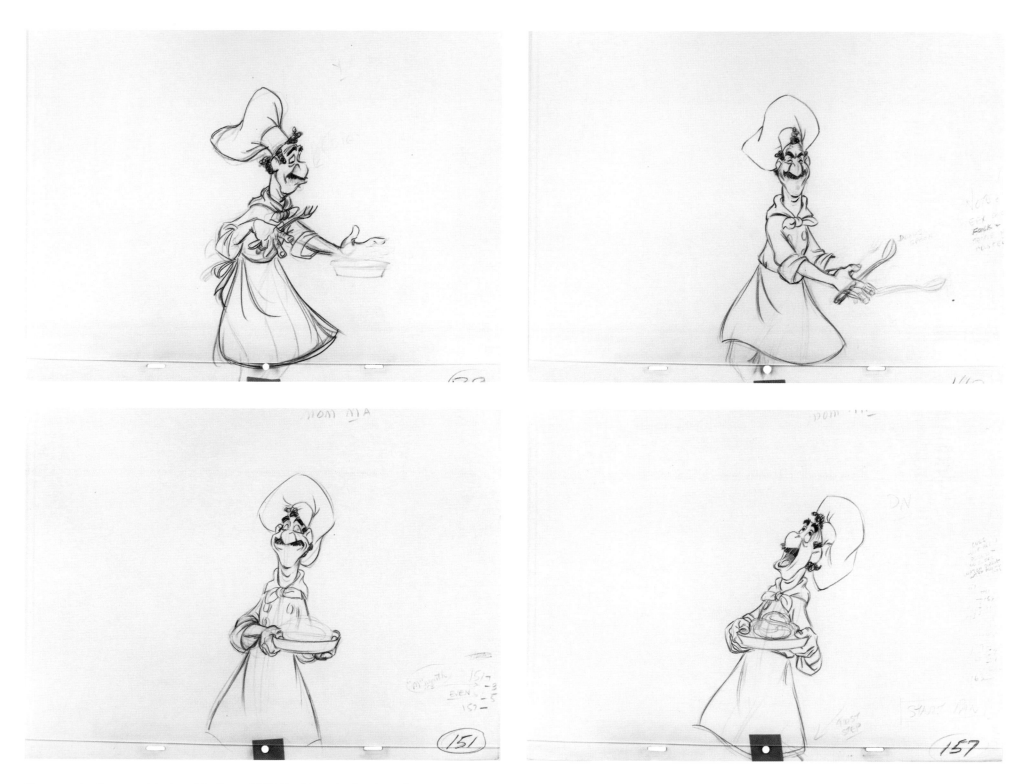

Clean-up animation scene | *Lady and the Tramp*, 1955 | Graphite and colored pencil on paper

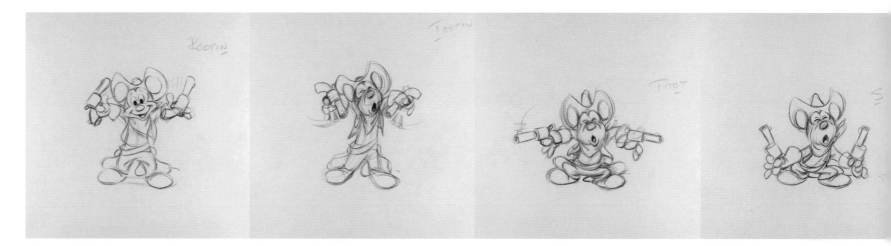

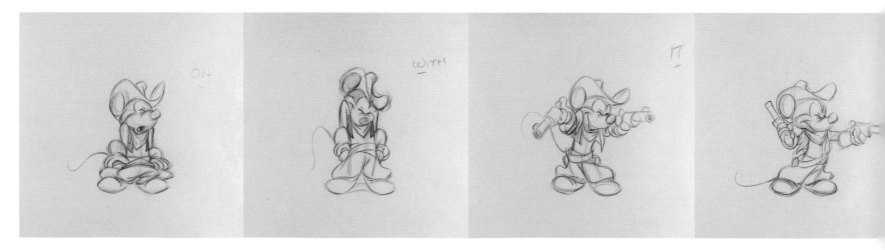

Rough animation scene | *Mickey Mouse Club*, 1955 | Graphite and colored pencil on paper

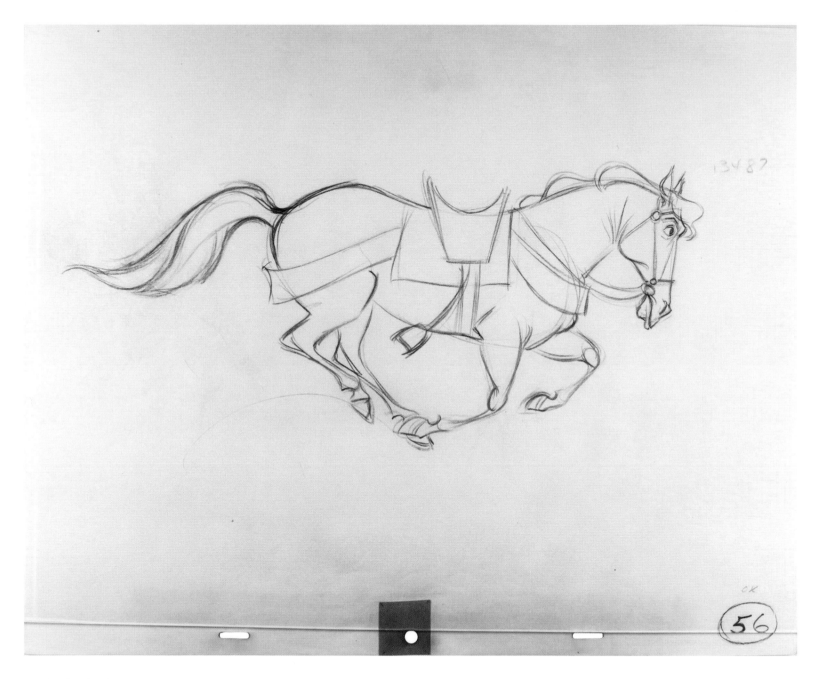

Rough animation drawings
Sleeping Beauty, 1959
Graphite and colored pencil on paper

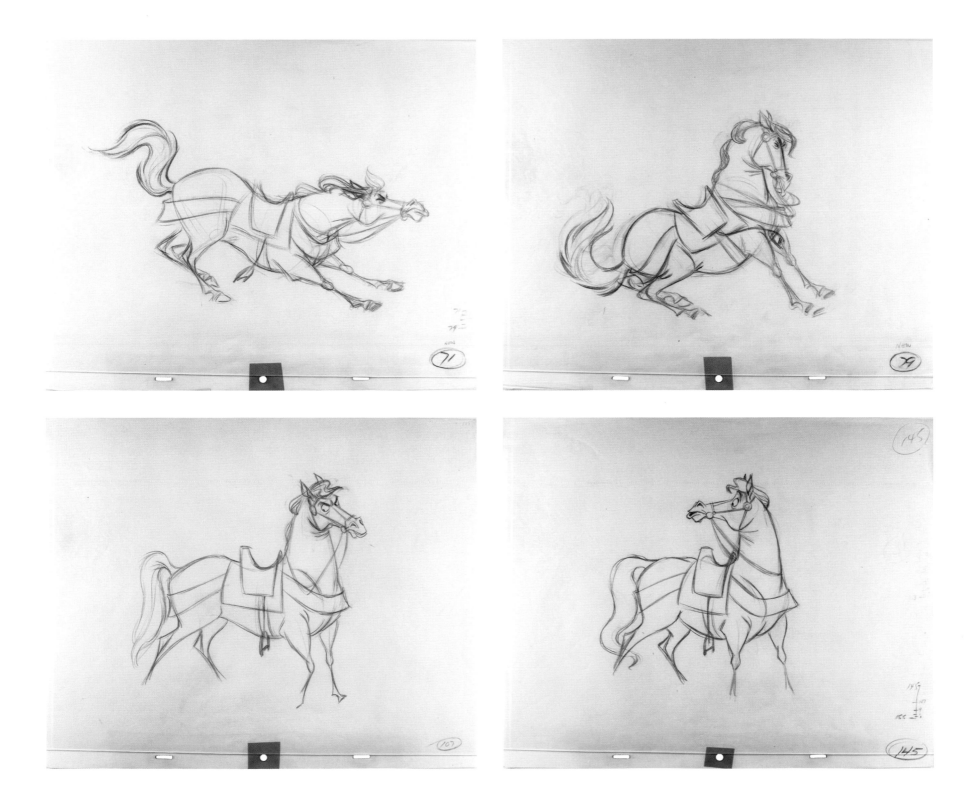

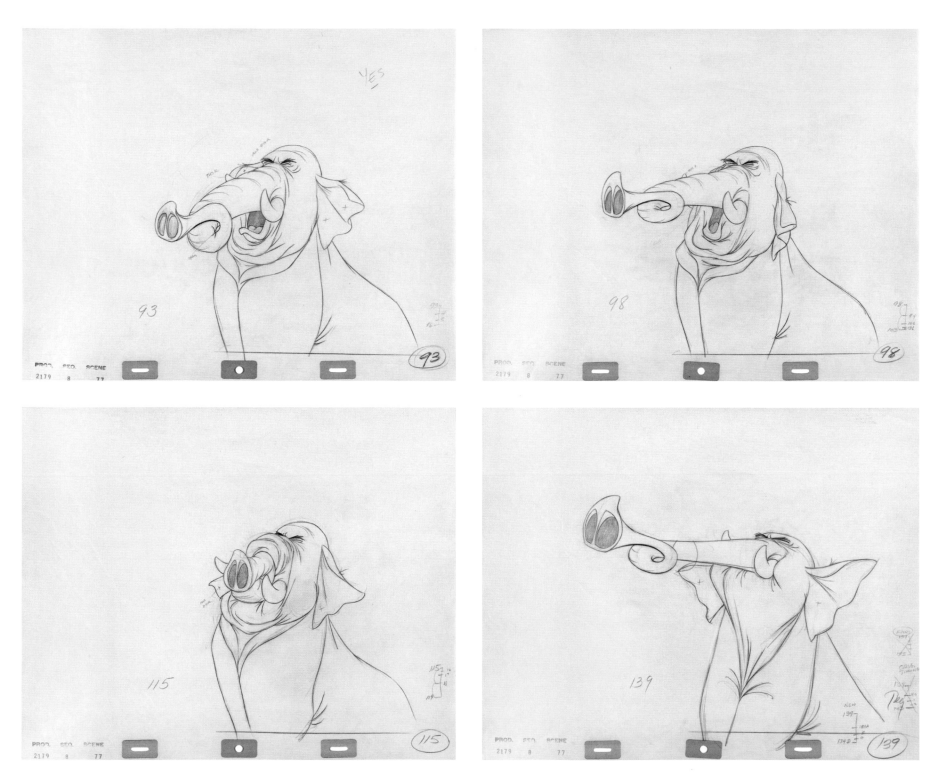

Clean-up animation drawings | *The Jungle Book*, 1967 | Graphite and colored pencil on paper

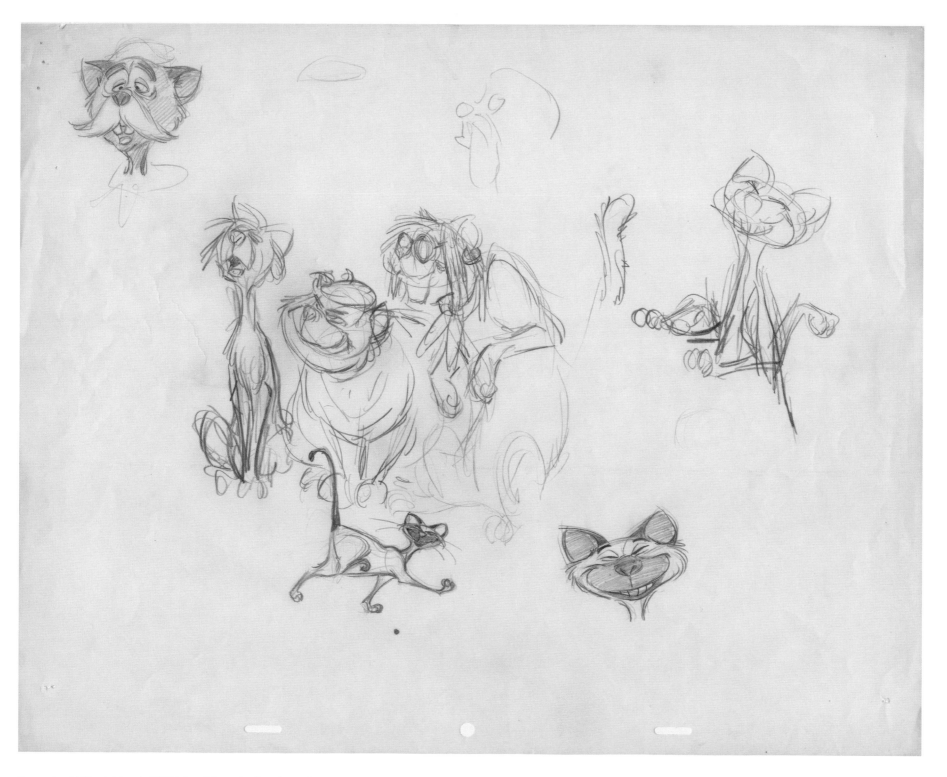

Concept art | *The Aristocats*, 1970 | Graphite and colored pencil on paper

LES CLARK

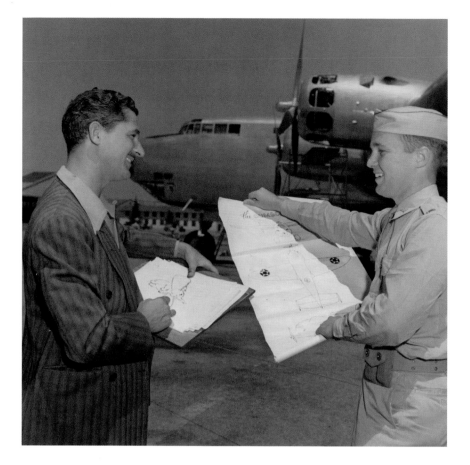

Les Clark and a serviceman inspect a drawing of Dumbo and a drawing of a Dumbo airplane, 1941

LES CLARK

Les first met Walt and Roy Disney in 1925: He was a high school student when he served them ice cream at a candy store on Vermont Avenue. When Walt hired him two years later, he said, "You know this is only a temporary job, Les. I don't know what's going to happen." That "temporary job" would last forty-eight years, stretching from the silent-film era to the advent of television, and from the weightless "rubber hose" animation of *The Skeleton Dance* (1929) and the early Mickey Mouse shorts to the gracefully stylized realism of *Sleeping Beauty* (1959).

Because of his quiet personality, Les often garners less attention than some of the other members of the Nine Old Men. However, his work ranged from the comic intensity of Mickey bringing the brooms to life in *Fantasia*'s "The Sorcerer's Apprentice" (1940) to the charming clumsiness of Lady as a puppy in *Lady and the Tramp* (1955).

After Les directed two sequences in *Sleeping Beauty*, Walt moved him to educational films and television, where his work included the original titles for the *Disneyland* program. His TV producer Ken Peterson said, "Les never settled for anything that wasn't top quality—his work always had that fine finish."

Director Wilfred Jackson commented, "[Les] is a modest person, not at all inclined to blow his own horn, and you might not suspect he had an important part in what was done at the Studio just from hearing Les talk about himself . . . He is one of quite a few quiet, shy, talented, dedicated artists who worked hard and long, almost unseen and unheard of behind the scenes, to help make Walt's cartoons turn out the way they did."

‹ Les Clark at his animator's desk with a Mickey Mouse drawing at the Hyperion studio, c. 1930

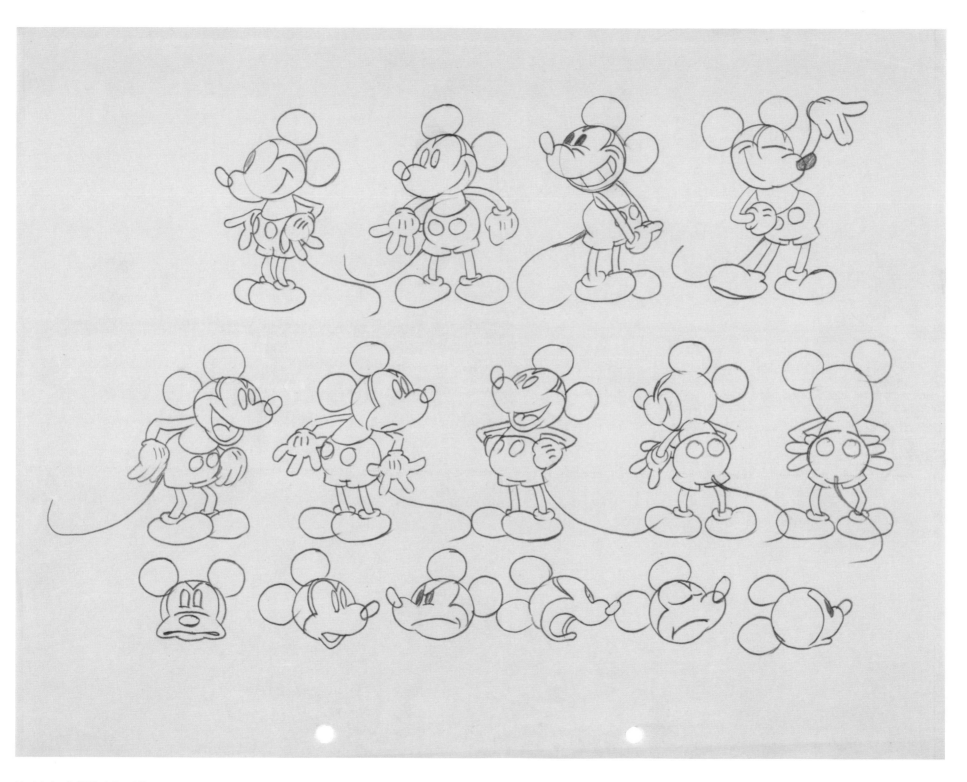

Model sheet, 1930s | Graphite on paper

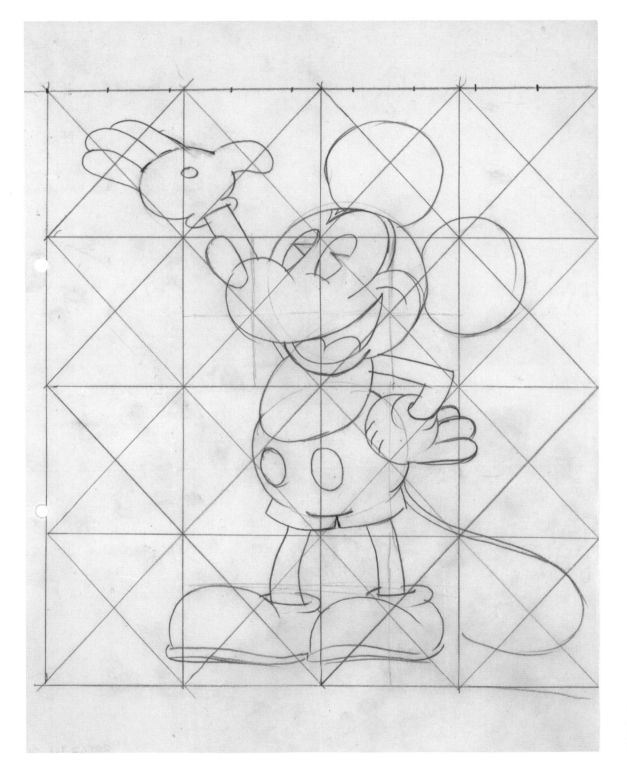

One of the earliest known
advertising drawings of
Mickey Mouse, 1929
Graphite on paper

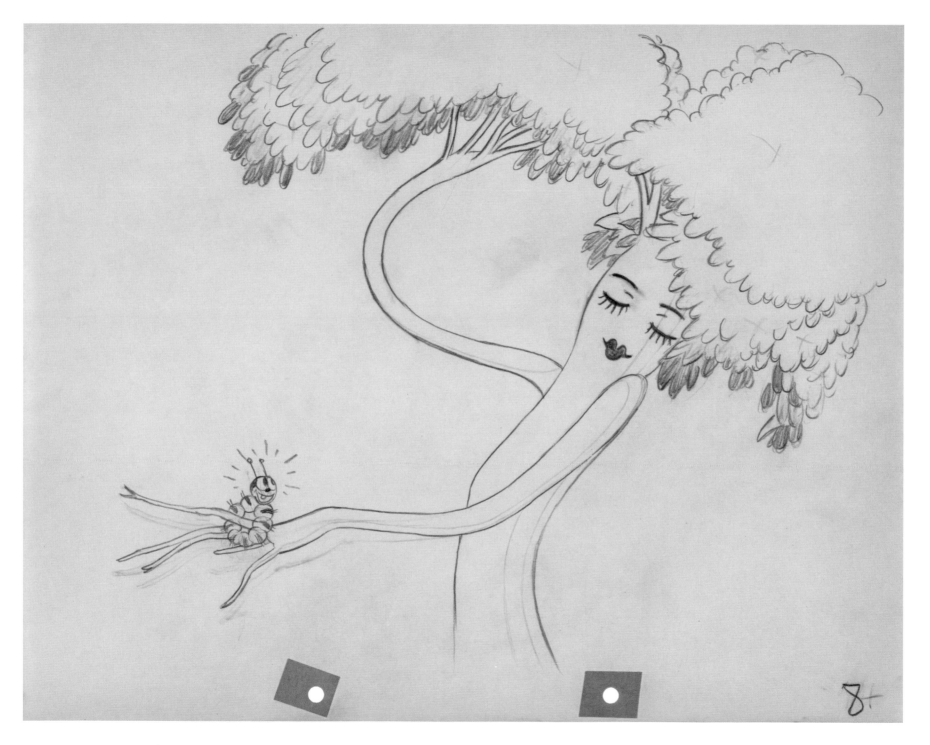

Clean-up animation drawing | *Flowers and Trees*, 1932 | Graphite and colored pencil on paper

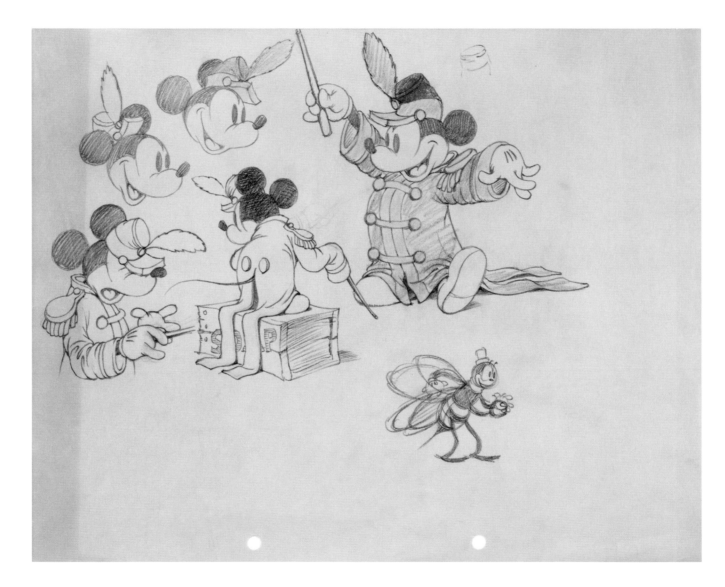

Concept art
The Band Concert, 1935
Graphite, colored pencil, and ink on paper

▸ Model sheet, 1930s | Graphite on paper

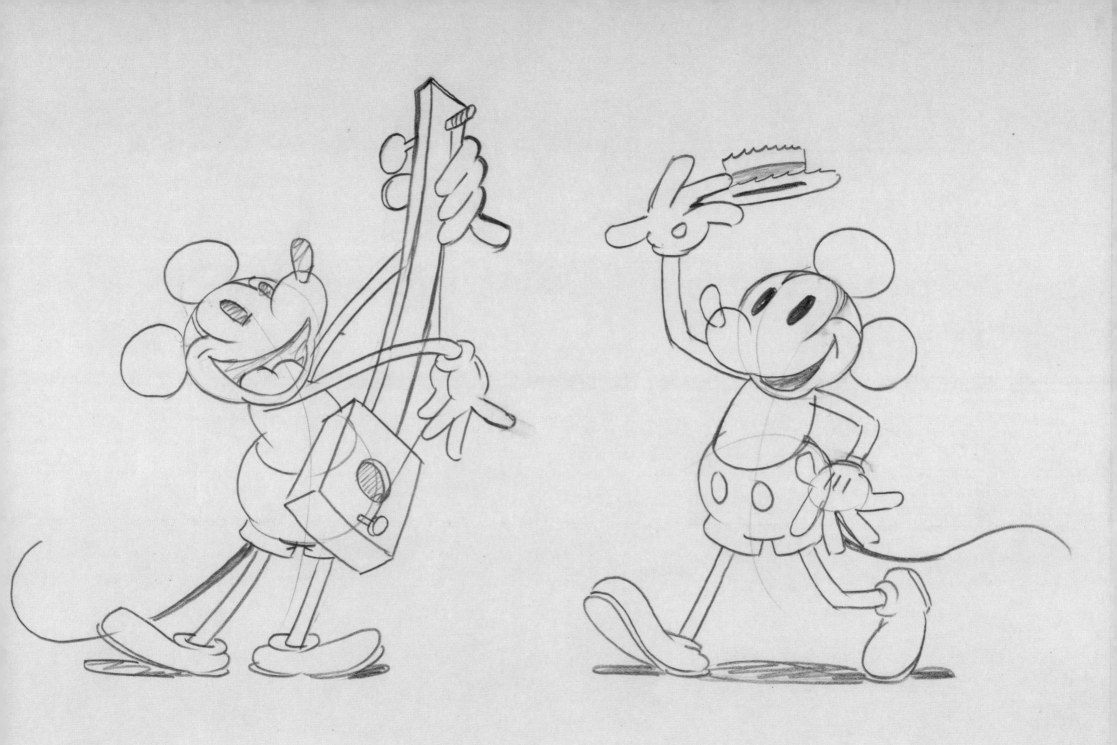

Clean-up animation scene | *Building a Building*, 1933 | Graphite on paper

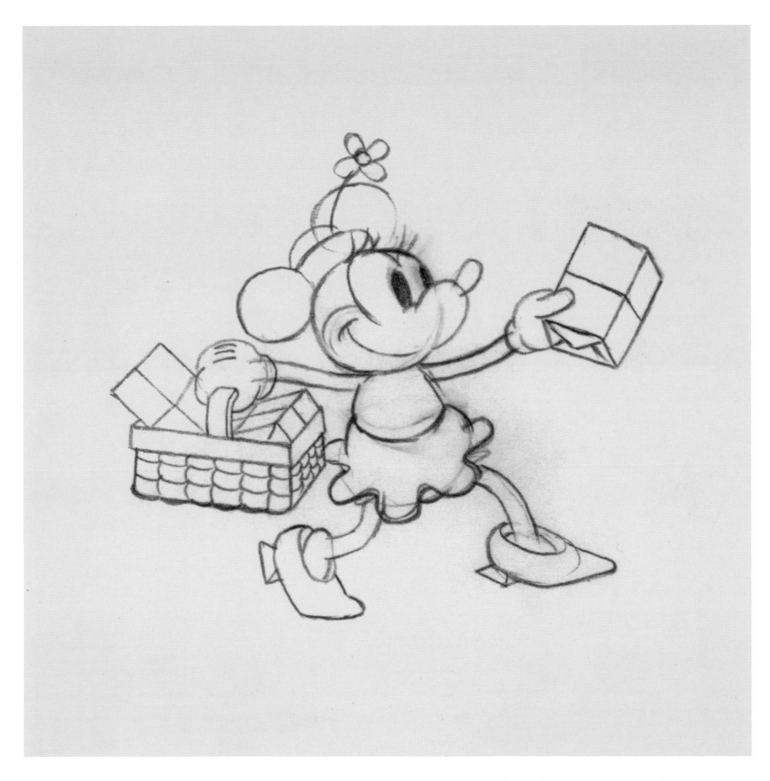

Clean-up animation drawing | *Building a Building*, 1933 | Graphite on paper

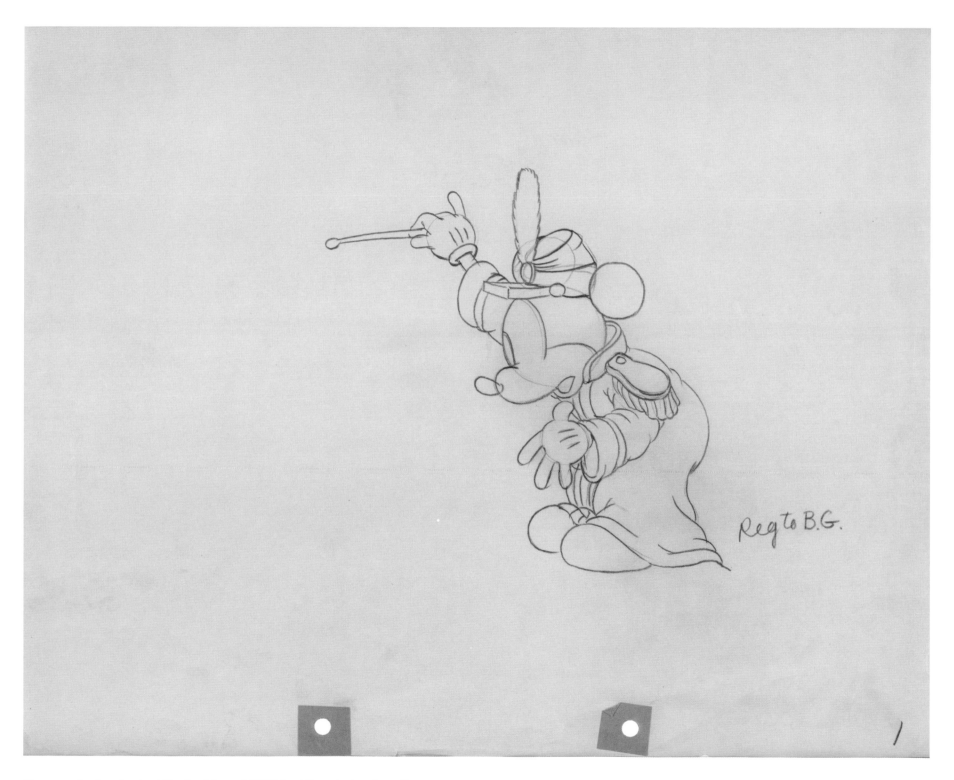

Clean-up animation drawing | *The Band Concert*, 1935 | Graphite and colored pencil on paper

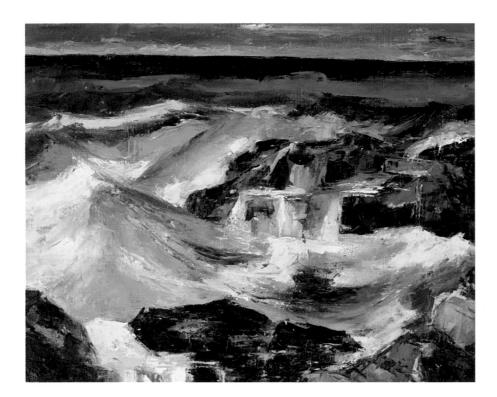

Baja California, c. 1956 | Oil paint on canvas

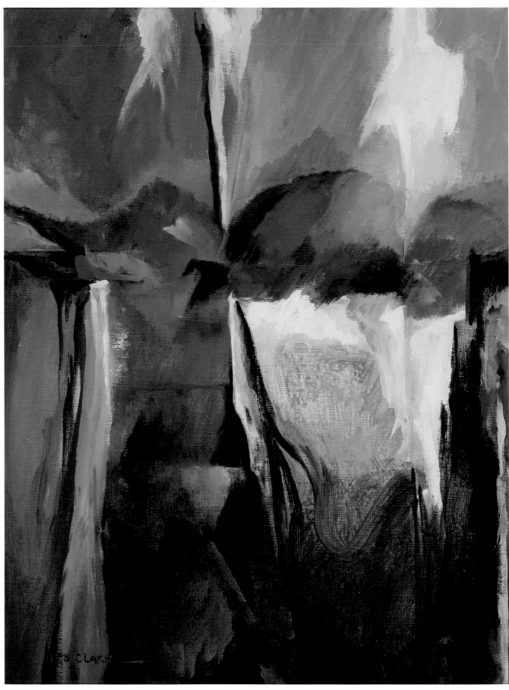

Mexican Bluffs, 1978 | Oil paint on canvas

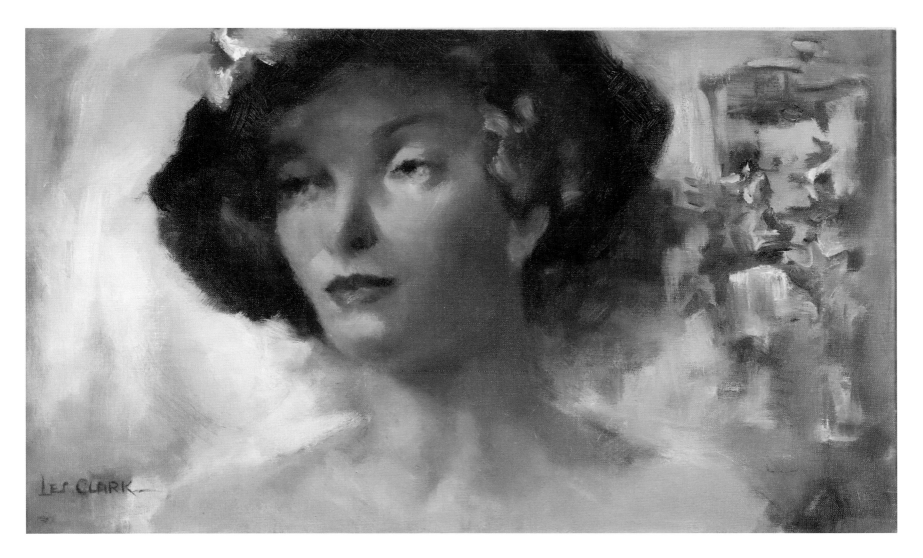

Model, 1960s | Oil paint on canvas

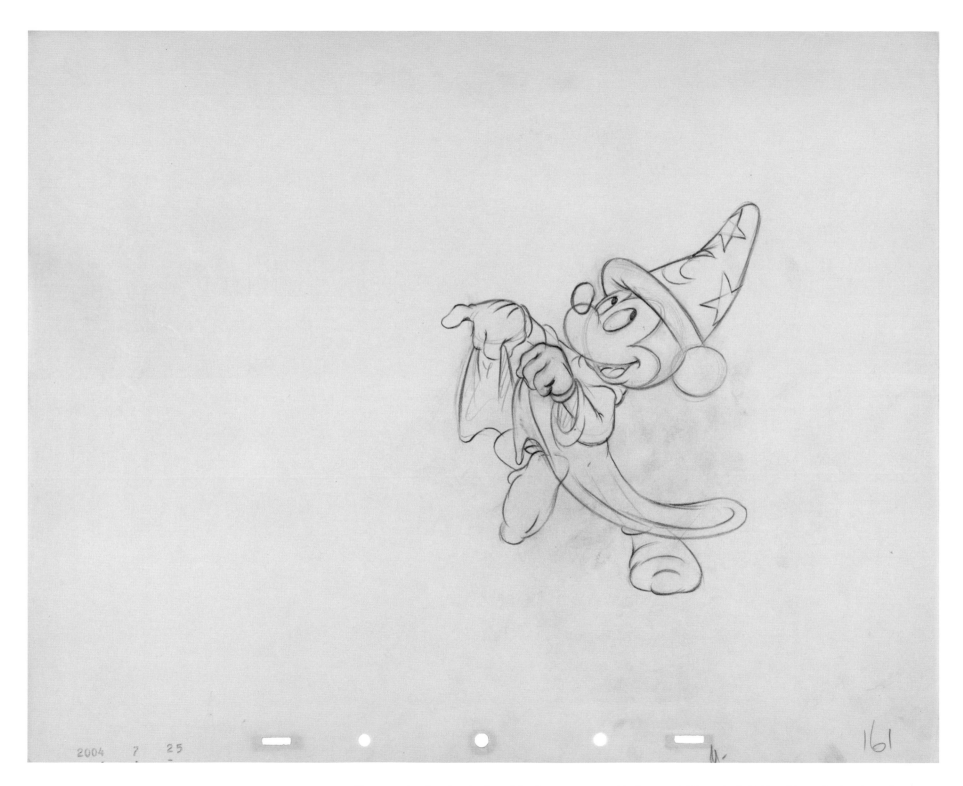

2004 7 25

161

Clean-up animation drawing from "The Sorcerer's Apprentice" segment | *Fantasia*, 1940 | Graphite and colored pencil on paper

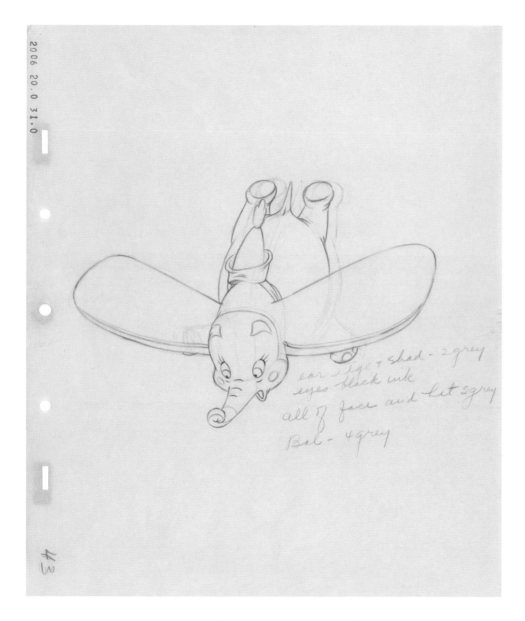

Clean-up animation drawing | *Dumbo*, 1941 | Graphite and colored pencil on paper

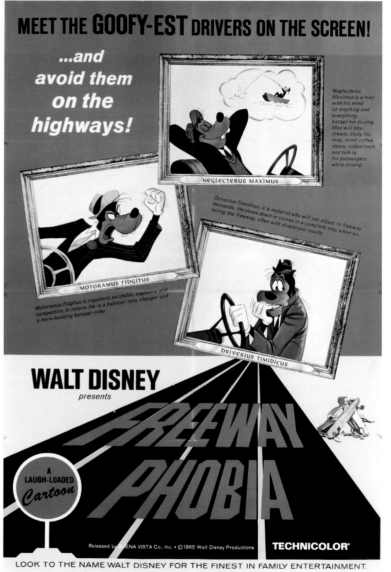

Movie poster | *Freewayphobia*, 1965 | Printed ink on paper

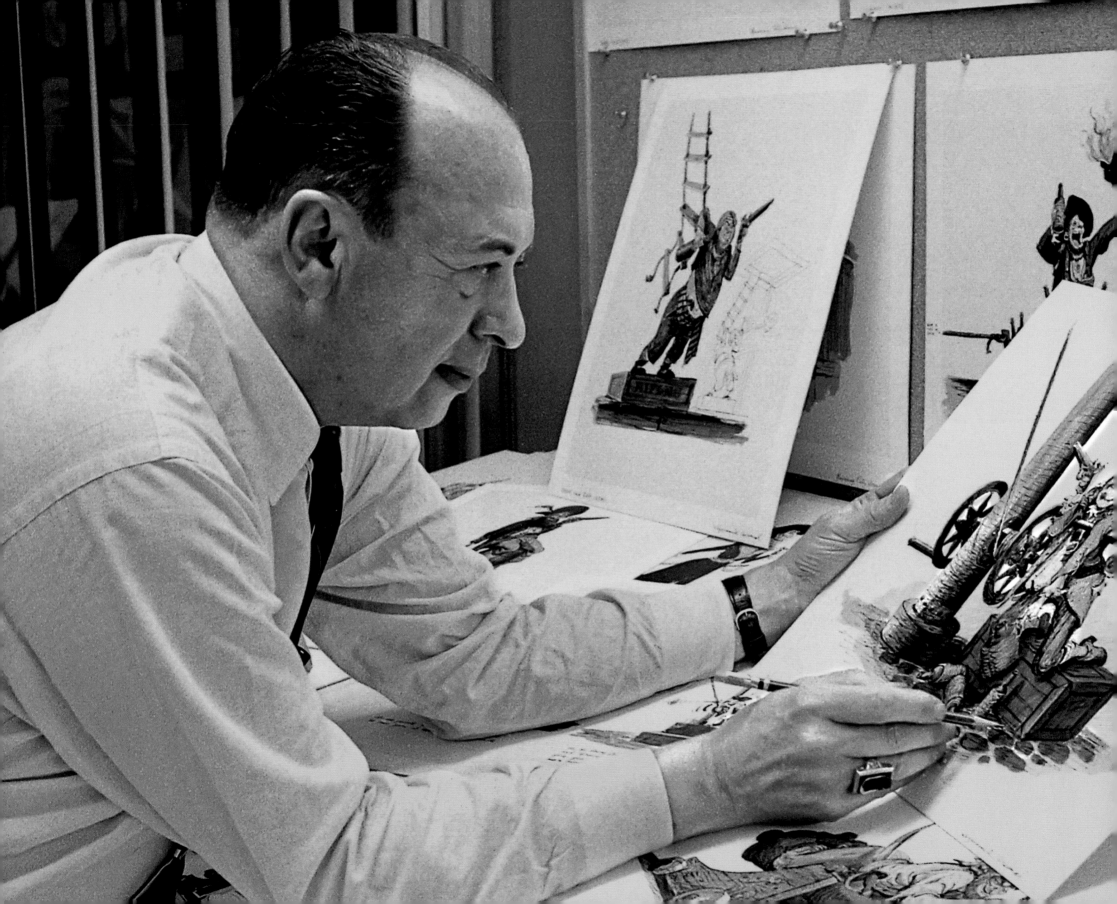

MARC DAVIS

MARC DAVIS

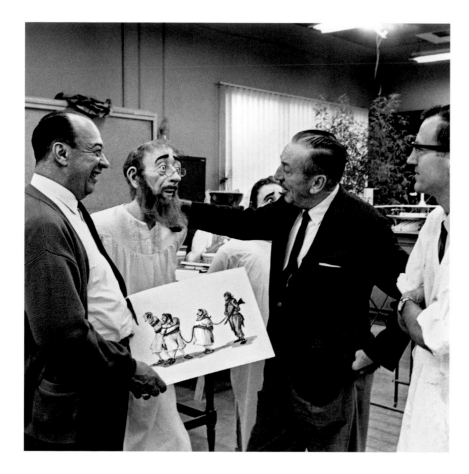

Marc Davis, Walt Disney, and Blaine Gibson with an Audio-Animatronics® pirate, c. 1965

Walt referred to Marc as his "Renaissance man": He could design characters, animate, and do story work. Even by the Studios' lofty standards, Marc was an exceptional draftsman. As a young man, he sketched the animals at the Fleishhacker Zoo in San Francisco and studied books on anatomy. After a day of animating at the Studios, he would sketch the dancers, acrobats, and animals he saw on TV, or read about art history.

"If you have a hard-backed sketchbook and a fountain drawing pen, you can draw anywhere," he said—and he proved it on travels to the wilds of Papua New Guinea. Marc also experimented with lithography and painted in oils; he said he made it a point to paint a tree from nature once a year, just to remind himself "what's real."

In addition to his animation duties, Marc took over legendary instructor Don Graham's life drawing classes at the Chouinard Art Institute after World War II. Marc's character Maleficent from *Sleeping Beauty* (1959) was a masterstroke of draftsmanship and acting that inspired the 2014 live-action film starring Angelina Jolie. Later, after Marc completed the animation of Cruella De Vil in *One Hundred and One Dalmatians* (1961), Walt moved him to Imagineering, where he applied his talents to designing attractions like *Pirates of the Caribbean* and *Haunted Mansion* for Disneyland and "it's a small world" for the 1964–65 New York World's Fair.

He summed up his approach to drawing in an interview in 1990: "Properly organized, a group of lines on paper can produce an illusion. You can make the image seem to rise out of the paper, you can make it seem round or flat. These principles underlie animation: They affect the shapes that make up the characters. It was these principles that were terribly important to Don Graham, and they're terribly important to me."

‹ Marc Davis with Disneyland concept art, 1965 | *Pirates of the Caribbean*, 1967

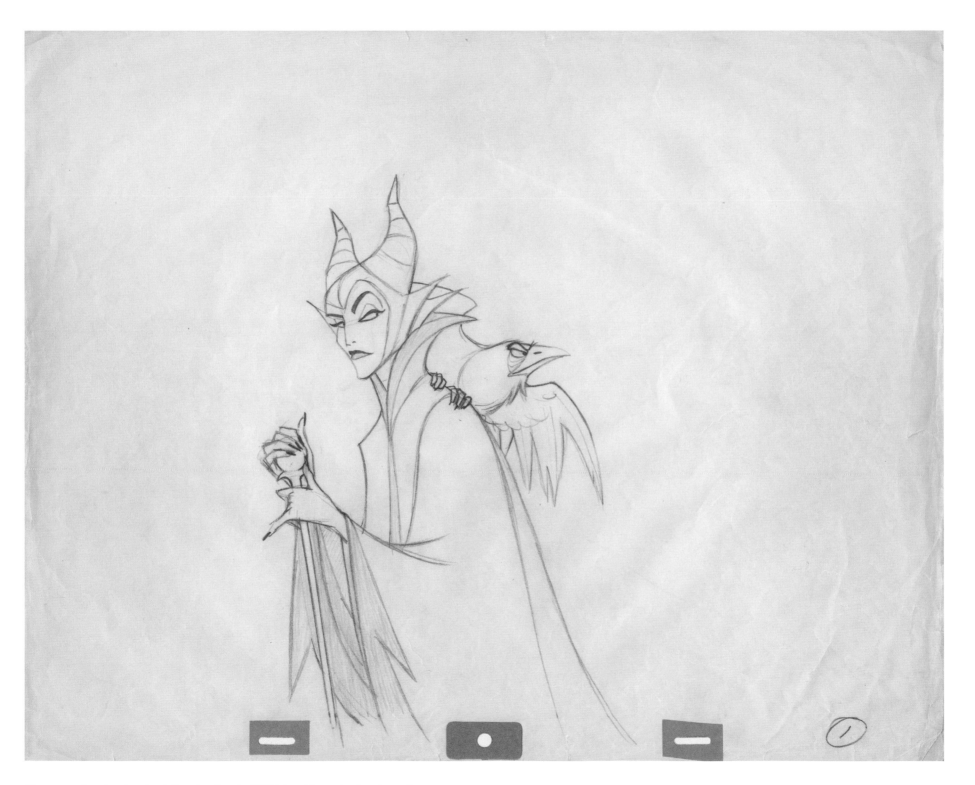

Clean-up animation drawing | *Sleeping Beauty*, 1959 | Graphite and colored pencil on paper

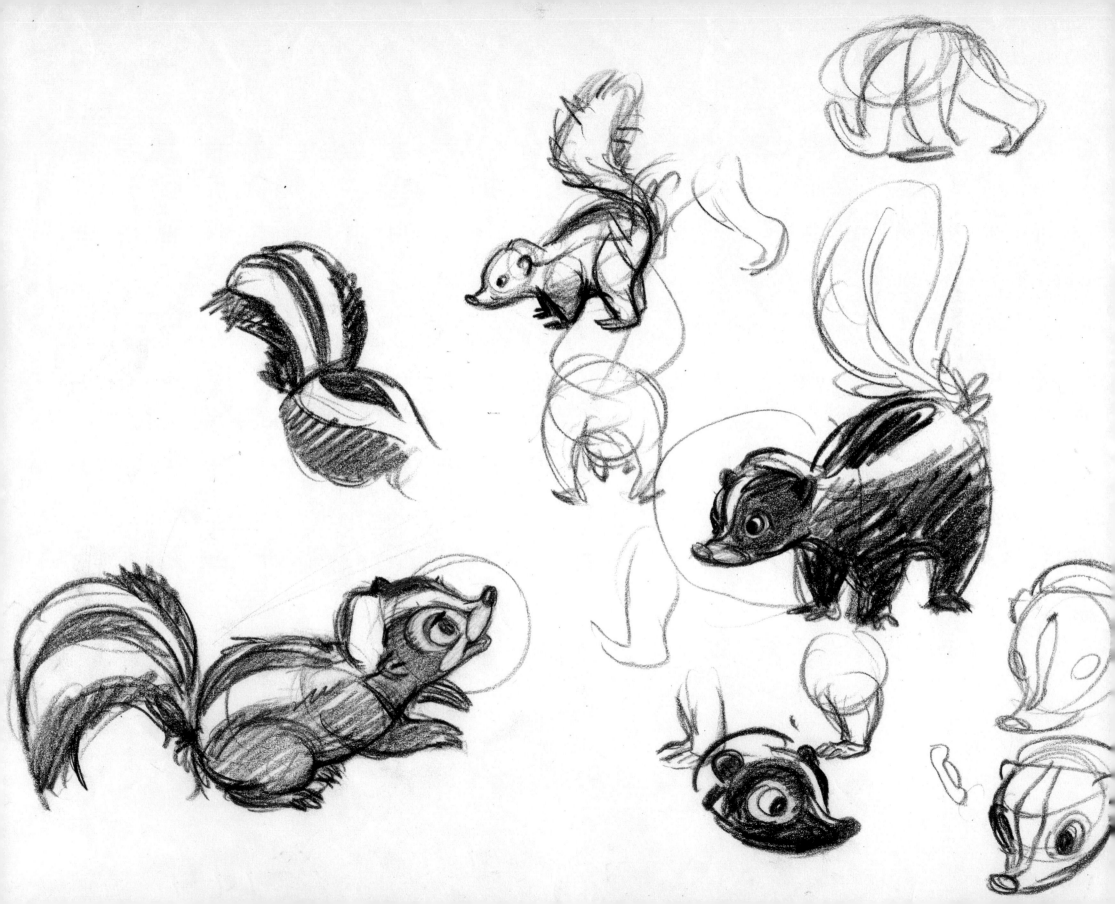

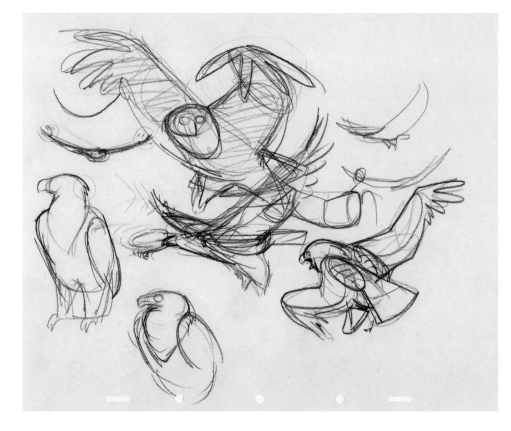

Concept art | *Victory Through Air Power*, 1943
Charcoal on paper

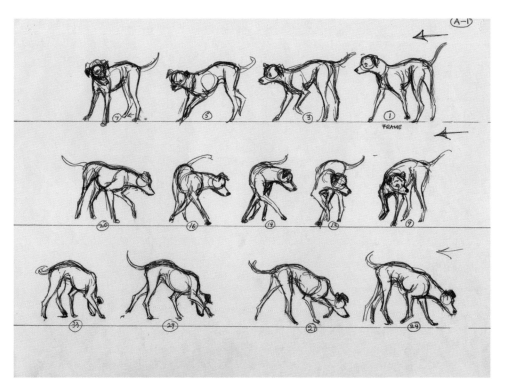

Live-action study
One Hundred and One Dalmatians, 1961 | Ink on paper

‹ Concept art | *Bambi*, 1942 | Colored pencil on paper

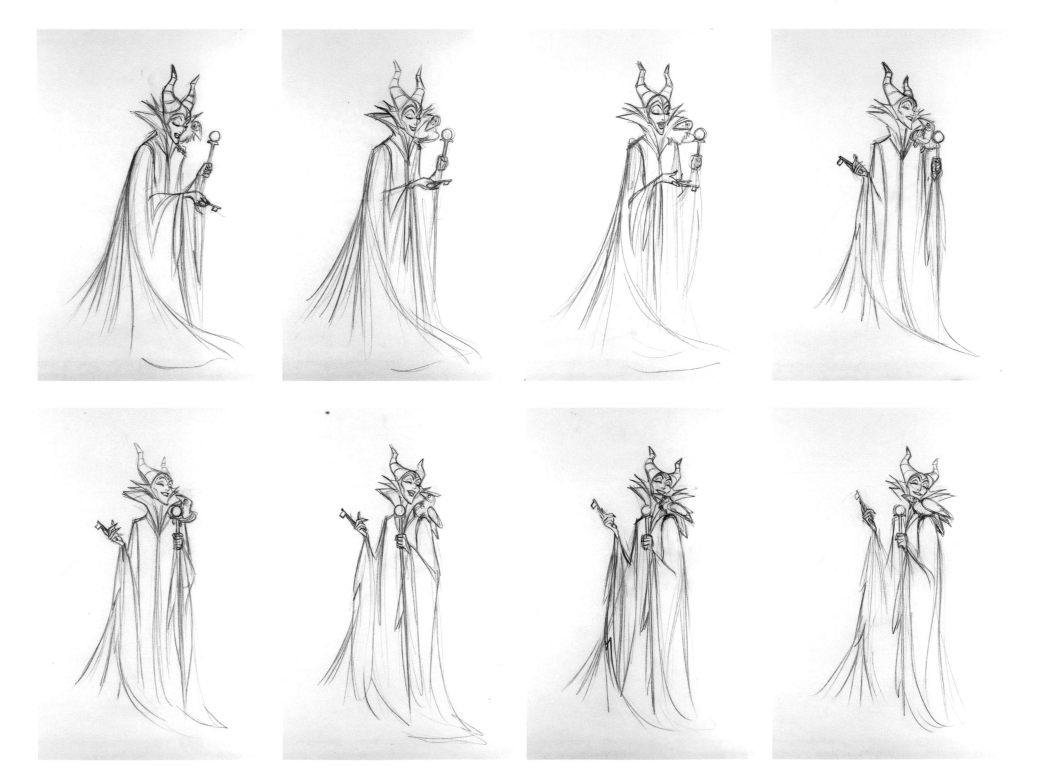

Rough animation scene | *Sleeping Beauty*, 1959 | Graphite on paper

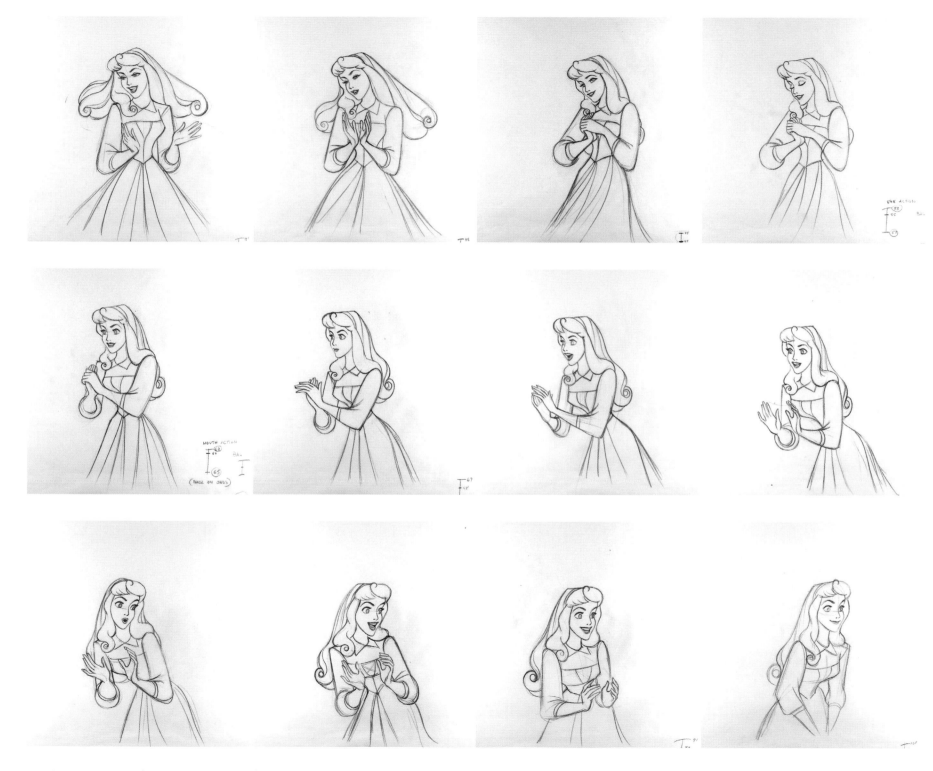

Rough animation scene | *Sleeping Beauty*, 1959 | Graphite on paper

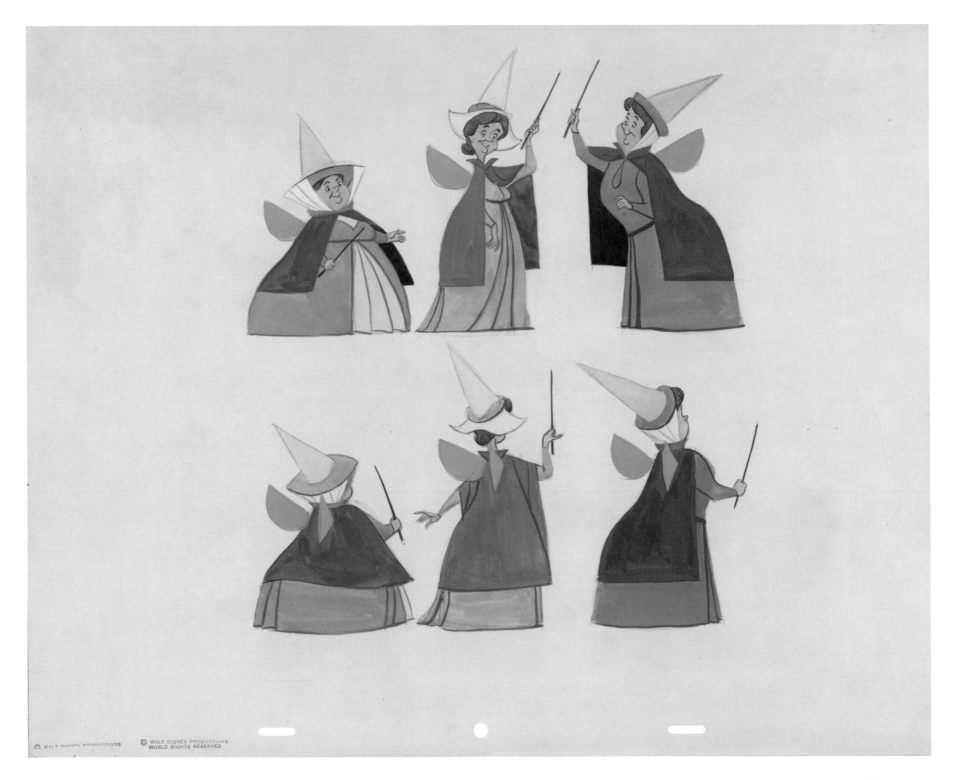

Concept art | *Sleeping Beauty*, 1959 | Gouache and graphite on paper

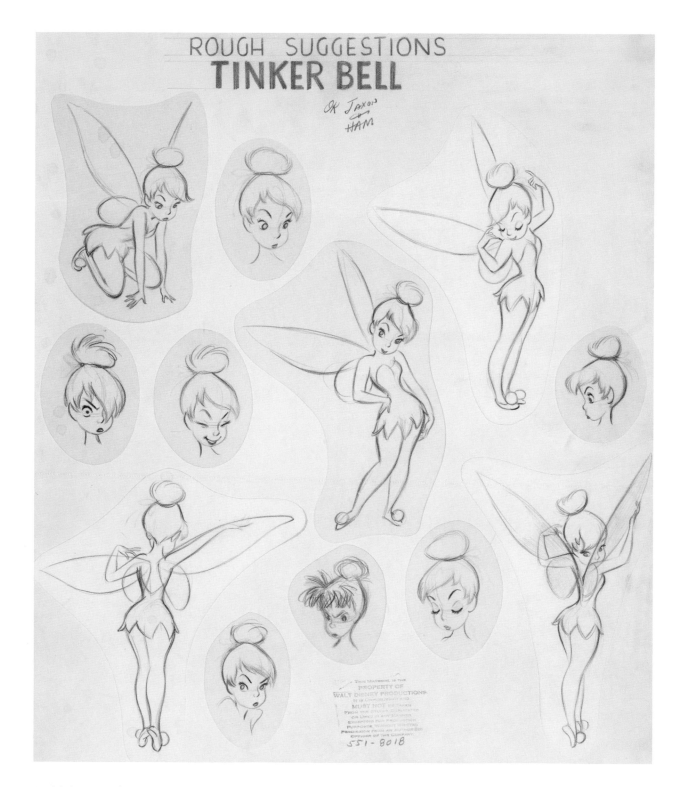

Model sheet, 1951 | *Peter Pan*, 1953 | Graphite and colored pencil on paper, collaged

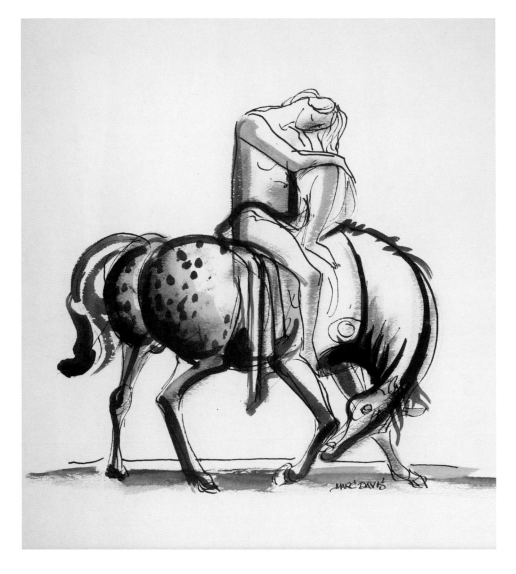

Lady Godiva, 1950s | Graphite and ink on paper

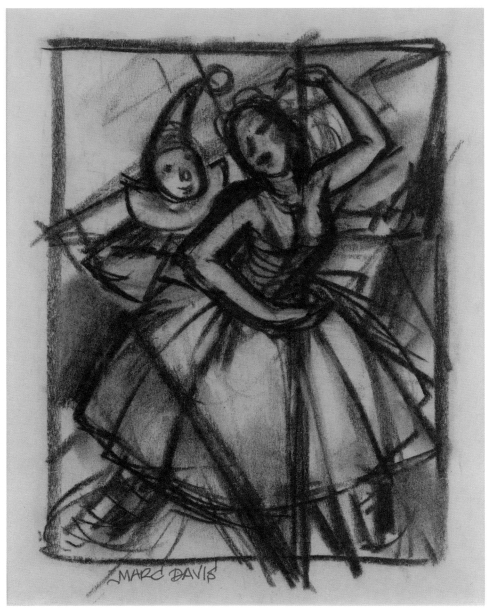

Dancers, 1950s | Charcoal on paper

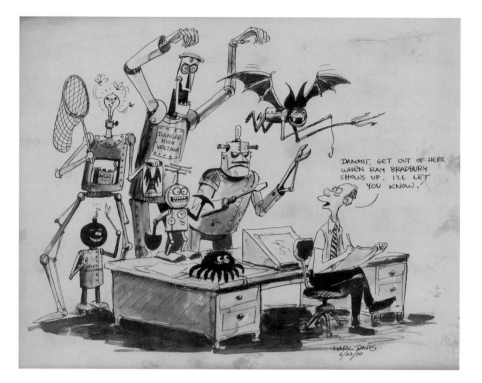

Caricature of Marc Davis mentioning
Ray Bradbury, 1970 | Ink on paper

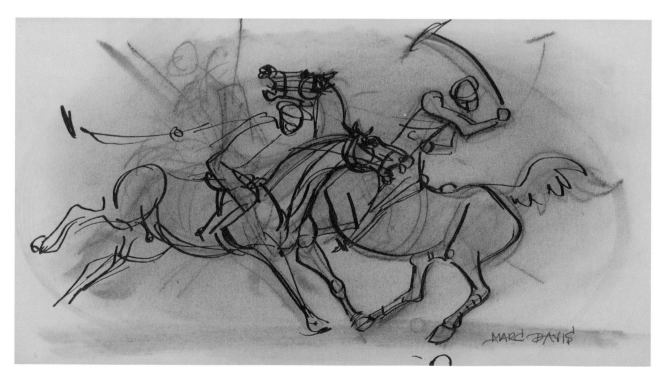

Polo Players, 1950s
Charcoal on paper

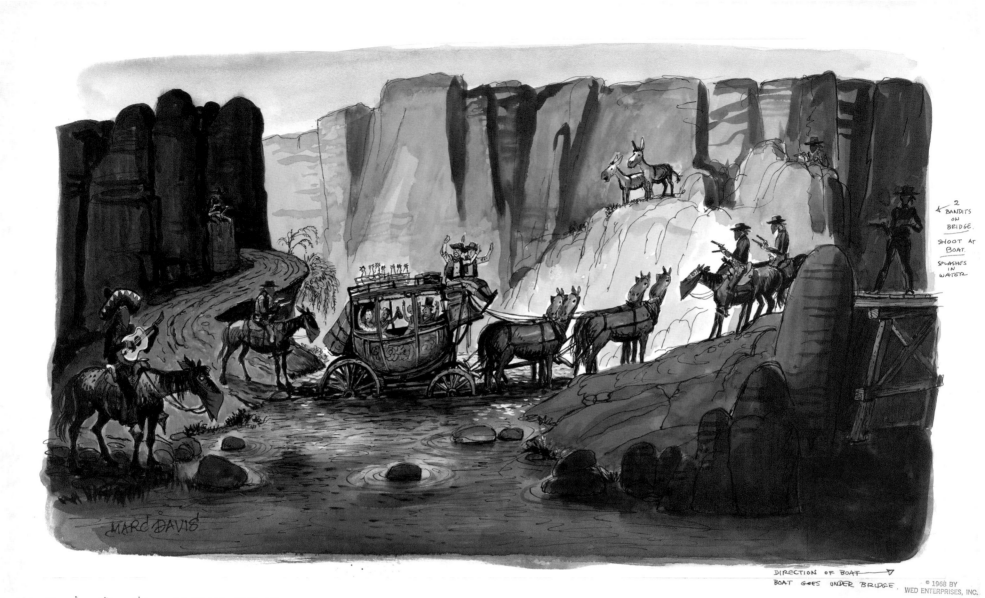

Singing Bandit STAGECOACH HOLD-UP

WESTERN RIVER RIDE

"Stagecoach Holdup with Singing Bandit" from the *Western River Ride* proposed for Walt Disney World
Attraction concept art, 1968
Pen, ink, gouache, and watercolor on paper

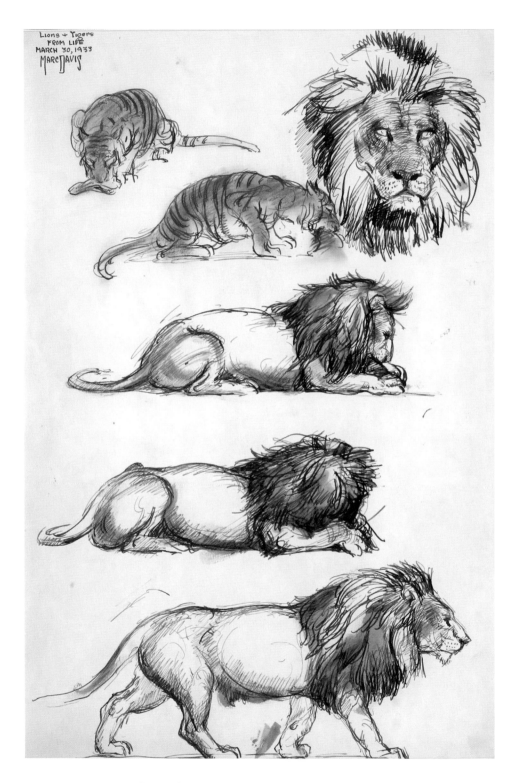

Lions and Tigers from Life, 1933 | Ink and oil pastel on paper

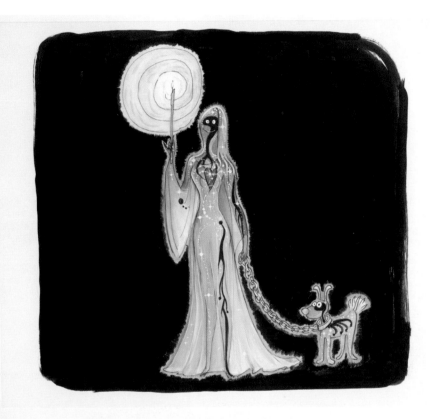

GHOST MADE FROM TRANSPARENT MATERIAL. MOVING LIGHTS INSIDE. HAUNTED MANSION

"Transparent Ghost with Dog" from *Haunted Mansion* at Disneyland
Attraction concept art
Pen, ink, gouache, and watercolor on paper

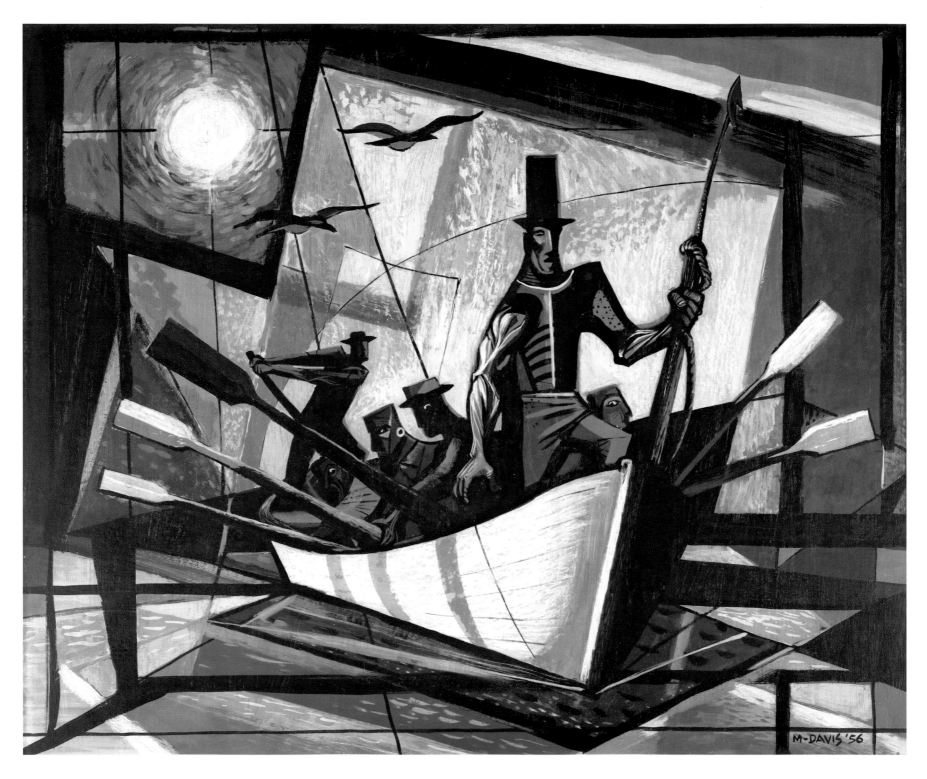

Queequeg Pursuing Moby Dick, 1956 | Oil paint on Masonite

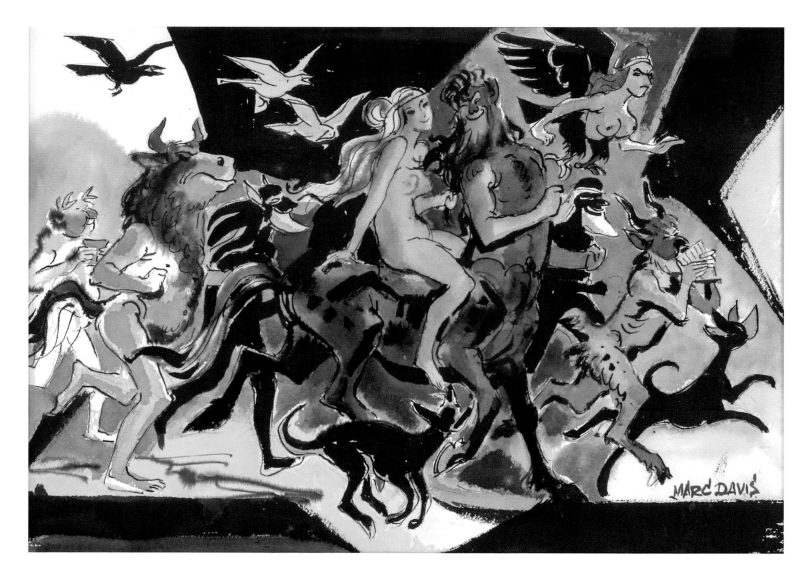

Pandora's Box, 1950s | Graphite and watercolor on paper

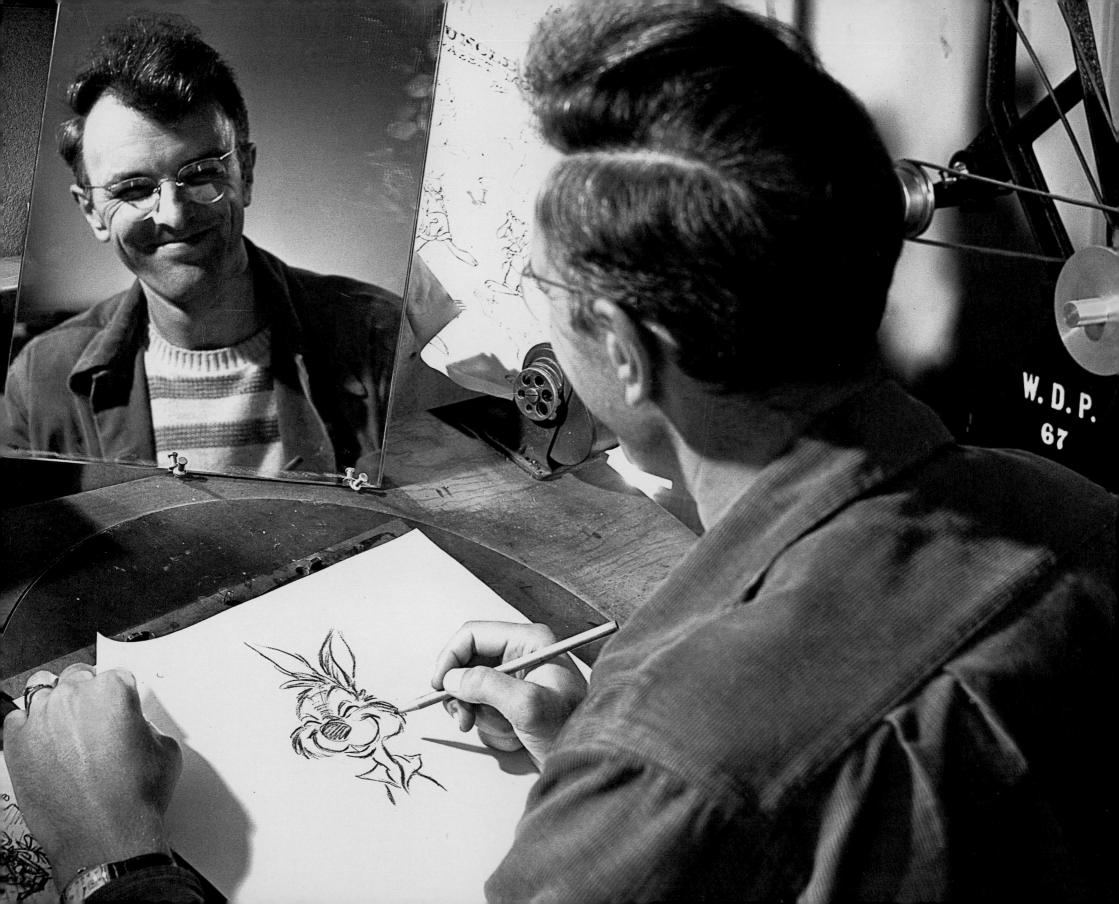

MILT KAHL

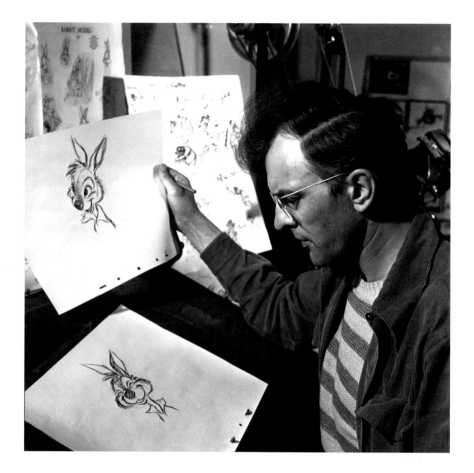

Milt Kahl with animation drawings of Brer Rabbit | *Song of the South*, 1946

MILT KAHL

Unlike his best friend, Marc Davis, who was never without a sketchbook, Milt never carried one. His assistant Stan Green recalled, "When five o'clock came, he wanted nothing to do with art, which amazed me. It was all chess and fishing. I don't think he did the wire sculptures until he retired. I never saw any artwork he did outside of studio work."

Milt was regarded by some as the greatest draftsman of the nine, and the others often brought their drawings to him to refine their poses with his eye for perfection. He enjoyed puzzles, such as double acrostics, and fly fishing—the most coolly intellectual of sports. Milt was a gifted chess player, but he was also a volatile one: Any loss would likely be followed by the sound of chess pieces hitting the wall.

He also had an uncanny ability to concentrate. Nearly everyone who worked with Milt had stories about talking to him for several minutes without him realizing someone was there. In everything he did, Milt held himself to the highest standard of excellence and expected nothing less of the people around him. When other artists praised his scenes, his standard response was, "Maybe I just work a little harder."

When asked to explain how he had done something, Milt would stammer, then conclude, "You just do it!" Drawing and animation came naturally to him. As a draftsman, his only rival at the Studio was Marc, who said, "He was just such a natural for drawing. He hadn't studied a great deal—he just had it all there in the tips of his fingers right from the beginning."

‹ Milt Kahl at his animator's desk | *Song of the South*, 1946

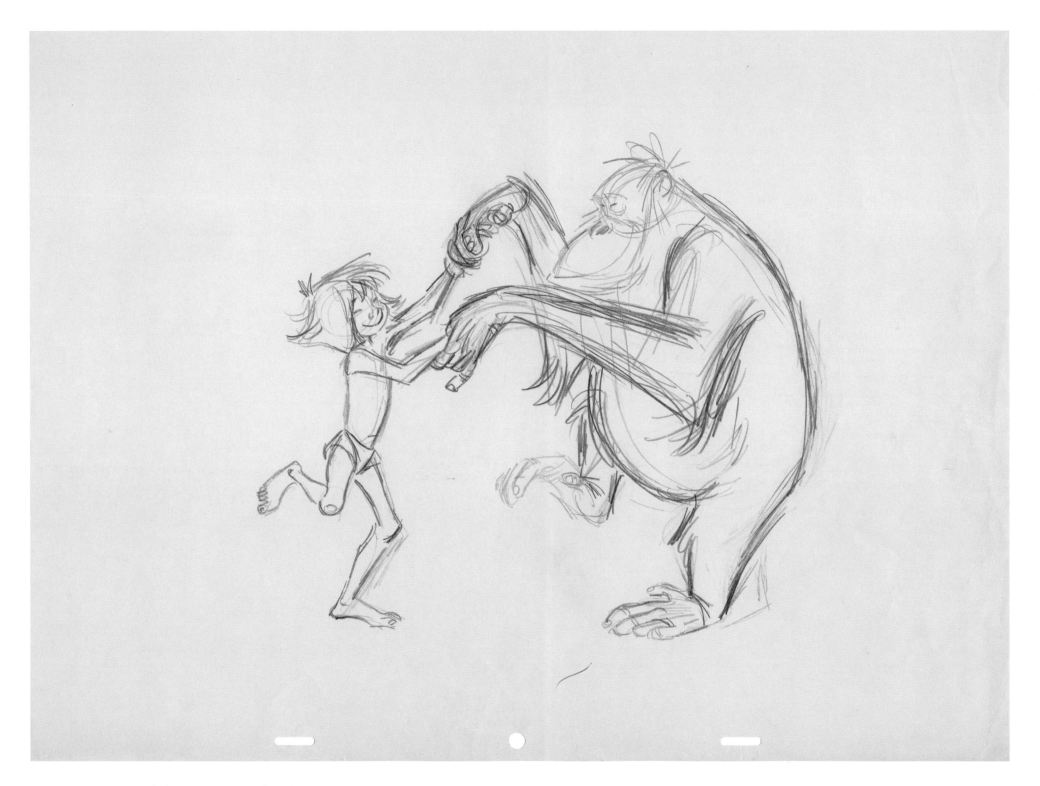

Rough animation drawing | *The Jungle Book*, 1967 | Graphite on paper

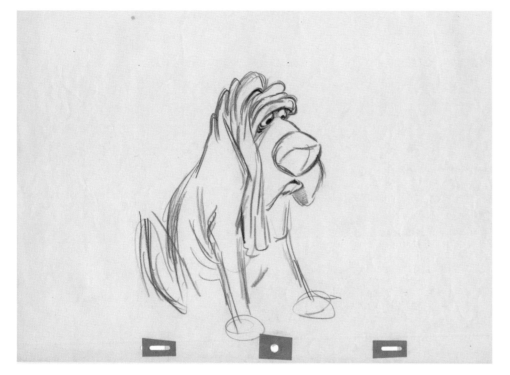

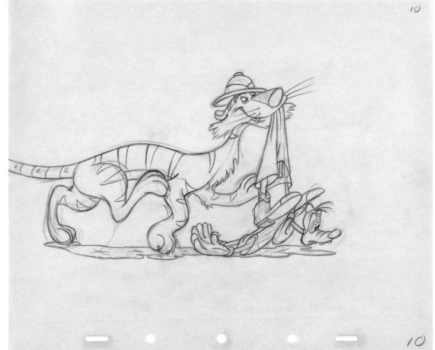

Rough animation drawing | *Lady and the Tramp*, 1955
Colored pencil on paper

Clean-up animation drawing | *Tiger Trouble*, 1945
Graphite and colored pencil on paper

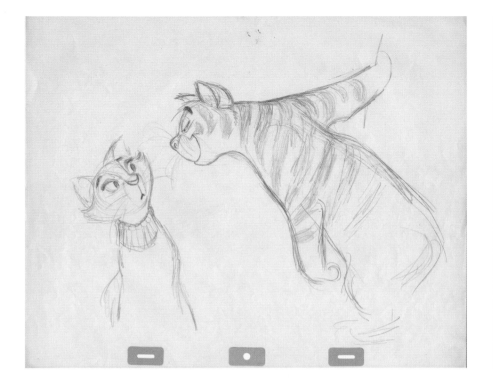

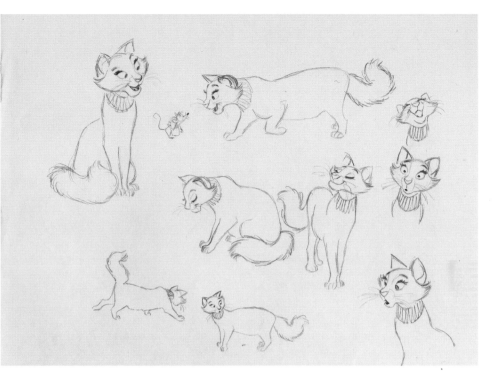

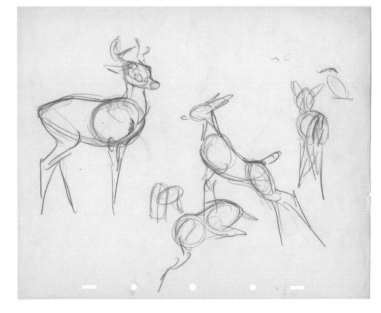

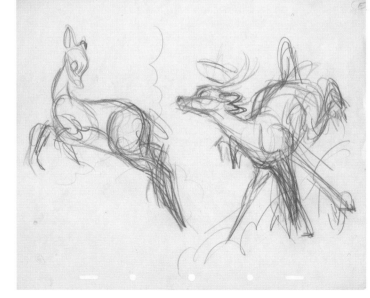

⊟ Rough animation drawing
The Aristocats, 1970 | Graphite on paper

⊟ Concept art | *Bambi*, 1942 | Graphite on paper

⊟ Concept art | *The Aristocats*, 1970 | Graphite on paper

⊟ Concept art | *Bambi*, 1942
Graphite and colored pencil on paper

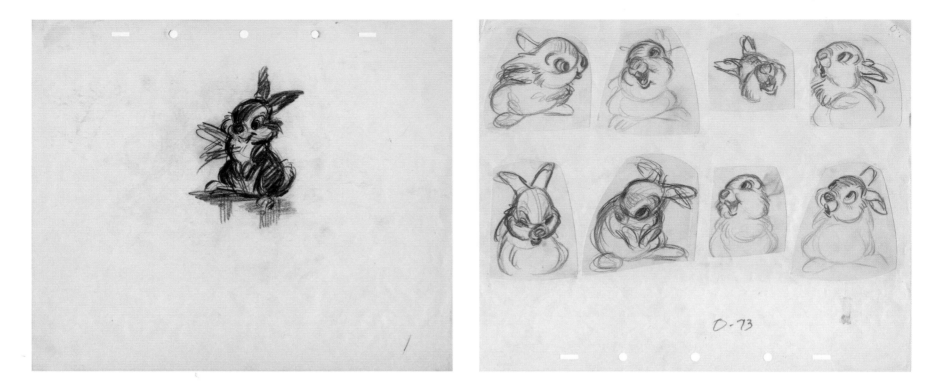

Concept art
Bambi, 1942
Charcoal on paper

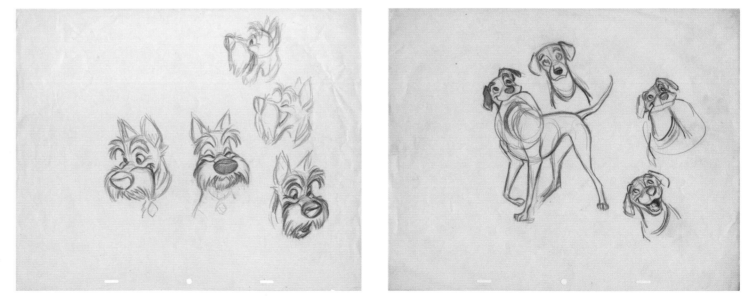

Concept art
Lady and the Tramp, 1955
Graphite on paper

⁞ Rough model sheet | *Bambi*, 1942
Graphite and colored pencil on paper, collaged

⁞ Concept art | *One Hundred and One Dalmatians*, 1961
Graphite and colored pencil on paper

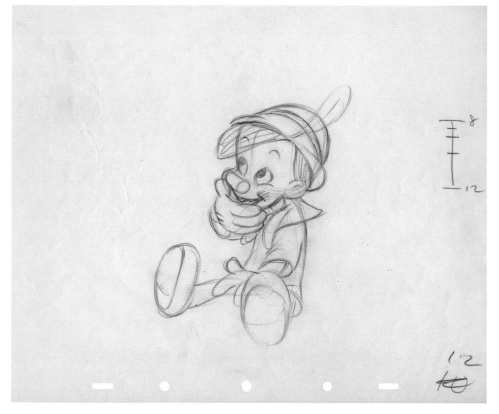

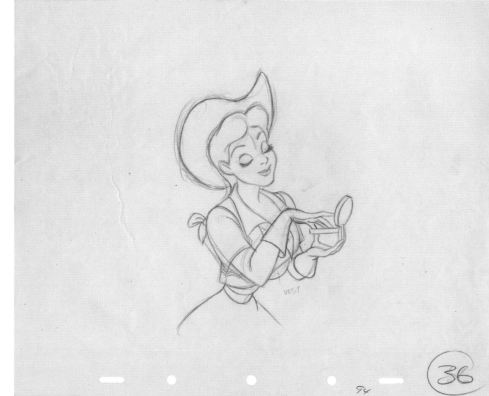

Clean-up animation drawing | *Pinocchio*, 1940
Graphite and colored pencil on paper

Clean-up animation drawing | *Melody Time*, 1948
Graphite and colored pencil on paper

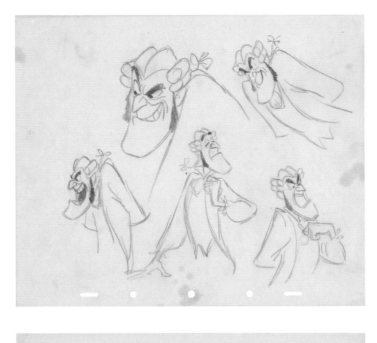

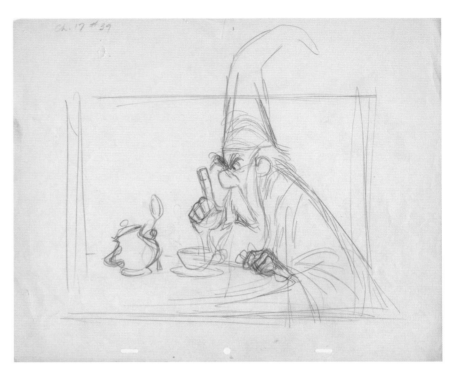

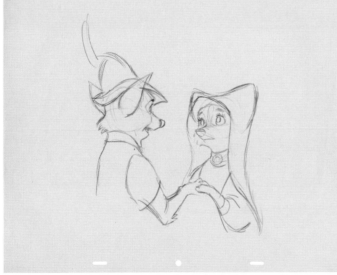

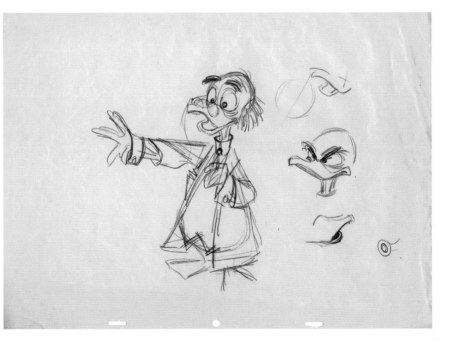

▉ Clean-up animation drawing from
"The Wind in the Willows" segment
The Adventures of Ichabod and Mr. Toad, 1949 | Graphite on paper

▉ Rough animation drawing
Robin Hood, 1973 | Graphite on paper

▉ Concept art | *The Sword in the Stone*, 1963 | Graphite on paper

▉ Concept art | *Walt Disney's Wonderful World of Color*, 1961 | Graphite on paper

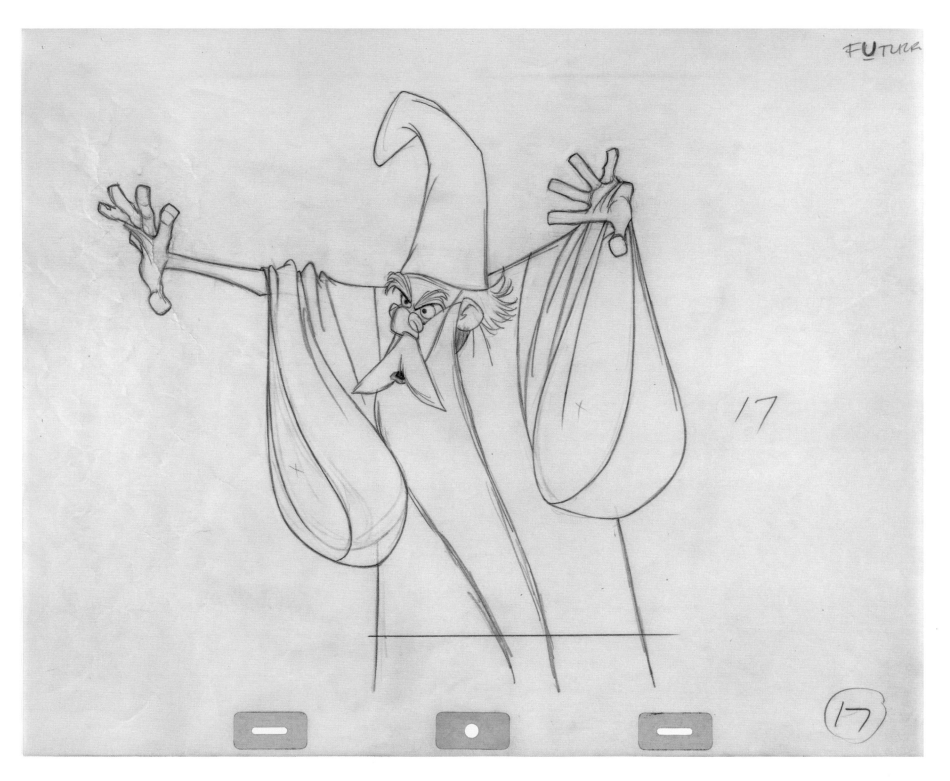

Clean-up animation drawing | *The Sword in the Stone*, 1963 | Graphite and colored pencil on paper

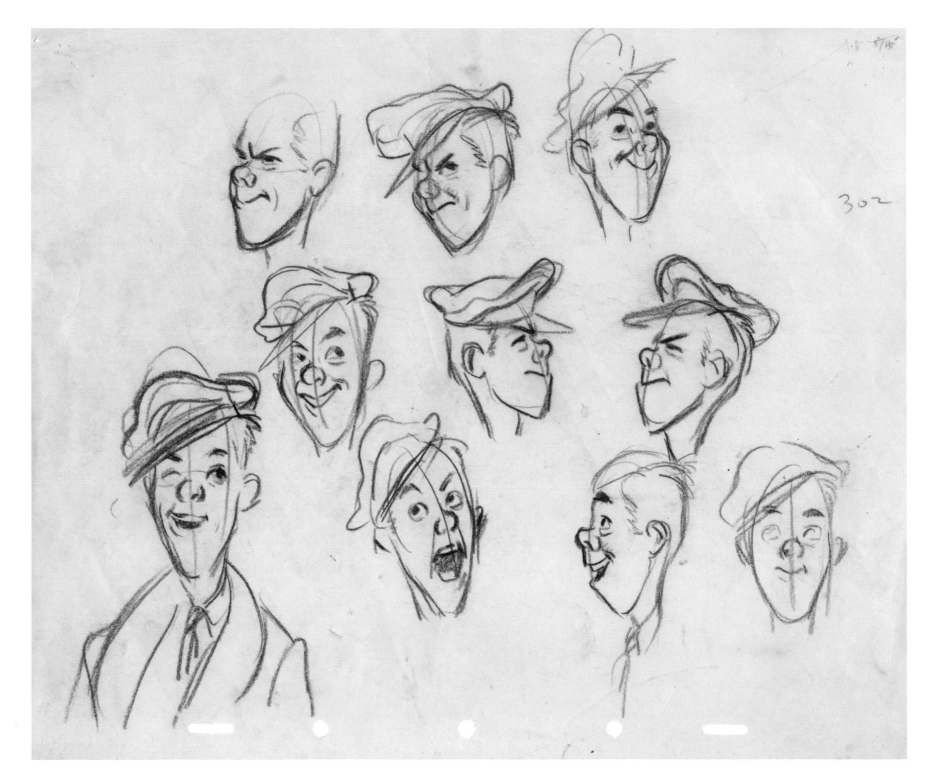

Sketches of a military person on The Walt Disney Studios lot, 1940s | Charcoal on paper

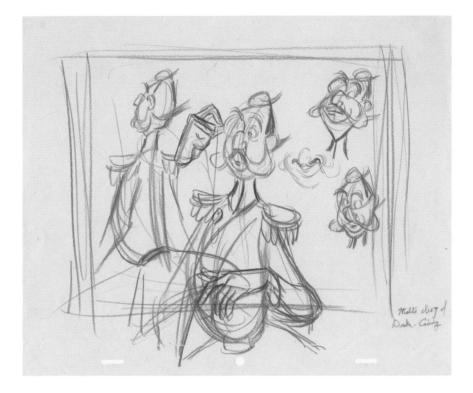

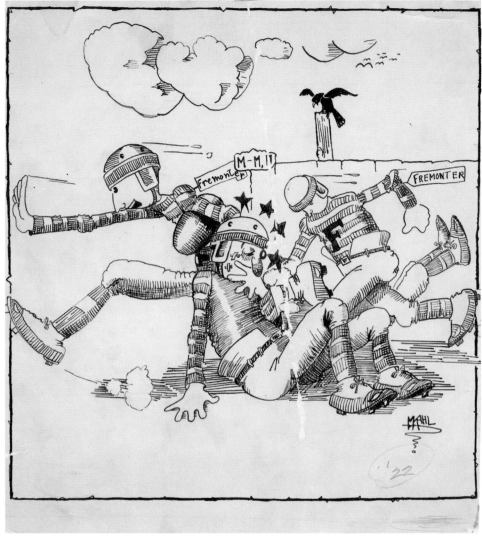

American Football cartoon, c. 1922 | Pen, ink, and graphite on paper

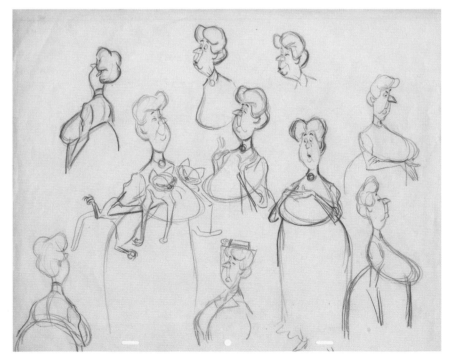

▐ Concept art | *Cinderella*, 1950 | Graphite and colored pencil on paper
▐ Concept art | *Lady and the Tramp*, 1955 | Graphite on paper

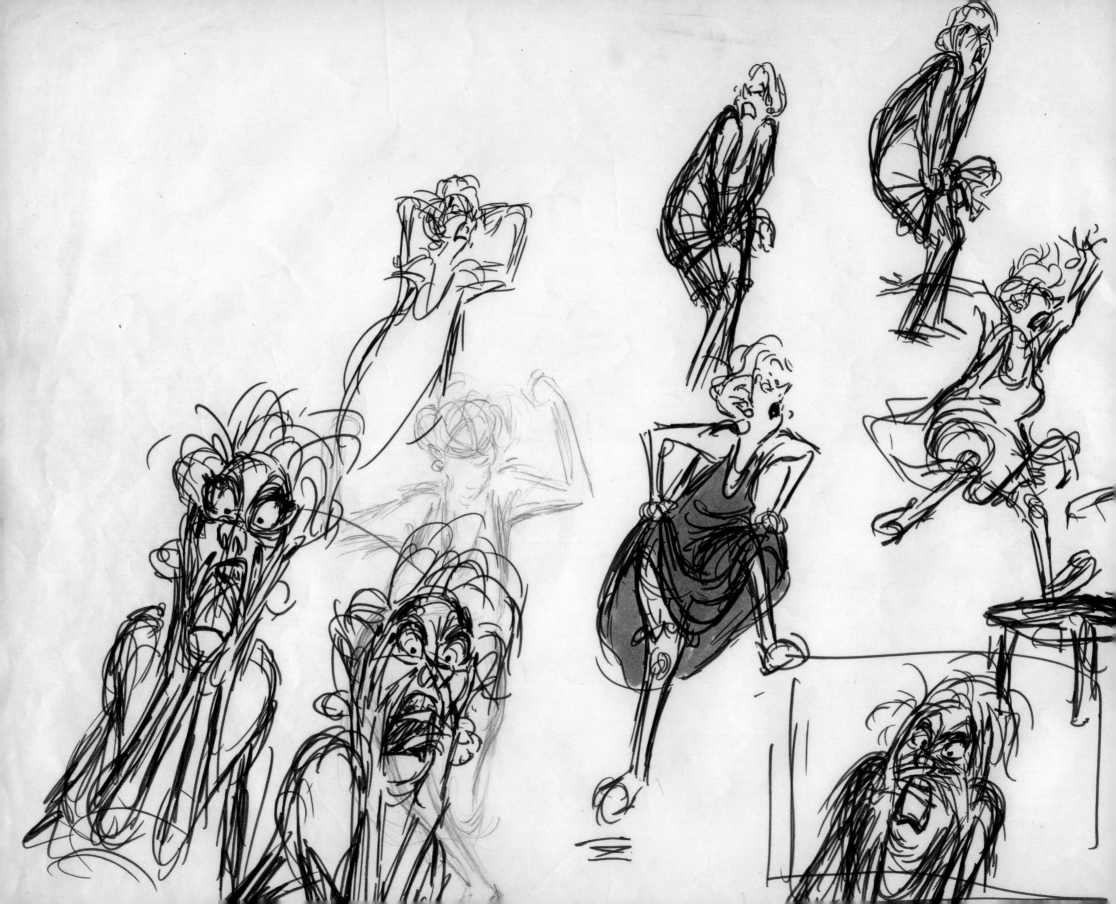

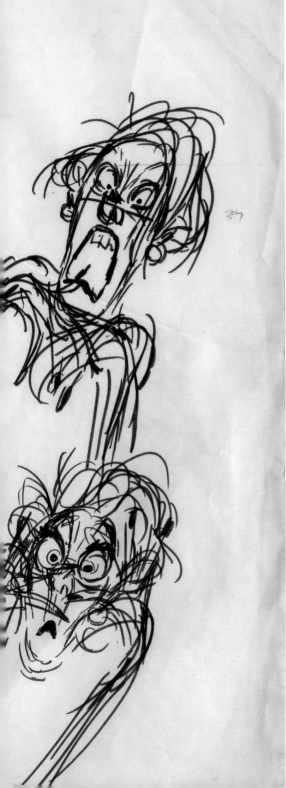

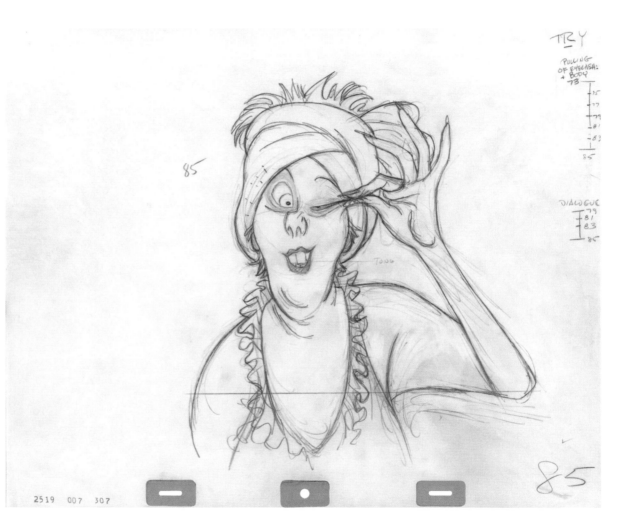

Clean-up animation drawing | *The Rescuers*, 1977 | Graphite and colored pencil on paper

Concept art | *The Rescuers*, 1977 | Ink and graphite on paper

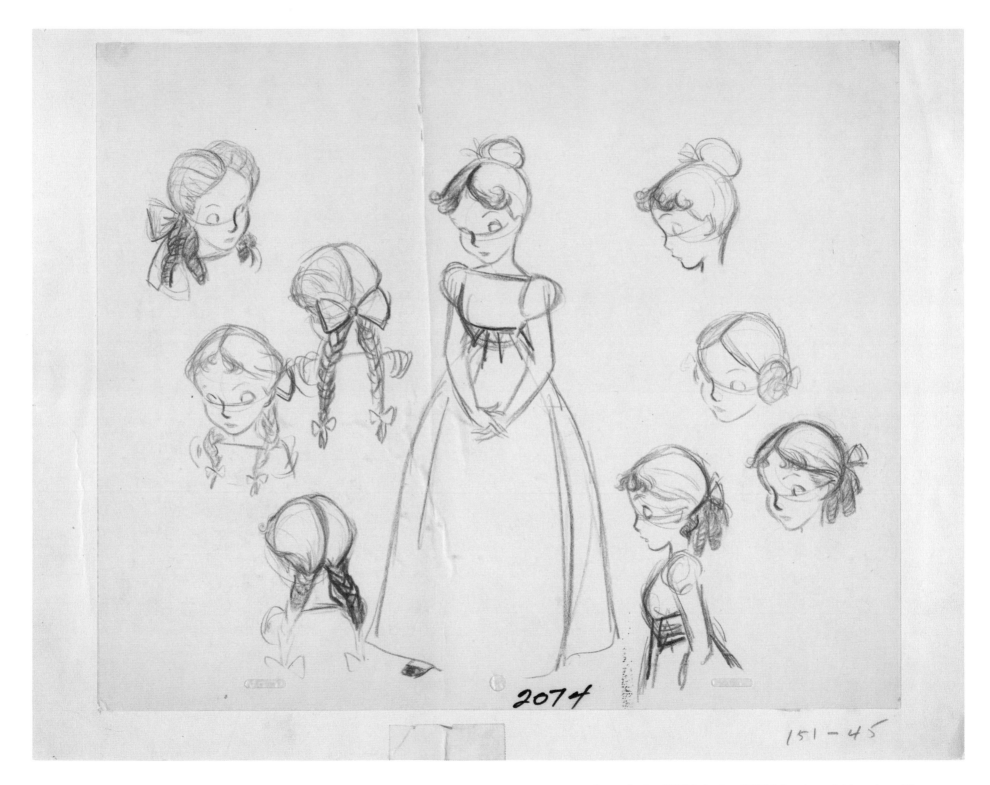

Concept art, c. 1951 | *Peter Pan*, 1953 | Colored pencil, ink, and graphite on paper

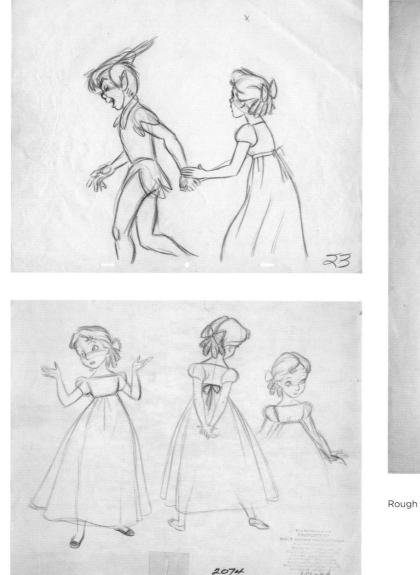

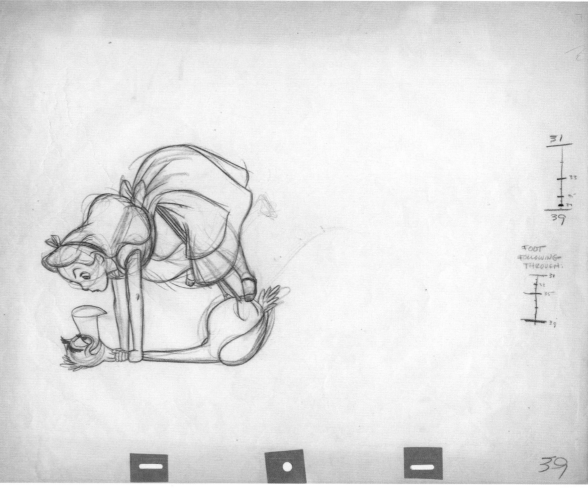

Rough animation drawing | *Alice in Wonderland*, 1951 | Graphite and colored pencil on paper

Rough animation drawing | *Peter Pan*, 1953 | Graphite on paper

Concept art, c. 1951 | *Peter Pan*, 1953 | Graphite and colored pencil on paper

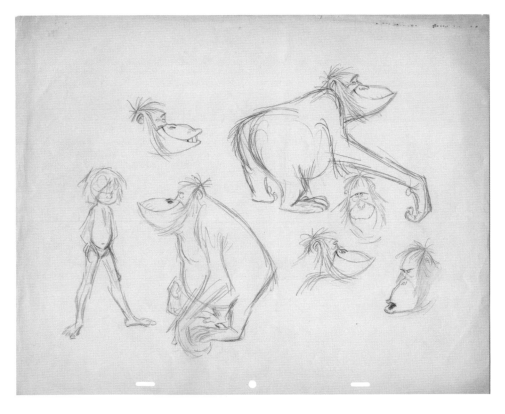

Concept art | *The Jungle Book*, 1967
Graphite and colored pencil on paper

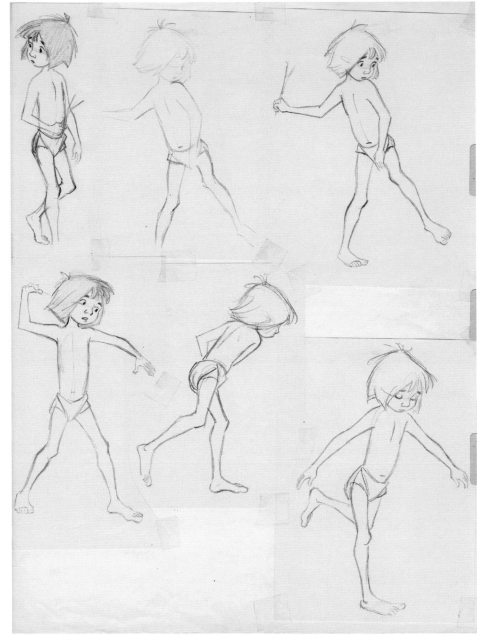

Concept art, sketched from live-action reference | *The Jungle Book*, 1967
Graphite and colored pencil on paper, collaged

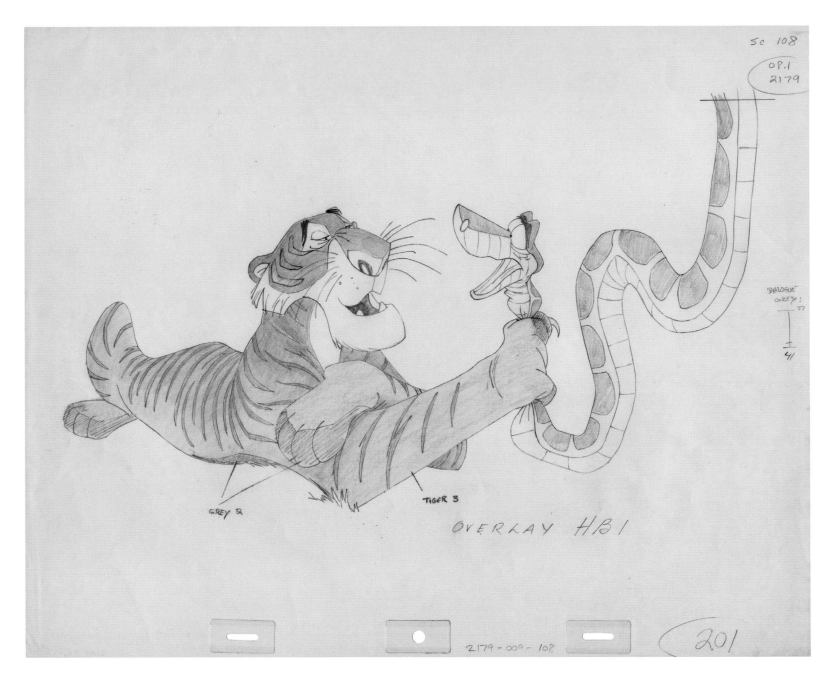

Clean-up animation drawing | *The Jungle Book*, 1967
Ink, graphite, and colored pencil on paper

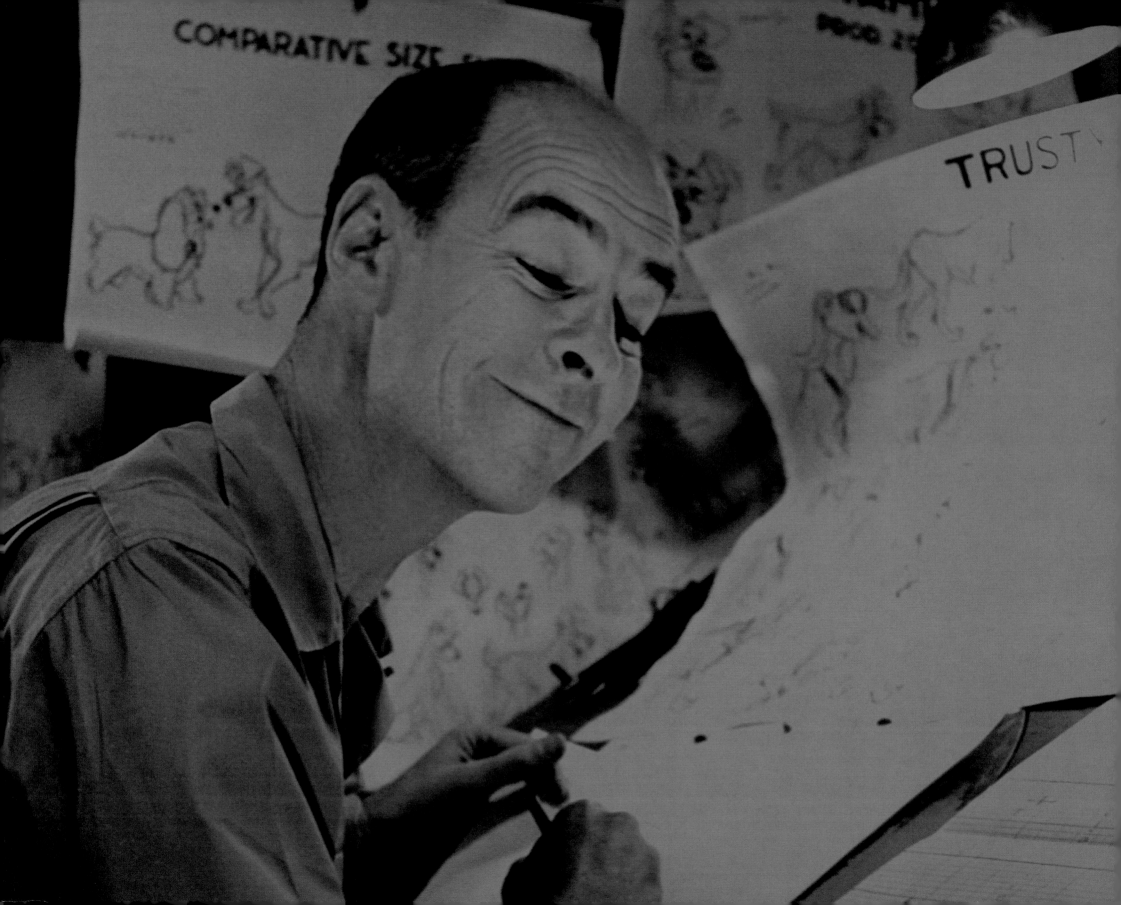

OLLIE JOHNSTON

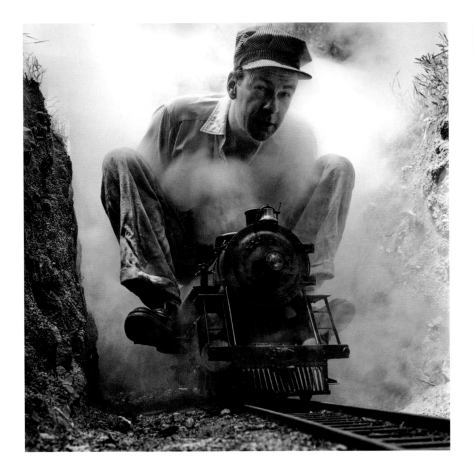

Ollie Johnston on the engine of the one-inch scale steam train on his La Cañada Valley Railroad

OLLIE JOHNSTON

Ollie's drawings reflect his gentle, soft-spoken nature. Glen Keane, who worked as his assistant, explained that "Ollie's pencil just seemed to kiss the paper." With his usual modesty, Ollie would point to a pencil that had belonged to Fred Moore, the animator who had trained him, saying it should still have a few good drawings left in it. A warmth permeates all of Ollie's work: Mr. Smee may be a pirate, but there's not a cruel bone in his body. Even in Ollie's scene when Pinocchio lies to the Blue Fairy, the puppet may feel trapped by his own falsehoods, but he's never malicious.

Outside the Studios, Ollie was best known for his love of railroading, an interest he shared with Ward Kimball and Walt. A one-inch scale steam train ran through his yard in Flintridge. Beginning in 1962, he spent six years finding and restoring a 1901 Porter steam engine that once hauled coal; he christened it the *Marie E.* after his wife and installed it at his vacation home in the mountains of Julian, California. Ollie glowed with happiness when he took friends for rides on either train, and a "steam up" with the accompanying informal potluck was a coveted invitation.

In 1981, Ollie and his longtime collaborator Frank Thomas published the definitive bible on the art of animation, entitled *Disney Animation: The Illusion of Life*. It quickly became required reading for future generations of animators. The longest lived of the Nine Old Men, Ollie received the National Medal of the Arts from President George W. Bush in 2005, but he seemed to take greater pleasure in personal tributes from friends.

‹ Ollie Johnston at his animator's desk | *LIFE* magazine, 1953

Rough animation drawing | *Sleeping Beauty*, 1959 | Graphite and colored pencil on paper

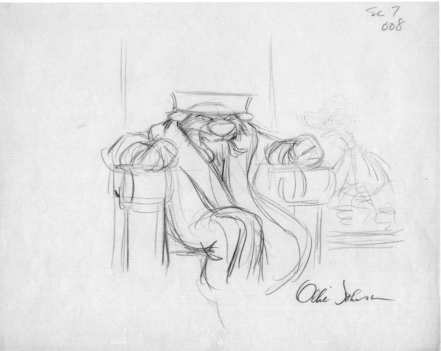

■▢ Concept art from the "Peter and the Wolf" segment
Make Mine Music, 1946
Graphite and colored pencil on paper

▢■ Rough animation drawing
Robin Hood, 1973
Graphite and colored pencil on paper

Clean-up animation drawing
Robin Hood, 1973
Graphite and colored pencil on paper

▸ Concept art | *The Rescuers*, 1977 | Graphite on paper

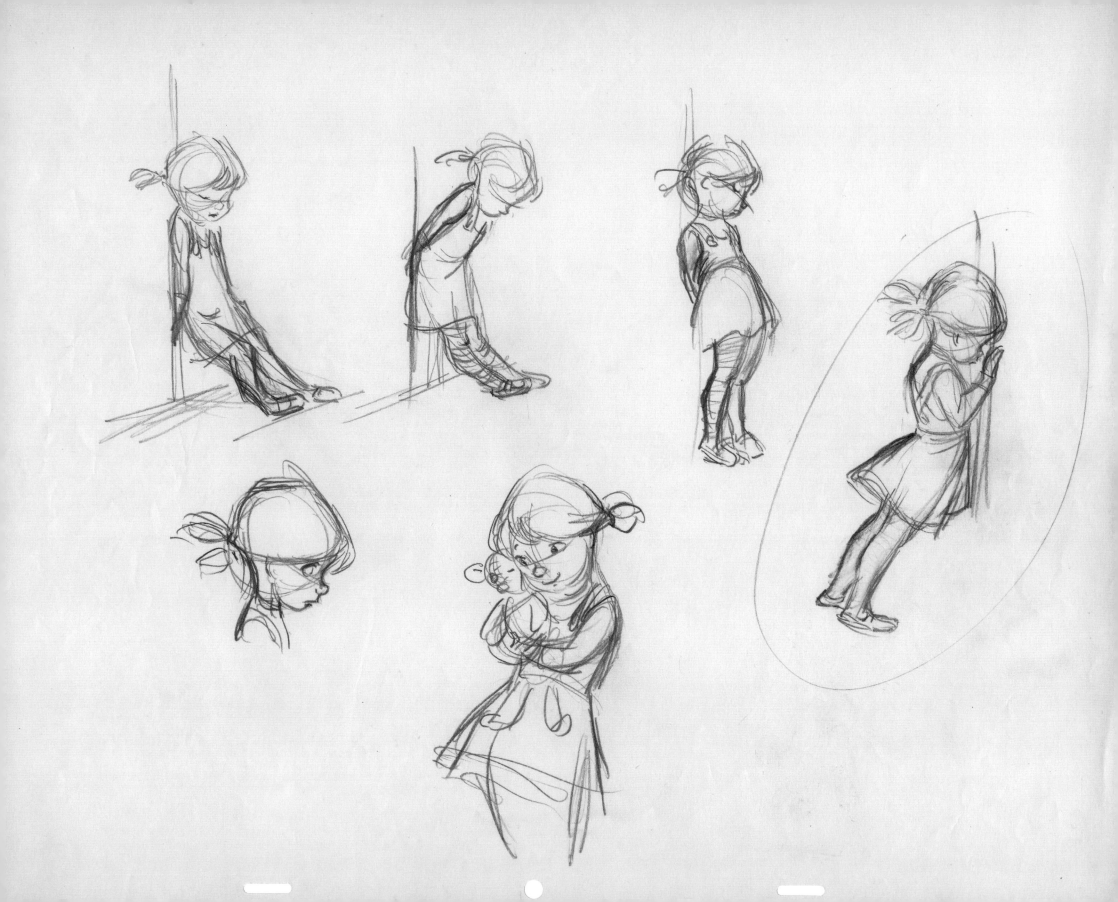

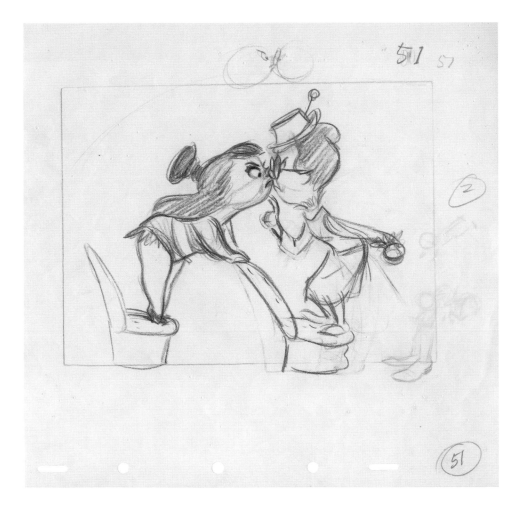

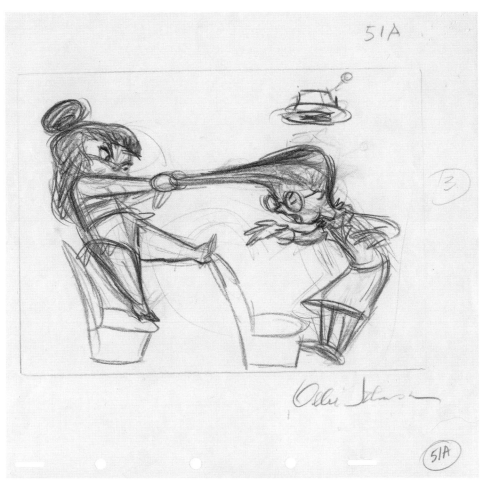

Rough animation drawings
Reason and Emotion, 1943
Graphite and colored pencil on paper

Seaside Scene | Watercolor on paper

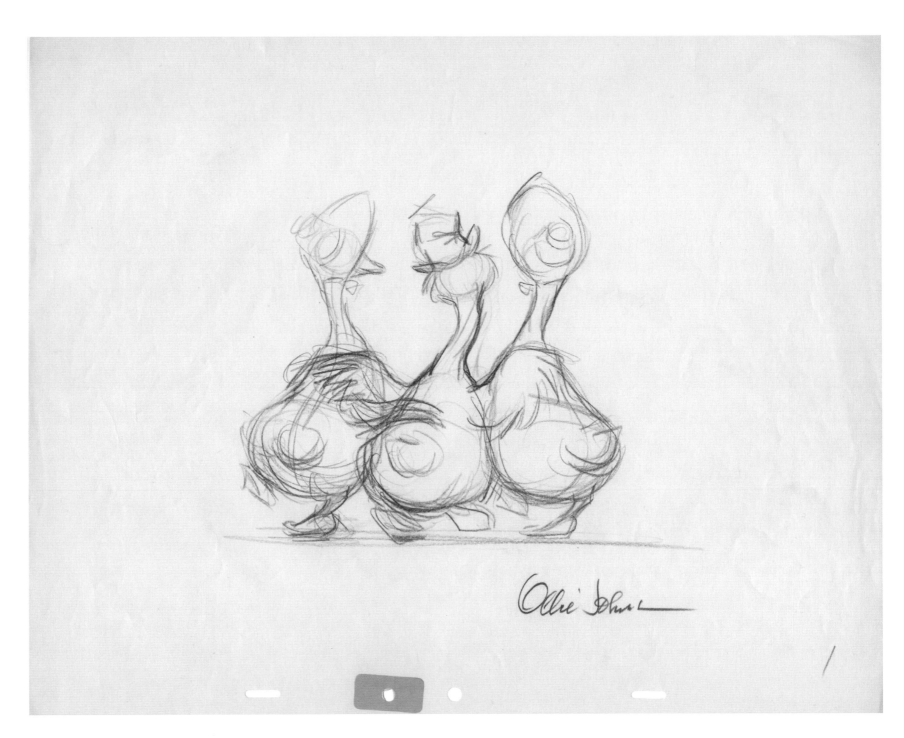

Rough animation drawing | *The Aristocats*, 1970 | Graphite and colored pencil on paper

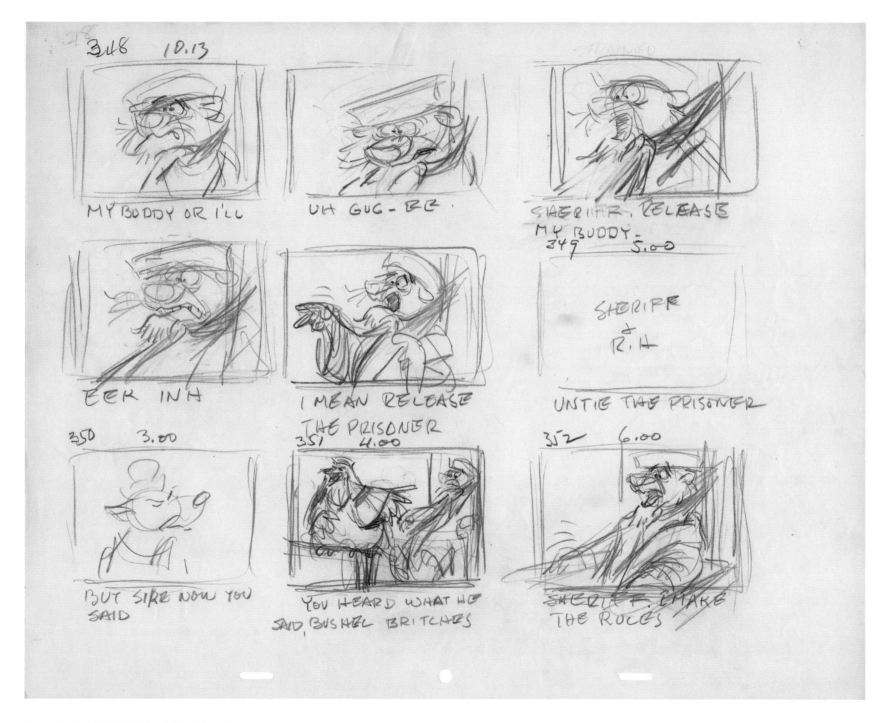

Story thumbnails | *Robin Hood*, 1973 | Graphite on paper

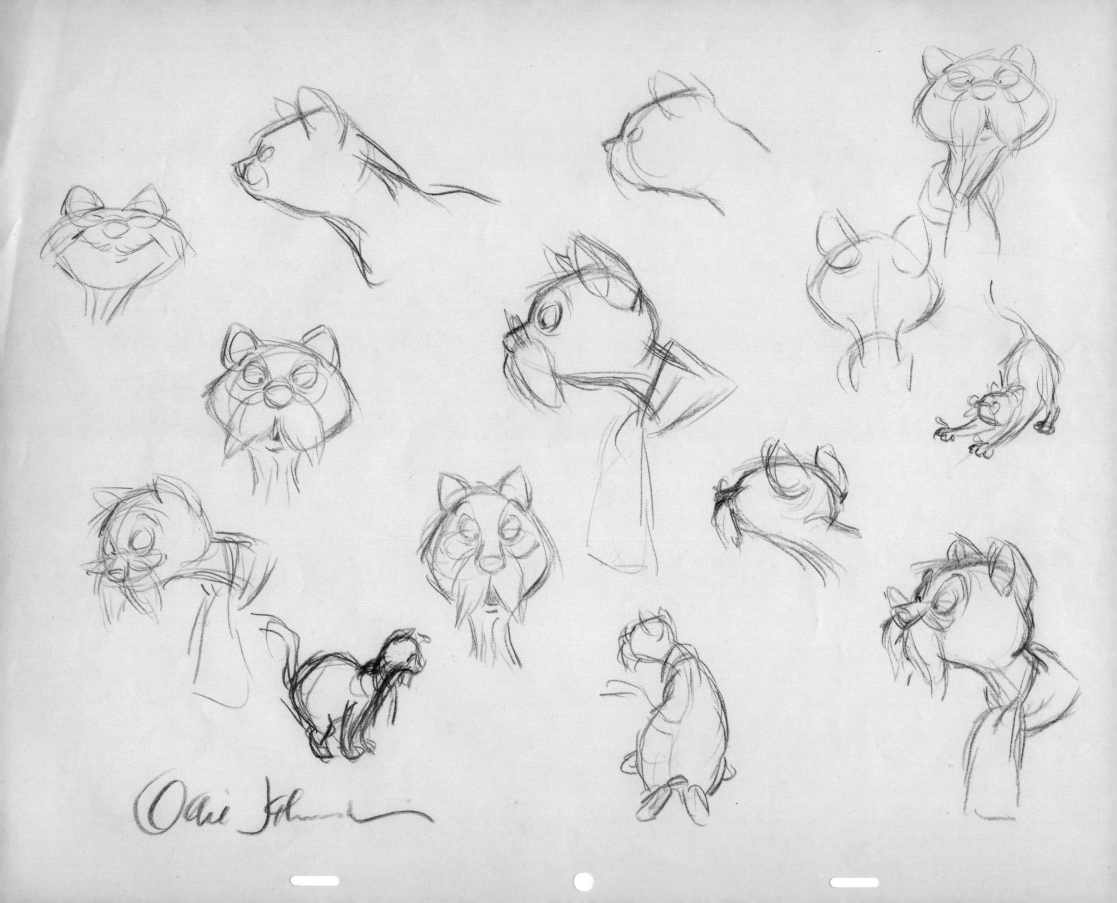

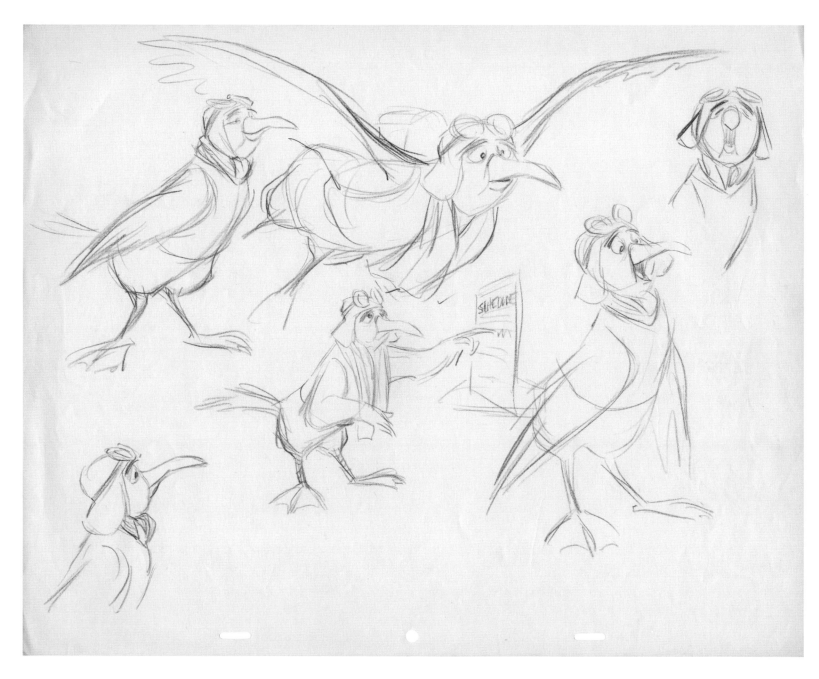

Concept art | *The Rescuers*, 1977 | Colored pencil on paper

‹ Concept art | *The Rescuers*, 1977 | Colored pencil on paper

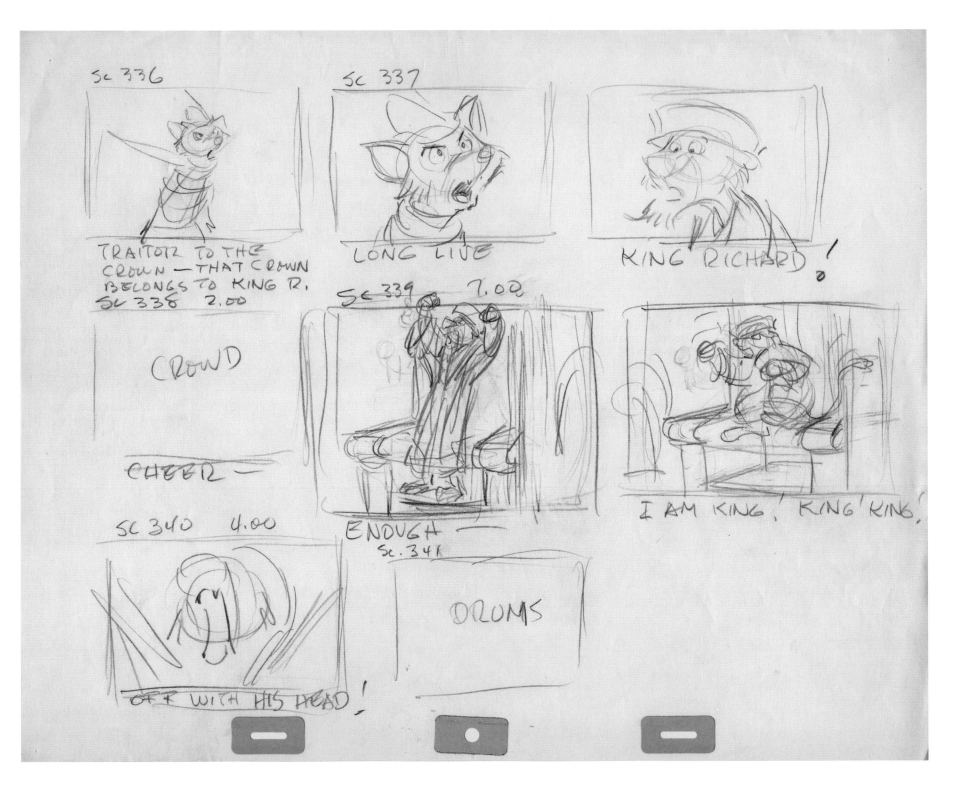

Story thumbnails | *Robin Hood*, 1973 | Graphite on paper

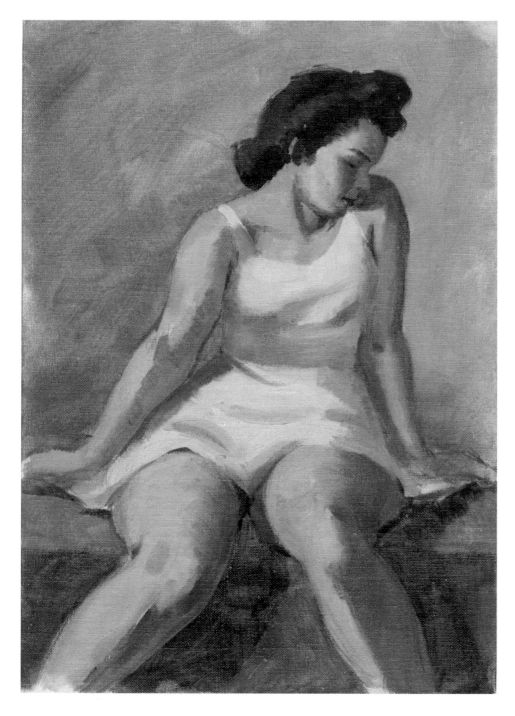

Woman Sitting in White Dress | Oil paint on canvas-covered paperboard

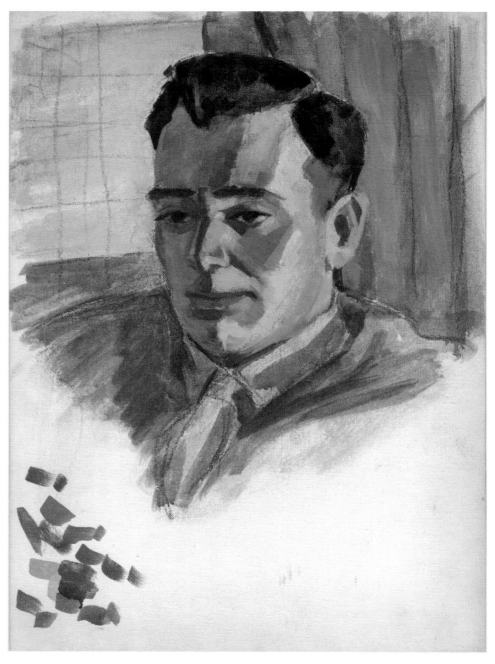

Portrait of a Man | Oil paint on canvas-covered paperboard

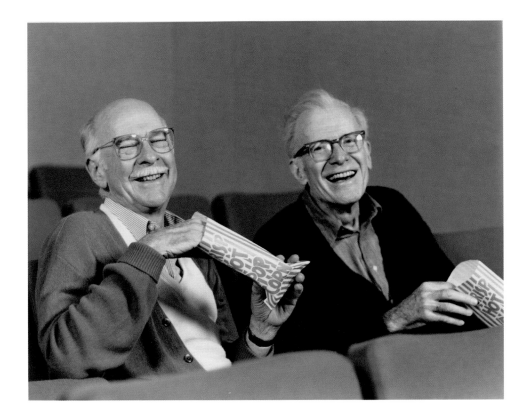

Ollie Johnston and Frank Thomas, 1989

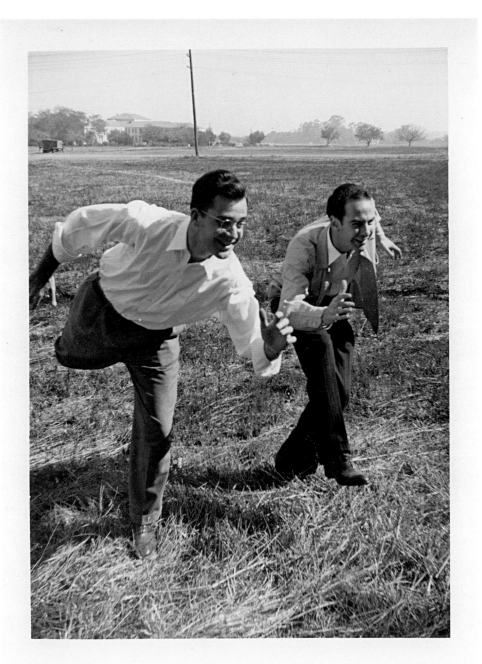

Frank Thomas and Ollie Johnston at Stanford University

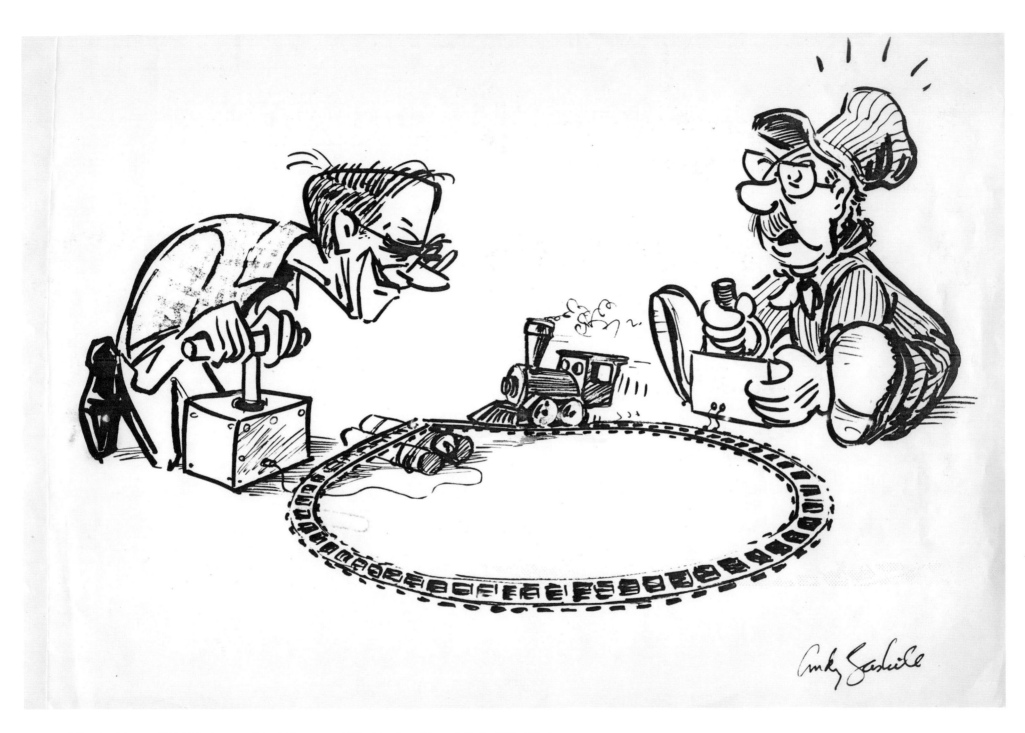

Andy Gaskill (United States, 1954–) | Caricature of Frank Thomas and Ollie Johnston with model train, 1980s | Photocopy on paper

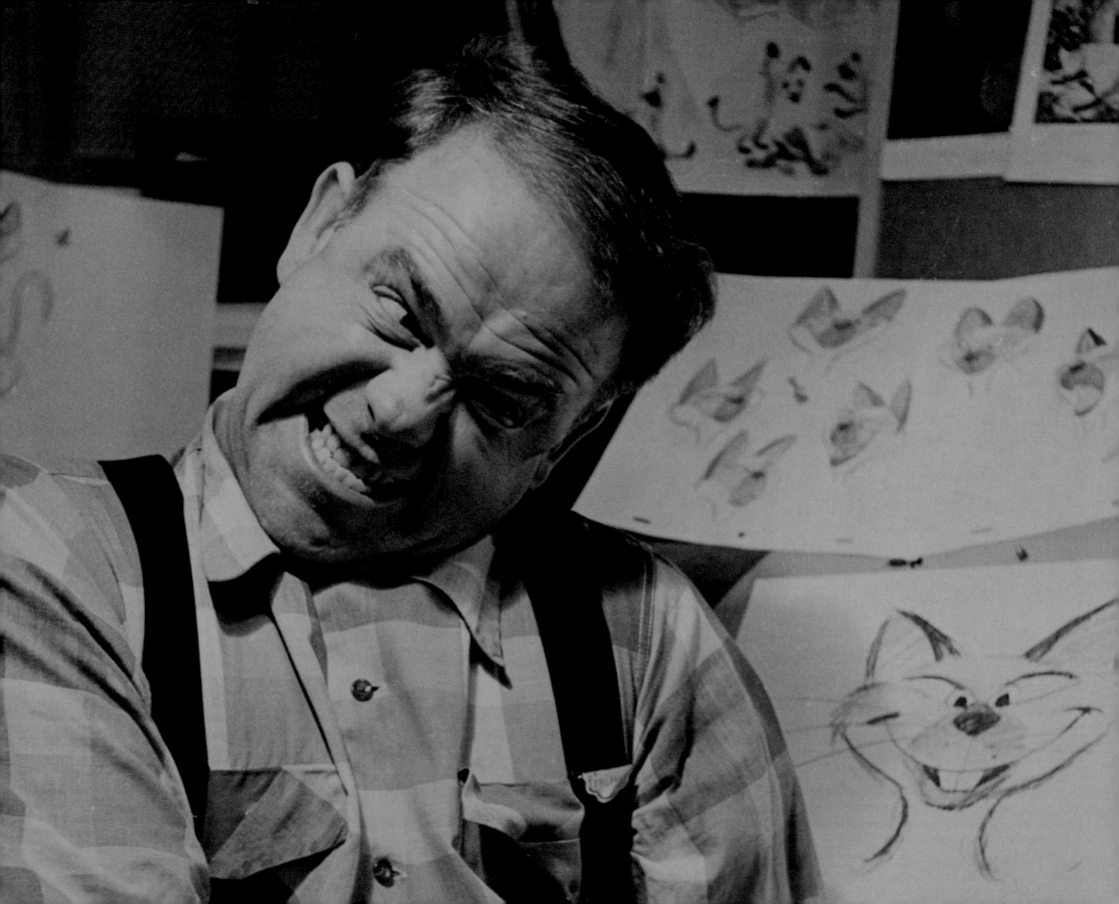

WARD
KIMBALL

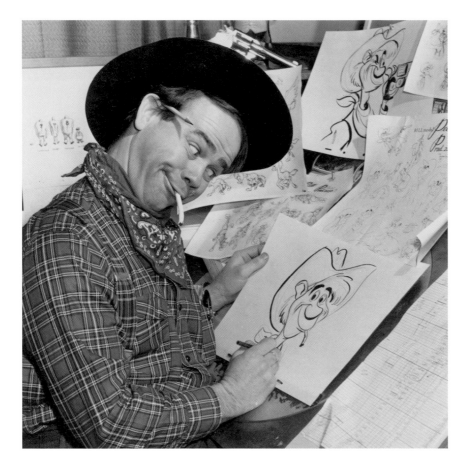

Ward Kimball drawing Pecos Bill | *Melody Time*, 1948

WARD KIMBALL

Ward was the most eccentric and flamboyant of the Nine Old Men. He favored oversized glasses and mismatched plaids, and he posed for a studio portrait wearing the paw from a gorilla suit on one hand. Although he created some of the Studios' most frenetic scenes—the Mad Tea Party in *Alice in Wonderland* (1951) and Donald, Panchito, and José performing the title song from *The Three Caballeros* (1945)—he also animated Pinocchio's beloved mentor and conscience, Jiminy Cricket.

Like Walt and Ollie Johnston, Ward was a railroad enthusiast. In 1938, he bought a full-size 1881 steam locomotive, which he restored and installed with other cars on a track at his San Gabriel home, dubbing the collection the Grizzly Flats Railroad.

Ward was also a talented painter, sculptor, caricaturist, and illustrator who delighted in swapping gag drawings with his fellow artists. When Walt would telephone on weekends, Ward would ask, "Walt who?"; When Walt replied, "Dammit, Kimball, it's Walt Disney!", Ward would ingenuously reply, "Well, I know several guys named Walt, I just wanted to know who I'm talking to."

In 1948, Ward formed the jazz band Firehouse Five Plus Two with other Disney artists, including Frank Thomas. They began playing for noon dances on the studio lot, but the group soon graduated to nightclubs and Milton Berle's and Ed Sullivan's television shows. *The Simpsons* producer-director and jazz musician David Silverman recalled, "When things started clicking on *The Simpsons*, I got a letter of encouragement and congratulations from Ward. I think he was happy to see that a new wave of animation was coming—and that at least part of the wave was cynical and sarcastic."

‹ Ward Kimball at his animator's desk | *LIFE* magazine, 1953

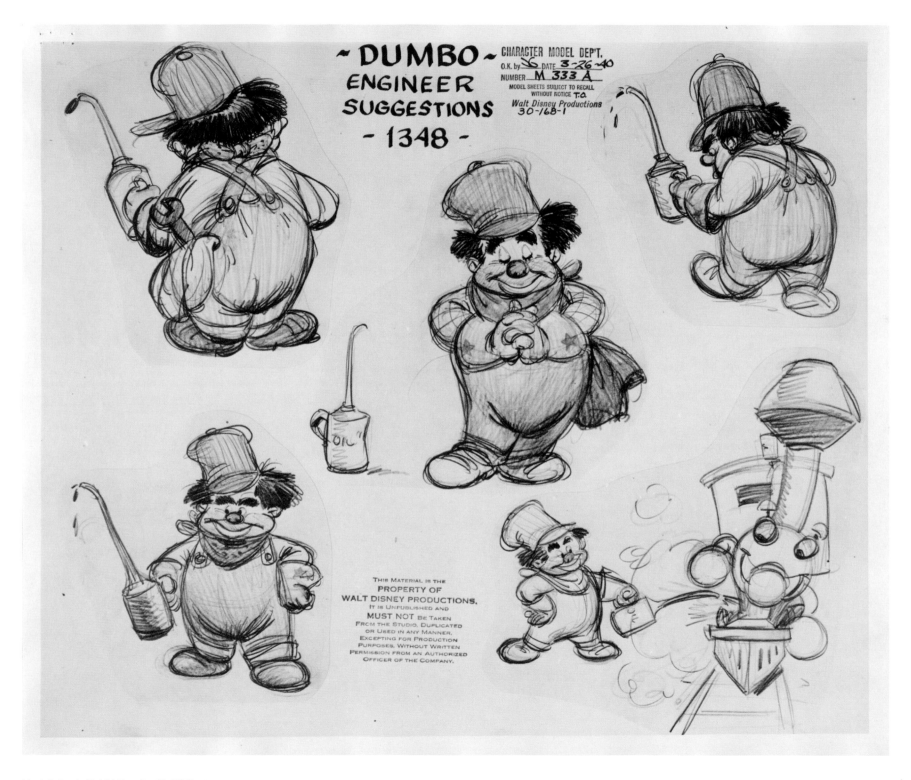

Model sheet, 1940 | *Dumbo*, 1941 | Photostat on paper

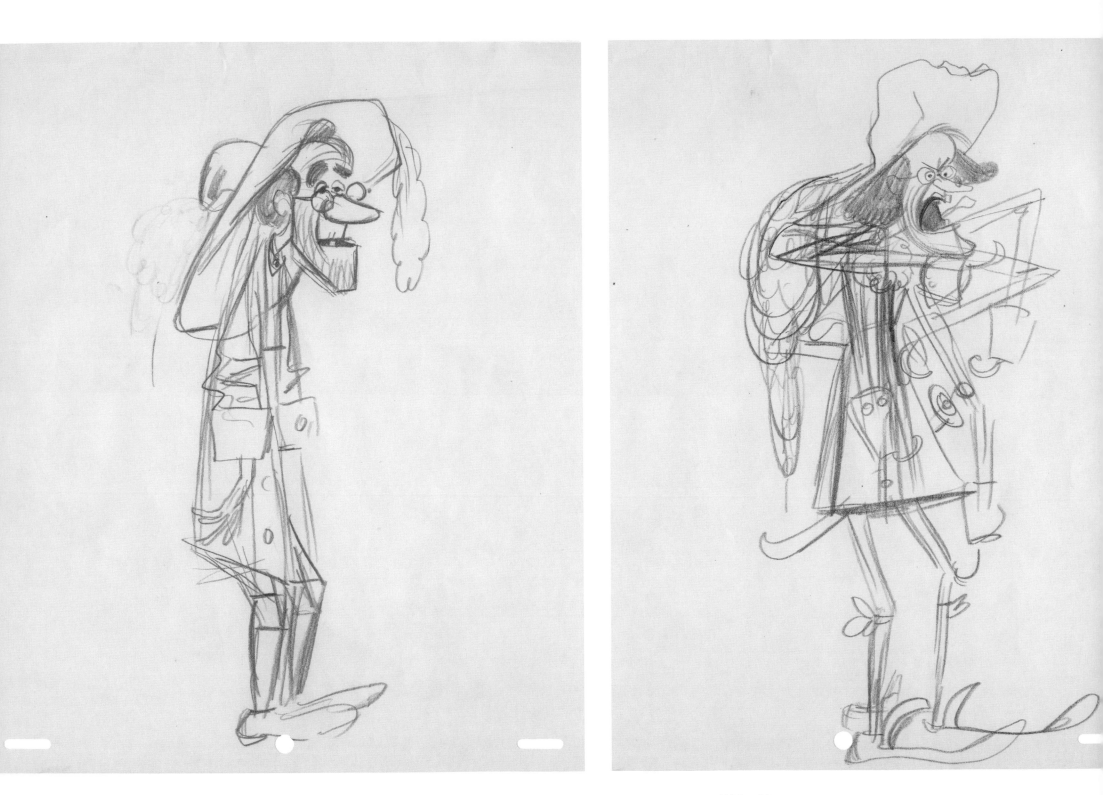

▪▫ Caricature of Frank Thomas | Graphite on paper ▫▪ Caricature of Milt Kahl | Graphite on paper

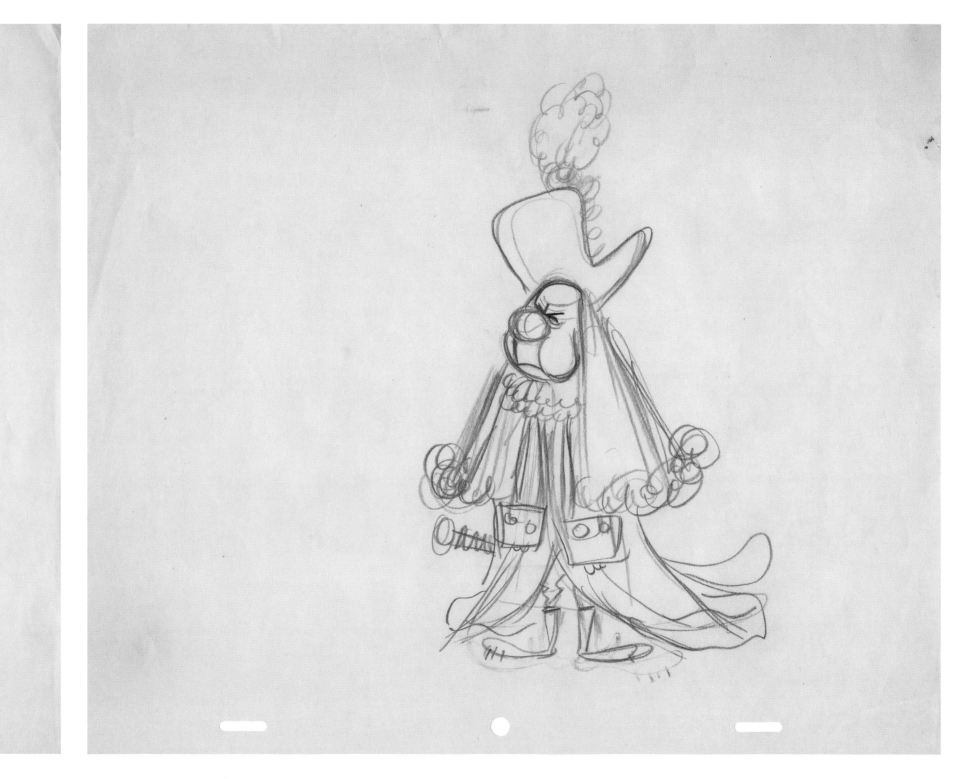

Caricature of Ollie Johnston | Graphite on paper

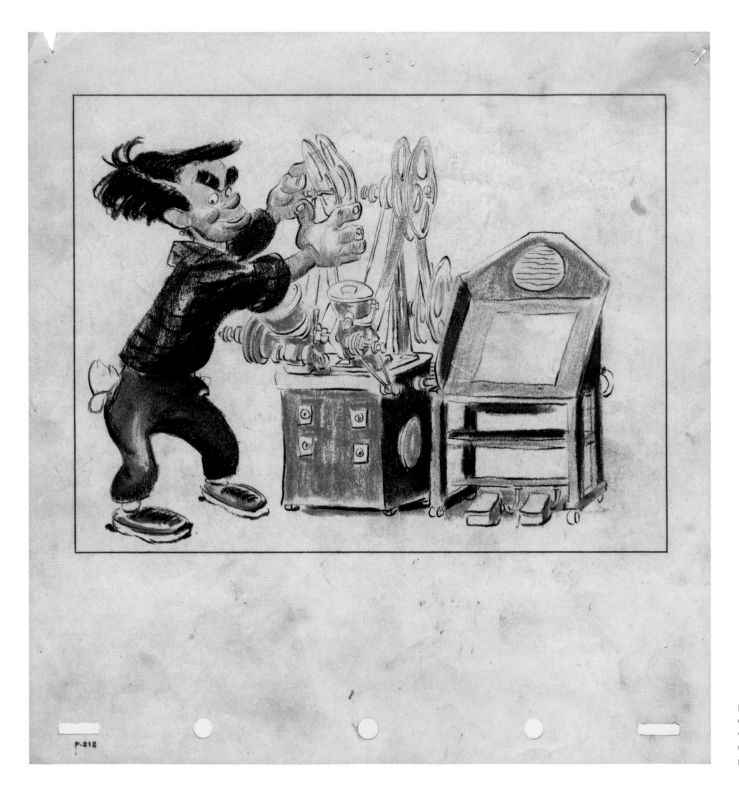

P-212

Milt Kahl (United States, 1909—1987)
Caricature of Ward Kimball
with a Moviola, c. 1940
Graphite, charcoal, colored pencil, and
pastel on paper

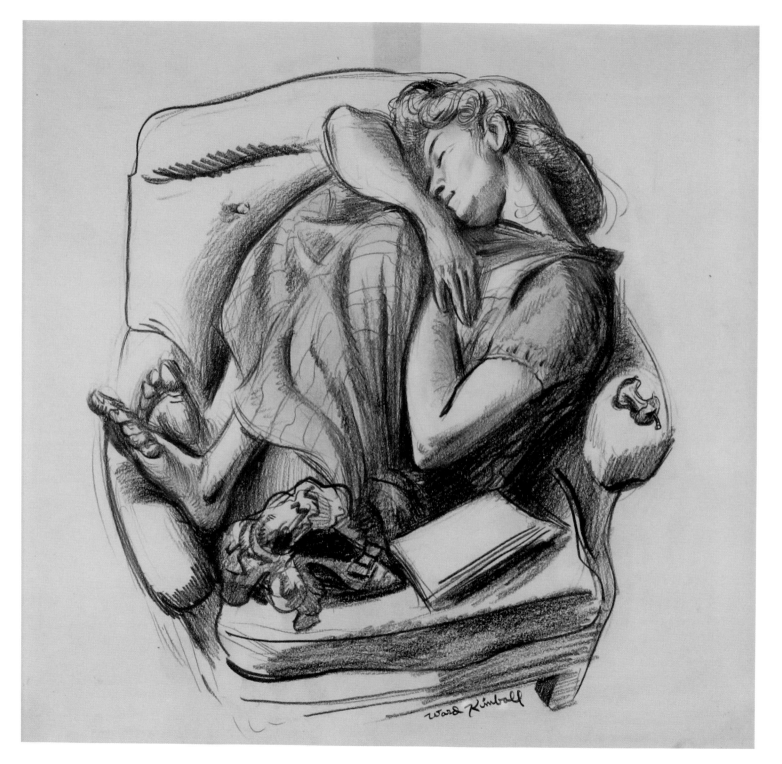

Betty Kimball, 1940s
Charcoal on paper

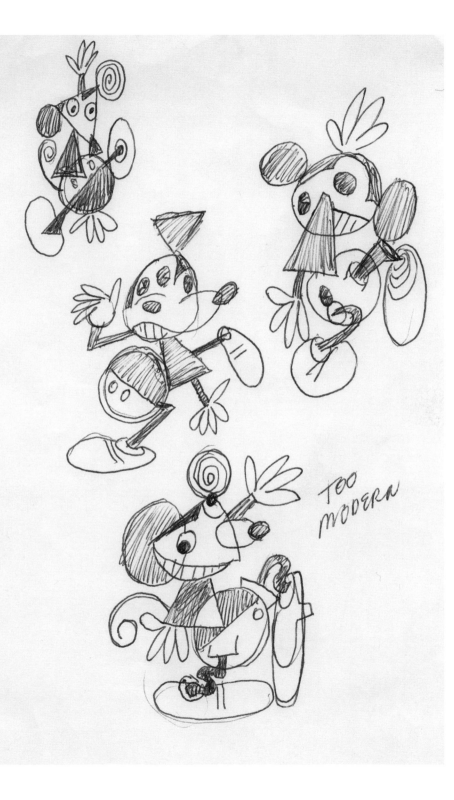

TOO
MODERN

Sketches of abstract
Mickey Mouse, 1985
Ink on paper

Rough animation drawings | Graphite and colored pencil on paper

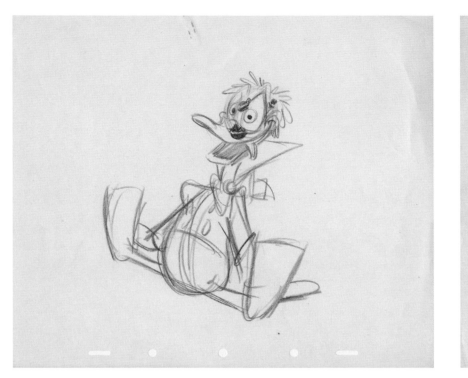

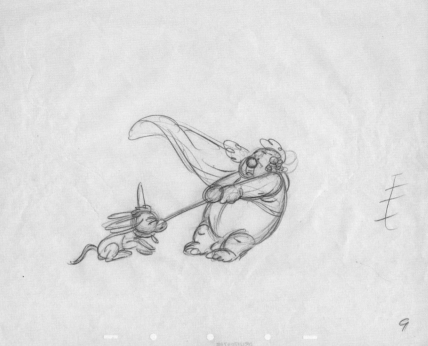

■□ Concept art
The Three Caballeros, 1945
Colored pencil on paper

□■ Rough animation drawing from
"The Pastoral Symphony" segment | *Fantasia*, 1940
Graphite and colored pencil on paper

Rough animation drawing
Alice in Wonderland, 1951
Graphite and colored pencil on paper

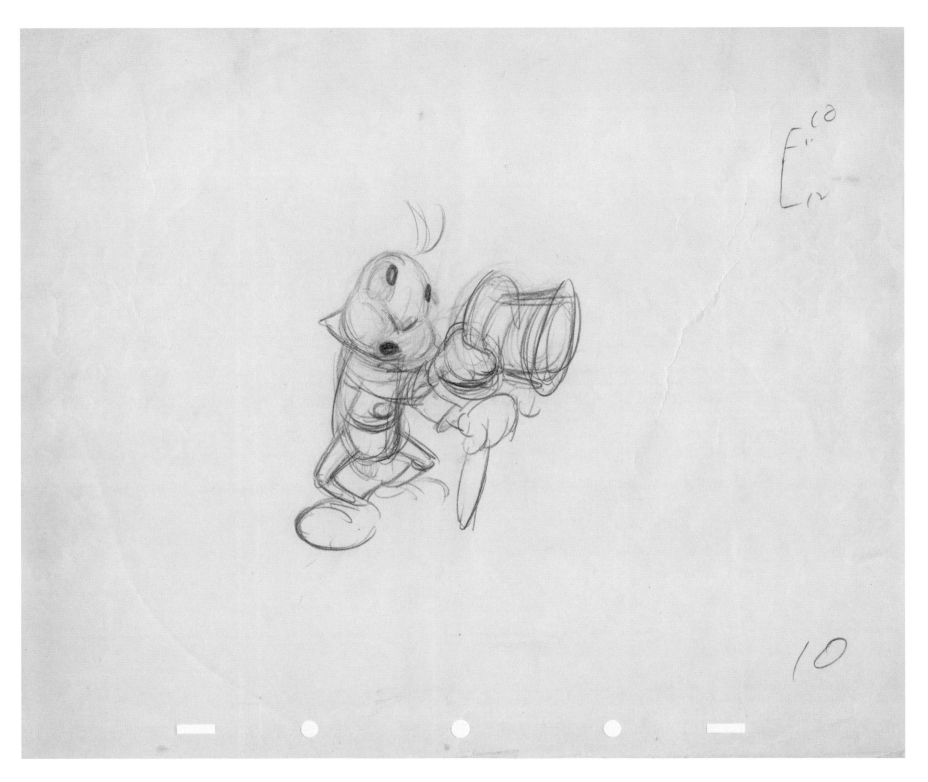

Rough animation drawing | *Pinocchio*, 1940 | Graphite and colored pencil on paper

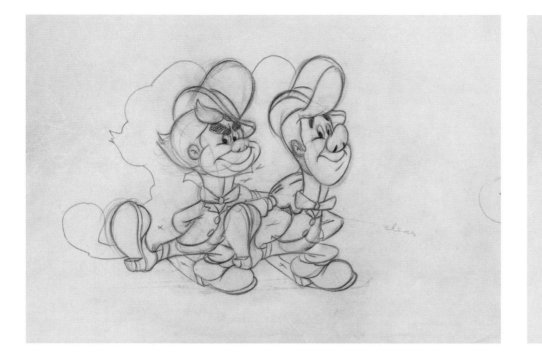

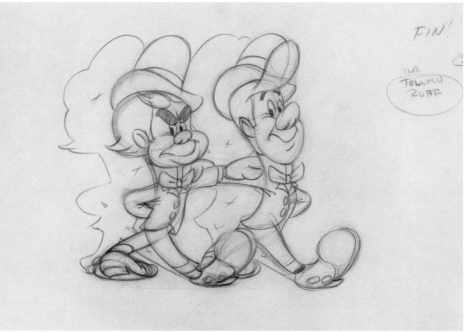

Clean-up animation drawings | *The Nifty Nineties*, 1941 | Characters based on Ward Kimball and Fred Moore
Graphite and colored pencil on paper

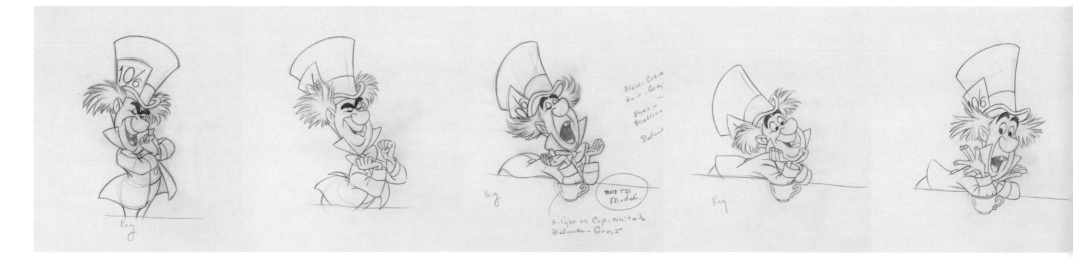

Clean-up animation scene | *Alice in Wonderland*, 1951
Graphite and colored pencil on paper

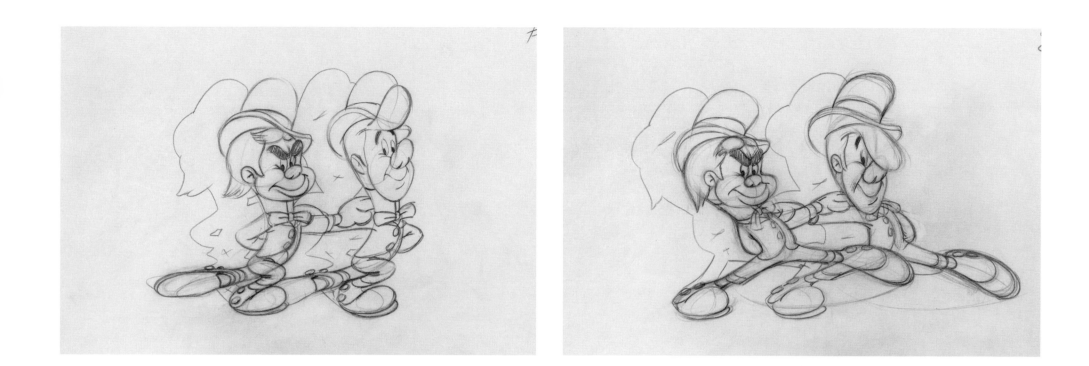

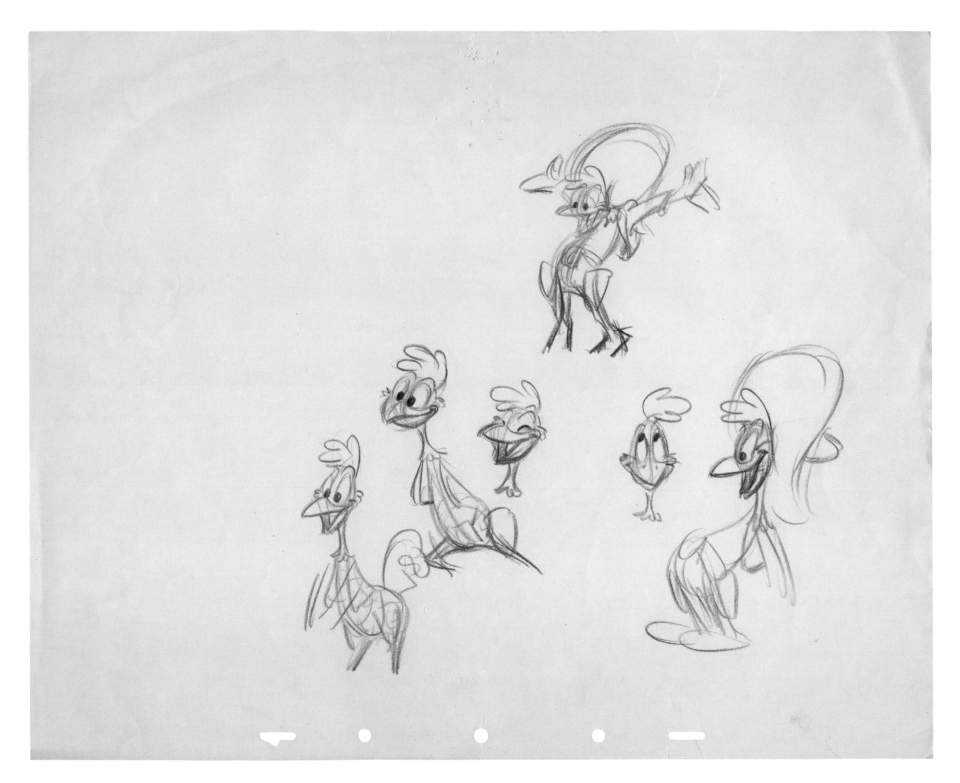

Concept art | *The Three Caballeros*, 1945 | Colored pencil on paper

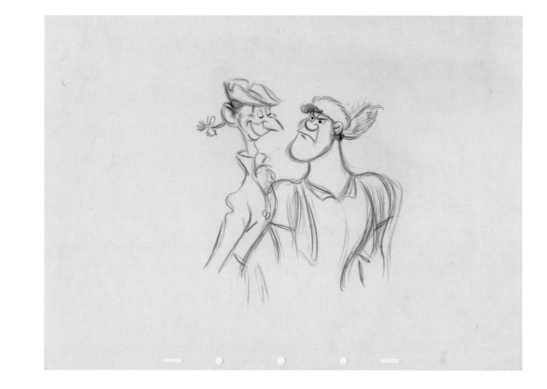

Concept art from "The Legend of Sleepy Hollow" segment
The Adventures of Ichabod and Mr. Toad, 1949
Graphite and colored pencil on paper

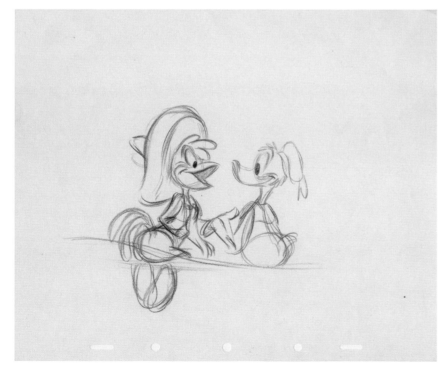

Concept art
The Three Caballeros, 1945
Graphite and colored pencil on paper

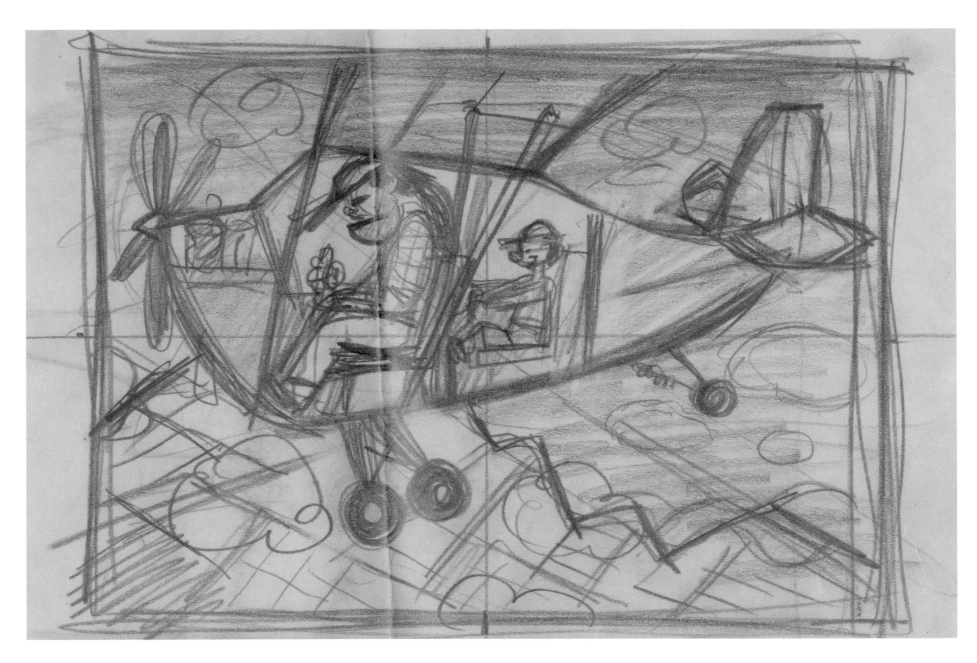

Johnny's First Ride rough sketch, c. 1946 | Graphite on paper

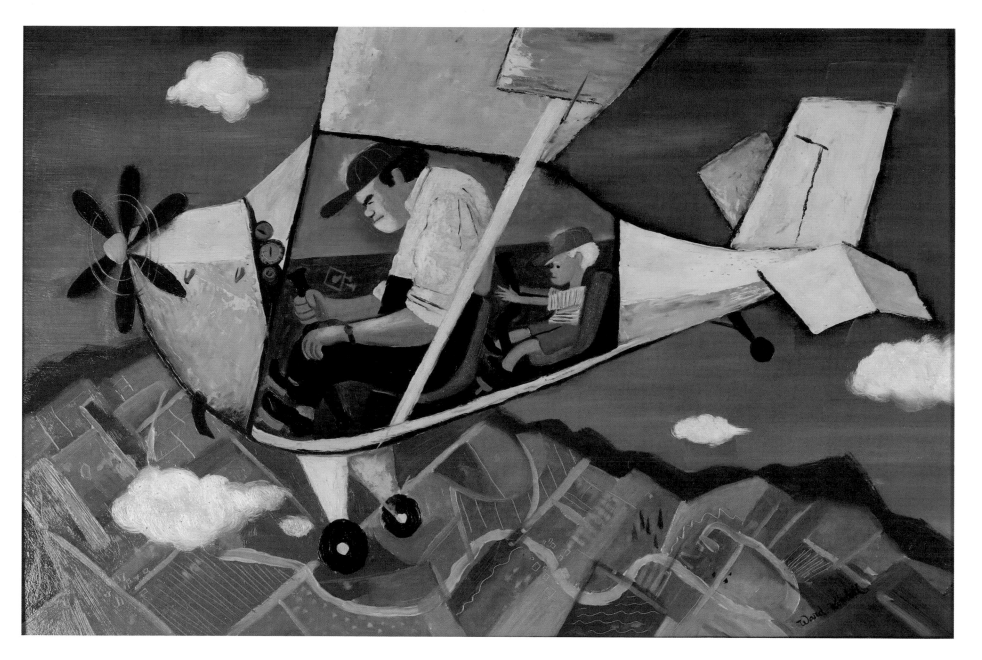

Johnny's First Ride, 1946 | Oil paint on Masonite

WOOLIE
REITHERMAN

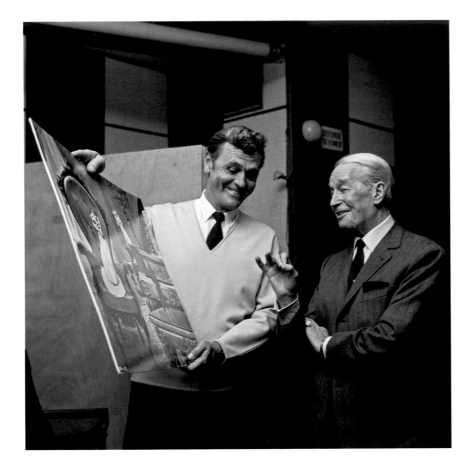

Woolie Reitherman holding a poster with Maurice Chevalier | *The Aristocats*, 1970

WOLFGANG "WOOLIE" REITHERMAN

Woolie's handsome, deeply lined face gave him the look of a hero in a Joseph Conrad novel—an impression his height, broad shoulders, brilliant Aloha shirts, and cigars only strengthened. During World War II, he served with the Army Air Transport Command, flying "over the hump"—over the Himalayas to China—a notoriously dangerous mission. He received the Distinguished Flying Cross and the Air Medal with one bronze Oak Leaf Cluster, and he remained an aviator until his death in 1985.

Like many of his fellow Disney artists, Woolie studied at the Chouinard Art Institute before coming to the Studios. He wanted to be a watercolorist, but jobs were scarce during the Depression and Walt Disney was looking for artists.

Woolie often handled fights and action sequences at the Studios, including Monstro the whale in *Pinocchio* (1940), the tyrannosaurus attacking the stegosaurus in *Fantasia* (1940), Tramp fighting the rat in *Lady and the Tramp* (1955), and Prince Phillip battling the dragon in *Sleeping Beauty* (1959). But he was also adept at comedy, as he proved in his work for the "El Gaucho Goofy" sequence in *Saludos Amigos* (1942) and Ichabod Crane's gawky dance with Katrina Van Tassel in *The Adventures of Ichabod and Mr. Toad* (1949).

When Walt turned his attention to television, live action, and Disneyland, he chose Woolie to serve as producer-director of the animated features. Frank Thomas said the choice was due to "energy and experience—he'd done a lot more different types of scenes." Although the Academy Award-winning director took pride in his ability to get the other artists to work together, Woolie said with typical candor, "I became a director because Walt said, 'Be a director!'"

‹ Woolie Reitherman directing his son (and voice actor) Bruce Reitherman, 1966
The Jungle Book, 1967

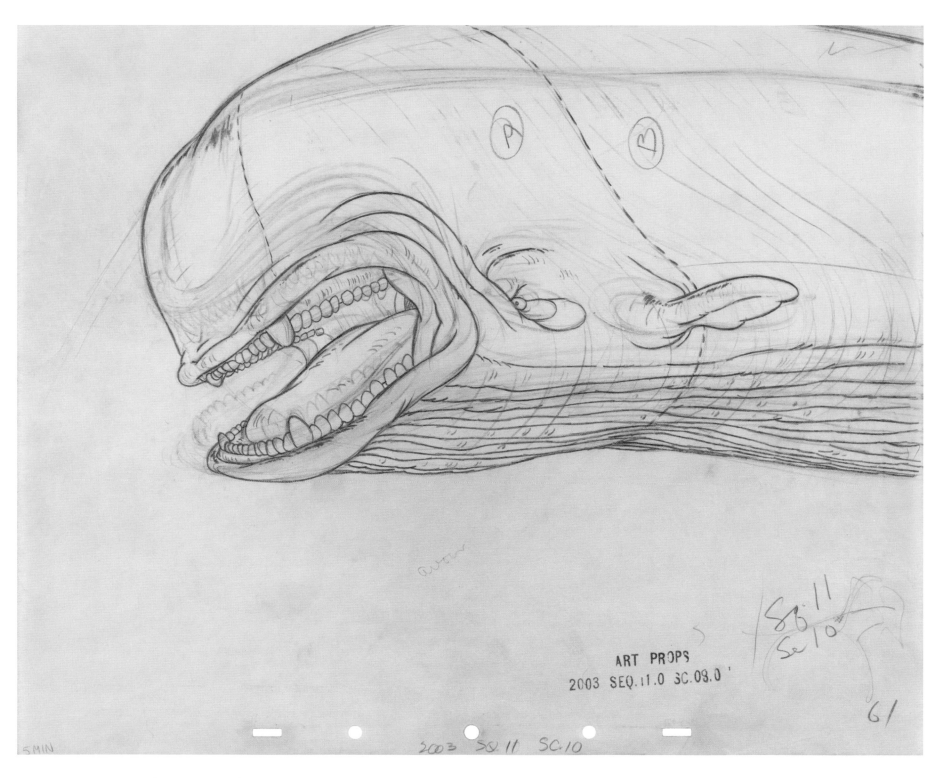

Clean-up animation drawing | *Pinocchio*, 1940 | Graphite, colored pencil, and grease pencil on paper

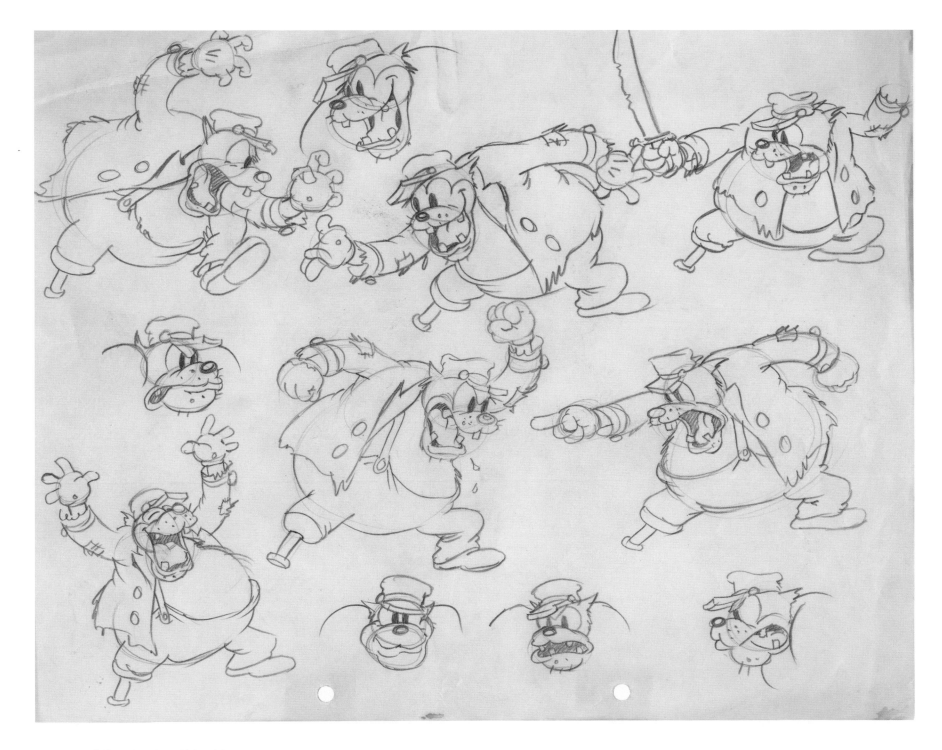

Concept art | *Shanghaied*, 1934 | Graphite on paper

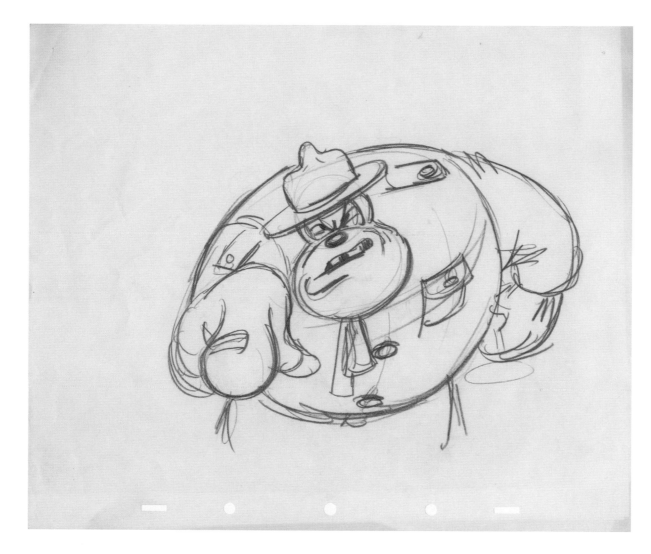

Rough animation drawing | *Donald Gets Drafted*, 1942 | Graphite and colored pencil on paper

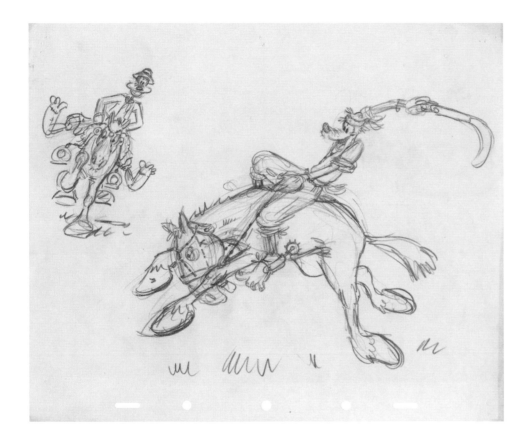

Concept art from the "El Gaucho Goofy" segment
Saludos Amigos, 1942
Graphite and colored pencil on paper

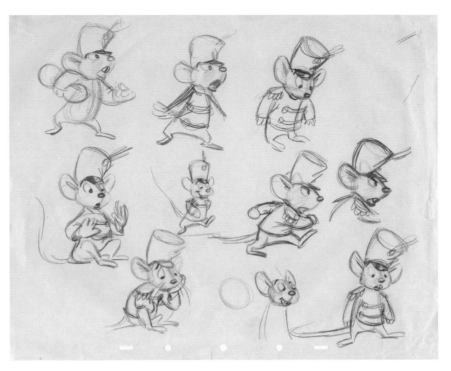

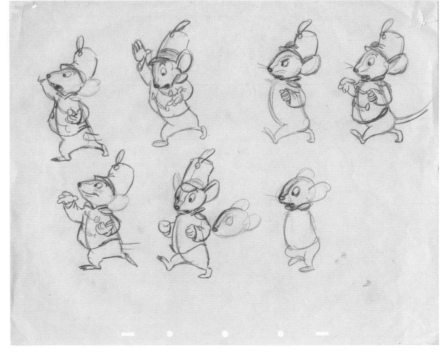

Concept art | *Dumbo*, 1941 | Colored pencil on paper
Concept art | *Dumbo*, 1941 | Graphite on paper

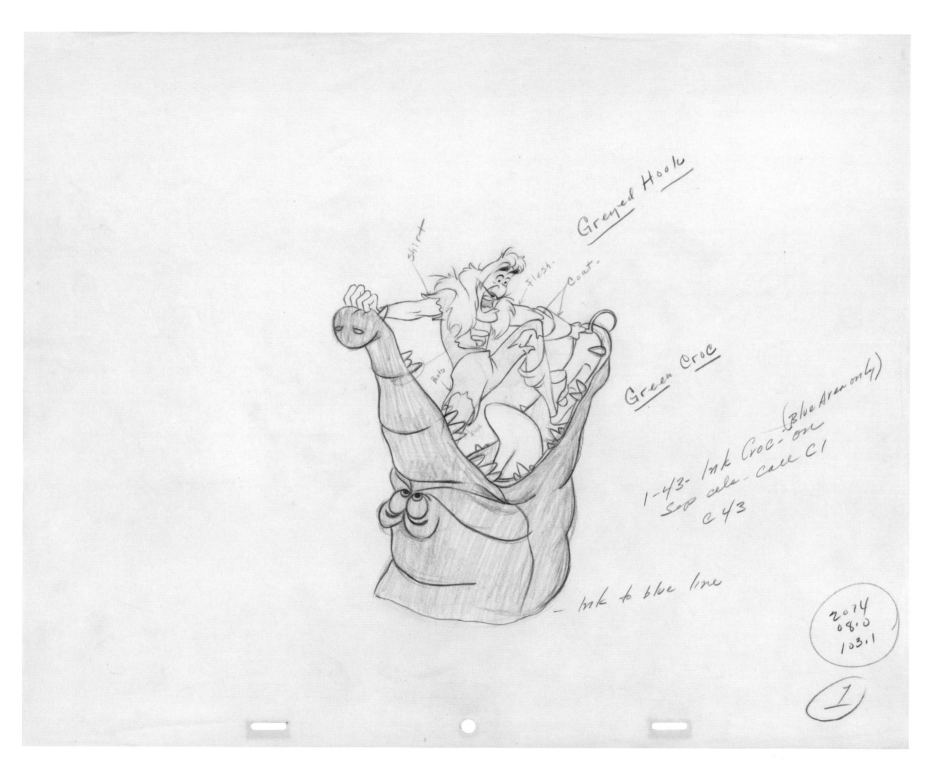

Clean-up animation drawing | *Peter Pan*, 1953 | Colored pencil and graphite on paper

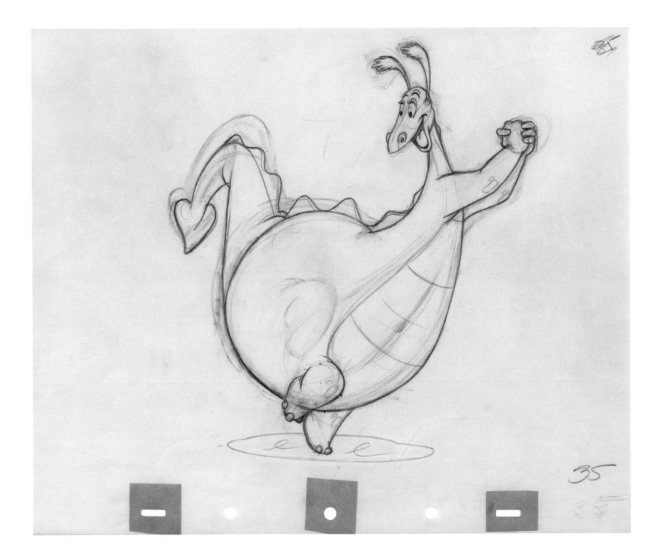

Clean-up animation drawing | *The Reluctant Dragon*, 1941 | Colored pencil and graphite on paper

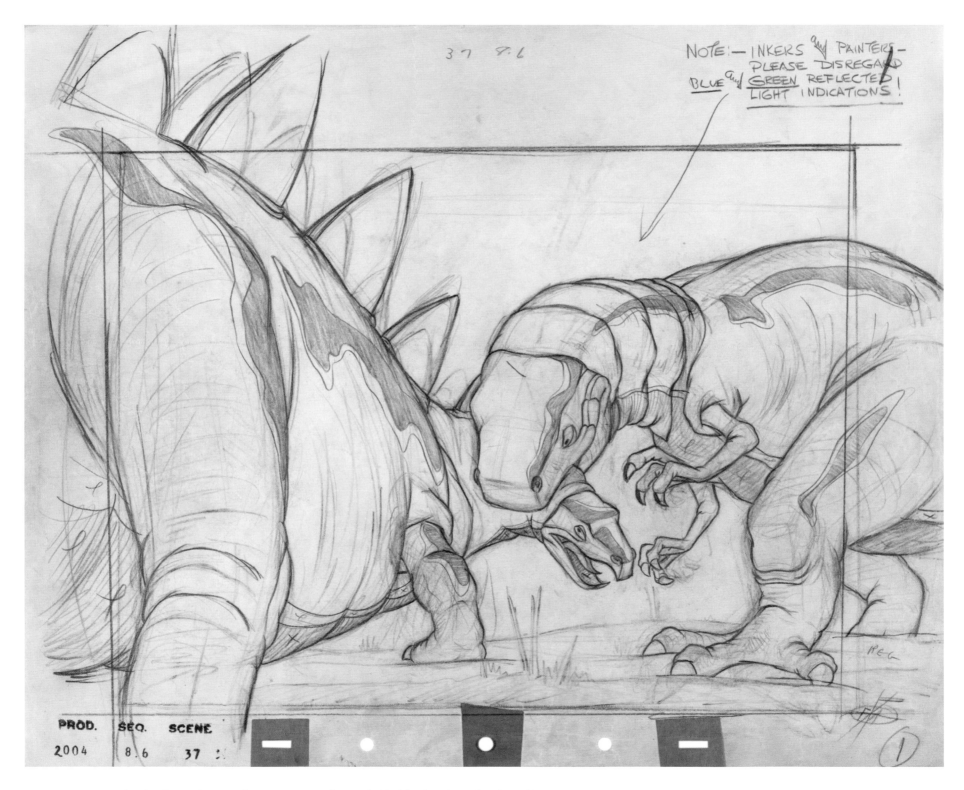

Clean-up animation drawing from "The Rite of Spring" segment | *Fantasia*, 1940 | Colored pencil and graphite on paper

9/13/77 "THE FOX AND THE HOUND"

SEQ. CHART

			HULETT KRESS WRITER	STORY		
				STORY SKETCH IN WORK	RECORDING	STORY R
920	OPENING TITLES			MEL / TED		
	MEL FOX HUNT	TREATMENT ✓				
001	? BABY FOX IS FOUND CROWS AND OWL AND BIRDS	TREATMENT BIRDS + OWLS	LARRY	MEL TED	CASTING BIRDS OWL	STARTED
Don, Burnie L.A. Pomeroy	KIND LADY ADOPTS FOX BIRDS	TREATMENT LADY DIAL. ✓	LARRY	MEL TED	LADY	NOT STAR
002 L.A. Pomeroy Don, Burnie	YOUNG FOX AND HOUND BECOME FRIENDS COW HAPPY LIFE ON FARM + BIRDS AND CATAPILLAR	TREATMENT LADY	LARRY	MEL TED? MEL TED	LADY BIRDS (FOX)	NOT STAR
Art, Gombert, Randy, Andy Art, Joe, Jeff, (Ted) Dick Lucas	"FRIENDSHIP" SCENES CHASE SCENES BIRDS? ARGUMENT OWLS? ✓	HUNTER CALLING TREATMENT LADY + HUNTER	LARRY	MITCH PETE BURNIE TAD MEL TAD	HUNTER/OWL LADY (BIRDS?)	CHASE IN WORK NOT STAR
003 GOOD MUSIC Don, Burnie LAUNDRY Art, Andy, Ted, Clemons	YOUNG FOX LOSES FRIEND (FOX ✓ BIRDS NO) KITCHEN SCENES – HUNTER LEAVES – "ELIMINATION" SONG ✓	TREATMENT LADY REWRITE BIRDS HUNTER?	LARRY LARRY	NEEDS NEW STORY BD BURNIE MEL-TED BIRDS TED GET B. MAMA SONG?	LADY FOX + BIRDS BIRDS-SING	NEW B STARTED CORRECT ON BIRDS
03.5 LARRY–STEVE–TED	MONTAGE – WINTER TO SPRING BIRDS-OWL (TOD? KIT FOX)	TREATMENT	LARRY	NEEDS NEW SET/CARPET + DOGS (BIRDS TED)	BIRDS-OWL	CORRECT BIRDS ONLY FEW SAFE
03.1	HUNTER RETURNS BIRDS-FOX OWL MICKEY	TREATMENT	LARRY	INTO SPRING BIRDS TED	BIRDS ROONEY	CORRECT BIRDS-F
03.4 Art, Ollie MITCH Joe	TOD GOES TO SEE COPPER OWL * CHASE ONTO TRESTLE maybe owl?	REWRITE BIRDS ✓ HUNTER DIAL	LARRY HULETT LARRY	MITCH HALE MEL MITCH HALE MICH	CAST HOUND ROONEY HOUND HUNTER	CORREC HOUND R CORRECT OK SAFE
03.6	HUNTER SHOWS LADY INJURED CHIEF OUT	OUT	OUT			OUT
03.2 Don, Lucas · L.A. Pomeroy	LADY ABANDONS TOD IN FOREST – "FAREWELL" SONG OWL AND BIRDS TRY IT ✓	REWRITE BIRDS	LARRY	BIRDS TED	BIRDS – OWL	POSSIBL ADEQUA
03.3 MITCH, PETE	TOD'S MISERABLE NIGHT ✓ RABBITS BADGER PORCUPINE MICKEY ROONEY		HUELETT	DELOPE ANIMALS PETE	FOREST ANIMALS HUNTER	STARTE
004 LARRY KRESS–ART KEENE	FOX MEETS VIXEN – "BE YOUR NATURAL SELF" SONG BIRDS ANIMALS PORCUPINE BADGER OWL VIXEN MICKEY		LARRY	BIRDS TED BURNIE?	CORRECTIONS OWL · ROONEY SANDY –	CORRECTI OK, SAF PART
SEQ 08	HUNTER + DOGS DRINK + HOWL	MAYBE ROONEY SUGGESTS FISHING ANIMALS WATCHING + LAEFING			BIRDS · CAST BEAVER FOREST ANIMALS??	

LATER – HOUSE HUNTING? TIME TO
HAVE KIDS? – WHOOPING CRANES
COPPER RUNS ACROSS HOUND'S TRAIL LARRY HULET
BURROW – BEAR FIGHT – ENDING SNOW MOBILE / AIRPLANE

HUNTER – DOGS ANIMAL REEL M TO BE REPAIR

BIRDS?

PRODUCTION

IRECTION	LAYOUT	ANIMATORS	COMMENTS	2+30
RT				
UTH			L.A. LADY	3+00
TH/ART RICK JEFF	JOE CHASE	ANDY GASKIL	L.A. LADY LUCAS	
J./JEFF TH/RICK	GRIFF/SHAW JOE/SHAW	FRANK (GOMBERT) DALE OLIVER	L.A. TWO CARS + LADY COLOR MODELS - T.U. B.G L.A. LADY	
TH- RICK	?	EFX	L.A. LADY	
T/JEFF EE AREAS	GRIFFITH SHAW	FRANK (CLEMENTS) OLLIE (ANDY) OWL HUNTER	L.A. TRUCK (LUCAS) RUIF MODEL DWGS	
UTH/RICK	GRIFFITH SHAW	EFX ANIMATORS		
T/RICK	JOE? SHAW		L.A. TRUCK (LUCAS)	
T/RICK	JOE SHAW			
RT/RICK	JOE SHAW	EFX ANIMATORS		
UTH/RICK	SHAW GRIFF	POMEROY (NOVEMBER EFX ANIMATORS	L.A. CAB. (LUCAS L.A. LADY	
RIC?/ART UTH				
T/JEFF	GRIFFITH SHAW	OLLIE (KEENE) FOX VIXEN - OWL	COLOR MODELS T.U. B.G FOX VIXEN	
			COLOR MODELS TWO HOUNDS	
RT?	MEL GRIFF	OLLIE CARTWRIGHT?		
ETCH				

Sequence chart, 1977
The Fox and the Hound, 1981
Graphite and ink on paper

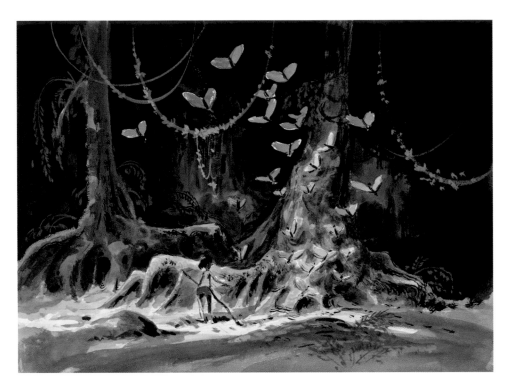

Disney Studio Artist
Concept art
The Jungle Book, 1967
Gouache and colored pencil on paper

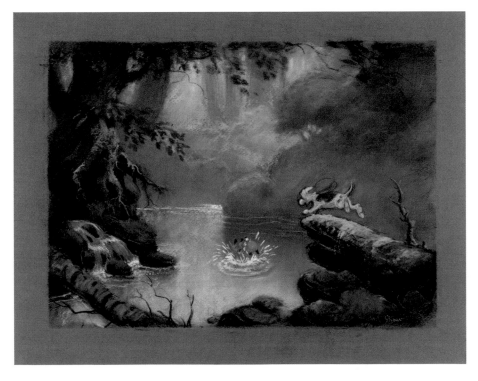

Mel Shaw (United States, 1914–2012)
Concept art
The Fox and the Hound, 1981
Pastel on mat board

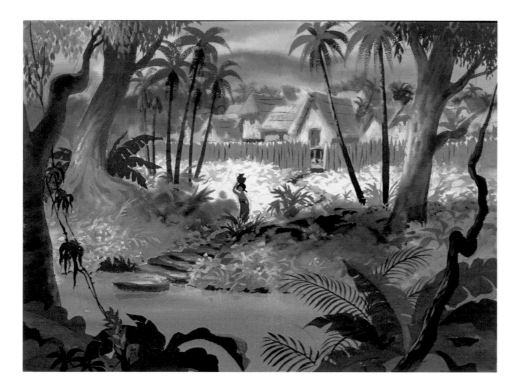

Disney Studio Artist
Concept art
The Jungle Book, 1967
Gouache and graphite on paper

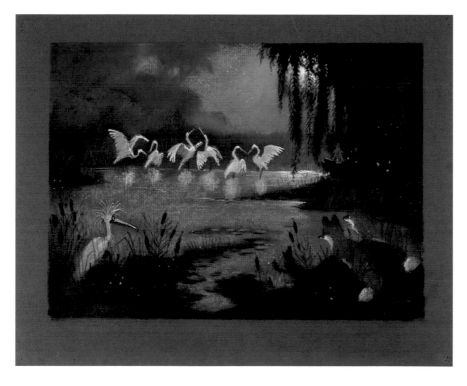

Mel Shaw (United States, 1914–2012)
Concept art
The Fox and the Hound, 1981
Pastel on paperboard

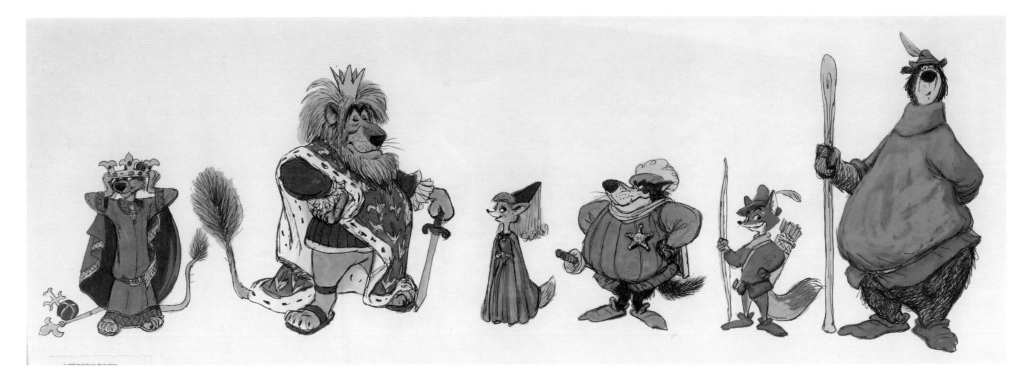

Ken Anderson (United States, 1909–1993) | Concept art | *Robin Hood*, 1973 | Ink and watercolor on paper

Long Beach Earthquake, 1933 | Watercolor on paper

Published by the Walt Disney Family Foundation Press © LLC
104 Montgomery Street in the Presidio
San Francisco, CA 94129

Copyright ©2018
Walt Disney Family Foundation Press ©LLC

Walt Disney Family Foundation Press is not affiliated with The Walt Disney Company or Disney Enterprises, Inc.

Library of Congress Cataloging in Publication data is available.

ISBN: 978-1-68188-444-8

10 9 8 7 6 5 4 3 2 1
2018 2019 2020 2021 2022
Printed in China

Acknowledgments

Walt Disney Family Foundation Press would like to acknowledge the following individuals for their contributions to this book: Don Hahn, creative direction; Andrew J. Nilsen, art direction and design; Charles Solomon, writer; Mark Gibson, photography and digital asset management; Bri Bertolaccini and Paula Sigman Lowery, fact-checking and copyediting; Kaitlin Buickel, Michael Labrie, Caitlin Moneypenny-Johnston, Jamie O'Keefe, and Tara Peterson, production assistance and asset management. Weldon Owen would like to thank Marisa Solís for her editorial assistance.

weldonowen

President & Publisher Roger Shaw
SVP, Sales & Marketing Amy Kaneko
Senior Editor Lucie Parker
Associate Editor Molly O'Neil Stewart
Creative Director Kelly Booth
Production Designer Howie Severson
Production Director Michelle Duggan
Production Manager Sam Bissell
Imaging Manager Don Hill

Weldon Owen is a division of
Bonnier Publishing USA
www.bonnierpublishingusa.com

The Walt Disney Company

Walt Disney Archives
Rebecca Cline, Justin Arthur, Kevin Kern, Ed Ovalle
Walt Disney Archives Photo Library
Holly Brobst, Michael Buckhoff, Joanna Pratt
Walt Disney Imagineering
Bob Weis, Jess Allen, Evelyn Frederick, Michael Jusko, Vanessa Hunt
The Walt Disney Animation Research Library
Mary Walsh, Fox Carney, Ann Hansen, Tamara Khalaf, Tracy Leach, Kristen McCormick, Jackie Vasquez
The Walt Disney Company Corporate Legal
Margaret Adamic

Artwork Lenders

Tony Anselmo: 104 Archive Photos/Getty Images: 42, 110, 112, 126 Clark Family: 72, 73 Alice Davis: 86, 87, 89 (left), 90, 91 Andreas Deja: 23, 24, 29, 37–43, 46 (bottom), 47, 51, 54–57, 59, 79–83, 95, 96 (left), 97, 98, 100, 102, 103 (top and bottom left), 105–108, 113–116, 118–122, 130–132, 134, 135 (top and bottom left), 136, 137, 140, 141, 158 photos by Alfred Eisenstaedt/The Life Premium Collection/Getty Images, Disney characters: front cover (Ward Kimball, Frank Thomas, Ollie Johnston) Kahl Family: 92, 103 (right) John and Virginia Kimball: 142, 143 Kelly Kimball: 133 (right), 135 Reitherman Family: 148–150, 154, 157 (bottom), 159 Thomas Family: 30–35 The Walt Disney Animation Library: 15, 16, 18–22, 25, 36, 48–50, 52, 53, 58, 63, 65–71, 74, 75 (left), 84, 85, 96 (right), 99, 101, 129, 138, 139, 147, 151–153, 156, 157 (top) The Walt Disney Archives Photo Library: front cover (Eric Larson, Woolie Reitherman, Les Clark, John Lounsbery, Milt Kahl), 4, 8, 14, 17, 44, 46 (top), 60, 62, 78, 94, 128, 144, 146 Walt Disney Imagineering: front cover (Marc Davis), 76, 88, 89 (right) Miri Weible, daughter and family: 62

Artwork Donors

All gifts belong to the Walt Disney Family Foundation.

Collection of the Walt Disney Family Foundation: 11, 12, 64, 75 (right), 109 Collection of Ollie Johnston: 6, 7, 26, 117, 123, 124 (left), 125

Artwork Copyright Holders

Archive Photos/Getty Images: 26, 110, 112, 126 © Disney: front cover, 4–8, 11, 12, 14–25, 28, 29, 36–44, 46–60, 62–71, 74–76, 78–85, 88, 89 (right), 92, 94–102, 103 (top and bottom right), 104–109, 113–116, 118–122, 124, 128, 129, 134–141, 144, 146–153, 156–158; Disney Characters © Disney: 110, 126

The Walt Disney Family Museum and Walt Disney Family Foundation Staff

Marilyn Abrams, Jan Abueg, Liz Anderson, Lawrence Arndt, Melvin Asher, Marlon Baez, Courtney Barker, Bri Bertolaccini, Vincent Bocchieri, Katherine Bove, Sheena Boyd Emilee Bozzard, Anna Buckley, Kaitlin Buickel, Shawn Carrera, Natalie Chan Tiffany Chen, Alison Chenoweth Revel, Katherine Coogan, Antonia Dapena-Tretter, Ryan Eways, Tyler Fahr, John Ferris, Alyson Fried, Mark Gayapa, Emmeline Geyer, Mark Gibson, Carla Gonzalez, Lara Hayner, William Hoffmann, Kirsten Komoroske, Jenna L'Italien-Uppal, Michael Labrie, Travis Lacina, Grace Lacuesta, Julie Long Gallegos, Summer Lynn McCormick, Anita Meza, Ariana Minolli, Caitlin Moneypenny-Johnston, Tonja Morris, Ryan Mortensen, Julian Mourier, David Nadolski, Sierra Najolia, Harvey Newman, Mayumi Nguyen, Andrew J. Nilsen, Jamie O'Keefe, Darcy Pease, Ernesto Perez, Tara Peterson, Marina Place, Caroline Quinn, Matt Ramos, Sarah Rothstein, Martín Salazar, Christine Shedore, Maureen Shields, Rosana Shushtar, Richard Stone, John Stroh, Peter Susoev, Channing Tackaberry, Danielle Thibodeau, Tracie Timmer, Jason Vanderford, Emily Vann, Marina Villar Delgado, Deb Waltimire, Nancy Wolf, Brienne Wong